ART AS TECHNOLOGY

The Arts of
Africa
Oceania
Native America
Southern California

Arnold Rubin
Zena Pearlstone, Editor

Hillcrest Press

Hillcrest Press, Inc.
P.O. Box 10636
Beverly Hills, CA 90210

ISBN 0-914589-04-0
LCCCN: 89-24463
© 1989 Hillcrest Press, Inc.

Designed by Robert Woolard
Typography by Freedmen's Organization, Los Angeles
Printed and bound in Japan by Dai Nippon

Cover: East Los Angeles Wall Mural by Willie Herrón.
1972. Photograph copyright Willie Herrón.

Acknowledgment is made to the following for permission
to reprint material copyrighted or controlled by them:

Academic Press, Inc. for excerpts from *The Aztecs, Maya*
 and their Predecessors: Archaeology of Mesoamerica
 by Muriel Porter Weaver.
African Arts and Anita J. Glaze for excerpts from "Woman
 Power and Art in a Senufo Village."
E.P. Dutton for excerpts from *Man's Rise to Civilization*
 as Shown by the Indians of North America from
 Primeval Times to the Coming of the Industrial State
 by Peter Farb.
Los Angeles Times for excerpts from "Living Space for
 Psychic Energy" by John Pastier. Copyright 1975, *Los*
 Angeles Times.
The Metropolitan Museum of Art for excerpts from *Art*
 Styles of the Papuan Gulf by Douglas Newton and *The*
 Asmat of New Guinea edited by A.A. Gerbrands.
Mouton de Gruyter for excerpts from "Anthropology and
 the Study of Art in Contemporary Western Society:
 The Pasadena Tournament of Roses" by Arnold Rubin
 in *The Visual Arts: Plastic and Graphic* edited by
 Justine M. Cordwell.
Oxford University Press for excerpts from *Drama of*
 Orokolo by F.E. Williams and *Primitive Art and*
 Society edited by A. Forge.
Jerome Rothenberg for excerpts from *Technicians of the*
 Sacred.
Summit books for "The Return of Ritual" in *The Healing*
 Arts: A Journey Through the Faces of Medicine.

All other permissions, for images and texts, have been
requested.

Table of Contents

Arnold Rubin, 1985. Photograph, Zena Pearlstone.

In April 1987, a year before he died, Arnold received the following from an elementary school student in Portsmouth, Virginia, where Arnold grew up. The letter said, in part:

> We [our class] are looking for Portsmouth people who have made a notable achievement in order that they may be honored by our city.
> I would appreciate it if you would answer this set of interview questions.

It is appropriate that some of Arnold's responses appear in this text, his gift to all his students.

QUESTION: What do you like *best* about your job?
RUBIN: The opportunity, as a teacher and scholar, to pass on information, ideas, and a critical perspective to young people who are engaged in working out their relationship to the world, as they were passed on to me at the same crucial stage in my own life; to contribute to the appreciation and understanding of cultural expressions outside the mainstream of European civilization.

QUESTION: Whom do you admire most among the world's great *heroes*, living or dead?
RUBIN: The independent, deeply creative artists, scientists, philosophers, religious leaders, who have changed the world through the force of their ideas: Ghandi, Martin Luther King, Karl Marx, Charles Darwin, Claude Levi- Strauss, Franz Boas . . .

QUESTION: Do you have any *favorite* books that you would recommend as reading for young people? For adults?
RUBIN: Eugen Herrigel, *Zen in the Art of Archery*; Lewis Thomas, *The Lives of a Cell*.

QUESTION: Do you have any particular *advice* for young people to follow today?
RUBIN: Celebrate diversity! Defend freedom!

Preface

To my knowledge, the course which prompted this book embodies a concept and a structure unique among art history courses in America. First offered in 1976, it reflects the UCLA Art History Department's commitment to a balanced presentation of world art at all levels of the curriculum, correcting the Western bias prevalent in most programs.

The course is interdisciplinary and eclectic in approach. While rooted in the humanistic concerns typical of traditional art historical scholarship, it draws heavily upon the methods, theories and data of the social sciences, particularly anthropology. The concept of the course is fundamentally relativistic, in that it accepts the functional equivalence and ethical neutrality of the beliefs and practices of all cultures. On the other hand, a prominent objective of the course is to identify the constraints and variables, the shared characteristics and distinctive differences in the arts produced by peoples organized into fairly well-defined types of social, political, and economic units. On account of the scope of the course, some of the scholarship may not be entirely up-to-date; by way of compensation, the myopia which comes with narrow specialization is avoided. In any case, our objectives are to foster development of a new way of looking at art rather than to accumulate a mass of new facts, to synthesize rather than to dissect.

Not surprisingly, this concept and structure, and these objectives, are inadequately supported by texts now in print. Available materials are either oversimplified, too narrowly focused, or too specialized and detailed to meet the needs of the course. (Publications based on earlier, unenlightened concepts of a unitary "Primitive" art are even less appropriate.) In short the lack of adequate study-aids has been a chronic problem for students in the course.

The specific cultures discussed here have been chosen for two purposes: 1. to illustrate and develop the principles around which the course is organized; and 2. to prepare students for Upper Division offerings in the African, Oceanic, and Native American fields.

Arnold Rubin
1981

Foreword

Arnold Rubin died of gastric cancer April 9, 1988 at the age of fifty. The completion of this book is my testimonial to him.

Arnold was born in Richmond, Virginia in 1937; his family moved to Portsmouth, where he grew up, shortly thereafter. In 1960 he received a Bachelor of Architecture from Rensselaer Polytechnic Institute and in 1969 a Ph.D. in Art History from Indiana University. His major field of interest was sub-Saharan Africa, specifically northeastern Nigeria where he lived for four years in the 1960s and early 1970s; from 1964 to 1966 a Ford Foundation grant financed pre-doctoral field research and a Fulbright-Hayes post-doctoral research grant permitted further research between 1969 and 1971.

Rubin was a tireless researcher and over a period of twenty years published about fifty catalogues, scholarly essays and reviews on various manifestations of African art, including the African presence in Japan. In 1983 he received a Fulbright-Hayes grant for field research in India to pursue the history of Africans in that country. His research and teaching interests branched out in the early 1970s to include American popular art and culture. He taught African, Oceanic and Native American art history, and courses in fieldwork methodology at the University of California, Los Angeles from 1967 to 1988.

In 1981, for the reasons described in the preface, Rubin assembled a working manuscript for his students which included a variety of readings and portions of the lectures from his course, "An Introduction to the Arts of Africa, Oceania and Native America." The manuscript was printed by the Academic Publishing Service (APS) at UCLA which made the book available to UCLA students and personnel. Slight revisions were made in 1983 and 1985.

Rubin never intended the APS publication to be the final version of the book. Before he became ill he was considering a major revision, but other commitments left him little time to rework the manuscript. If it had been done, he probably would not have considered the revised text as final. For Arnold this was a work constantly in progress; one that would see its final version in his golden years. Unfortunately, he was not given this opportunity.

Shortly before he died I promised to revise and publish the book but by then he was too sick to discuss these revisions. Consequently, I have left intact as much of the original text and format as possible. Text has been changed only when necessary. The excerpted readings he selected have been retained except in two cases where they were no longer suitable and have been replaced with the sections on Senufo and Asante art written for this volume. As a result of retaining the original material the sections are not uniform in format or coverage, a situation I deemed more appropriate than forcing the chapters into a standard form and thereby losing Arnold's own words and the passages he selected.

The Introduction and the two following chapters (Environmental and Cultural Factors, Utilitarian and Transactional Functions), with the exception of some revision to the Olmec material, remain virtually unchanged. The five inserts in these three chapters have been taken from Rubin's notes on class sections (weekly meetings between Teaching Assistants and small groups of students). I assembled the final chapter on Convergence primarily from his notes and writings, and our conversations.

All of the chapters on specific cultures have been revised and updated to some degree; those on the Southwestern United States and the Great Plains most heavily, and those on the Fulani, Asmat and Maori the least. I suspect that in this broad array of materials there remain some outmoded facts and interpretations. For these I am responsible and can only reiterate Arnold's statement that "our objectives are to foster development of a new way of looking at art rather than to accumulate a mass of new facts."

It has been noted by several people that Arnold was primarily a teacher. The course he gave on this material he considered one of his most important responsibilities and this textbook a primary contribution. This is Arnold's vision of the non-Western world as he communicated it to students for over twenty years. I trust it will be as provocative and seem as wise to future generations as it has to past.

Zena Pearlstone
1989

For Hannele and Gabriel

Acknowledgments

It is a tribute to Arnold and a source of great solace to me that so many of his peers, colleagues, friends, students, ex-students and family have contributed to this volume with unbridled generosity and love.

The following have read and commented on the chapters describing culture groups: Christine Dyer and John E. Stanton, Australia; Rachel Hoffman, Fulani; Karen Stevenson, Asmat and Maori; Anita J. Glaze, Senufo; Cecelia F. Klein, Olmec and Maya; and Raymond A. Silverman, Asante. Suggestions and corrections offered by each of these scholars have been incorporated into the text. I particularly want to thank Helen Crotty for the extensive comments she provided regarding the section on the Pueblos.

Doran H. Ross of the Museum of Cultural History at UCLA and Douglas Newton and Barbara Burn at the Metropolitan Museum of Art in New York graciously supplied many of the photographs. Craig Klyver of the Southwest Museum in Los Angeles was of particular help with the pictures for the Native American sections. I thank Frances Farrell and Richard Todd who always had time to take one more picture.

The following friends of mine and Arnold's helped find pictures, edit text, or otherwise provided needed services: Marla C. Berns, Judith Bettelheim, Herbert M. Cole, Mary Ann Fraser, Marc Haefele, Thomas F. Mathews, Sabrina Motley, Merrillyn Pace, Susan and John Picton, Holly and Marcos Sanchez and Joanna Woods-Marsden. Paulette Parker at the Museum of Cultural History was always available to locate information from Arnold's and the Museum's files. Joyce Boss has been a thoughtful editor and Robert Woolard, a conscientious designer.

Sophie Pearlstone, Hannele Rubin, Pauline Rubin and the late Herman Rubin have helped substantially with publication costs.

My special thanks to Cecelia F. Klein for her support and suggestions and Carolyn Dean for her artwork and more importantly her substantial presence as a sounding board and critic. To Jay T. Last my warm appreciation for supporting and encouraging this project at every stage.

I know Arnold would join me in blessing you, every one.

Zena Pearlstone

Introduction

Art historical scholarship began with the study of European antiquity, where relationships are clear, and has grown out of a system of shared political, religious, and economic values and ideas. Studies of non-Western art developed late, and have been characterized by a "wastebasket" approach—lumping into one field all the arts left over after the really significant artistic traditions have been parcelled out.

The mind of the Western research-worker is accustomed, by his work on the classics, to a reasonable number of new fragments discovered annually by a select band of archaeologists. Sudden shocks are coldly received and the select few flee from an avalanche of facts. It is admitted that centuries of erudition have amassed materials about the Greeks from which vast edifices have been built. We are accustomed to see these ancient bits of masonry slowly rising against the background of our culture: the least stone found is transmitted by respectful hands to the workers on the roof. But let thousands of exotic cities suddenly spring up, let unusual, strange and shocking facades arise, and they depreciate in value through their very number. This excess repels us and, turning our backs resolutely on the deluge, we take refuge in our convenient clichés (Griaule 1950:16).

A single course and concomitant textbook combining the arts of Africa, Oceania and Native America can only be viewed as a pedagogical convenience and a function of how little we know of the constituent areas. One way of dealing, in a ten-week course, with this mass of disparate material would be arbitrarily to devote, for example, one block of time to Africa, another to Oceania, etc. Instead, we start with a comparative examination of the structures within which art is produced and utilized, attempting to develop a valid framework for understanding how art operates within its cultural context. We then proceed to survey the arts of selected cultures, attempting to identify similarities and differences between them according to the types of social, political, and economic systems they embody.

Anybody tends to react and relate to the arts of his/her own culture instinctively and more or less without reflection. It is both easier and

harder to be objective about the arts of other times and places. For many, the process has first to involve un-learning, de-kinking—putting aside inaccurate preconceptions and erroneous information. To be able to generalize about what art is and does requires a holistic point of view rather than stringing together bits and pieces of information, even though such information about the cultures of Africa, Oceania, and Native America is rarely adequate to such an effort. Some students with a background in conventional art history may have to get beyond the idea that learning about art is learning dates and names of artists and patrons. (We have very little of that kind of information here.)

Rather than being an isolated and essentially self-contained activity, art shapes and is shaped by the cultural system which produced it, and thus is a unique record or trace or reflection of that system. Through their art, we can come to know other cultures in a special way, striving to understand them as "natural" and "normal" in the same instinctive (or at least empathetic) way we have come to terms with our own. The negative effects of stereotypes of non-Western cultures as "primitive"—the Tarzan syndrome—must be recognized, and the attitudes which underlie them examined.

That there are no primitive languages is an axiom of contemporary linguistics where it turns its attention to the remote languages of the world. There are no half-formed languages, no underdeveloped or inferior languages. Everywhere a development has taken place into structures of great complexity. People who have failed to achieve the wheel will not have failed to invent and develop a highly wrought grammar. Hunters and gatherers innocent of all agriculture will have vocabularies that distinguish the things of their world down to the finest details. The language of snow among the [Inuit] is awesome. The aspect system of Hopi verbs can, by a flick of the tongue, make the most subtle kinds of distinction between different types of motion.

What is true of language in general is equally true of poetry and of the ritual-systems of which so much poetry is a part. It is a question of energy and intelligence as universal constants, and, in any specific case, the direction that energy and intelligence (= imagination) have been given. No people today is newly born. No people has sat in sloth for the thousands of years of its history. Measure everything by the Titan rocket and the transistor radio, and the world is full of primitive peoples. But once change the unit of value to the poem or the dance-event or the dream (all clearly artifactual situations) and it becomes apparent what all those people have been doing all those years with all that time on their hands (Rothenberg 1969:xix).

In thus emphasizing belief and behavior, this text will draw heavily upon the work of social scientists. Keep in mind, however, that the focus is *art*, and the points of departure and destinations will always be *objects*, where they come from, why they look the way they do, and what they *mean*. As noted above, objects are records of cultural process, and they provide *direct*, unmediated access to the values and experiences of their producers—if we know how to read them. In other words, the objects provide direct testimony. They are not filtered through somebody else's consciousness (biases, preconceptions) as are data on social systems, for example, as gathered by anthropologists.

It is necessary at the outset to sift through a certain amount of historiographical debris in order to find out where we are in our attitudes toward the societies we are about to study, and how we got there. Following four hundred years of discovery and exploration, Europe by the late nineteenth century had embarked upon a vast colonial enterprise. For the first time, large numbers of Europeans came into relatively close contact with exotic cultures. Up until this time, these cultures—and the objects they produced—were regarded as curiosities. Nineteenth-century Europeans considered themselves elected to carry the "White Man's Burden" of liberating their "primitive" contemporaries from their benighted ways of life. Colonial peoples were regarded as withered branches on the evolutionary tree, dead in the water, frozen off, in contrast to nineteenth-century Europe and Euro-America, the full flower of man's evolutionary development. These judgements are typical of an

attitudinal framework called ethnocentrism, the belief that one's own way of life is natural and normal for mankind, better than any other (see page 14). Moreover, late nineteenth-century Europeans and Euro-Americans had the ideology and technology—Christianity, capitalism, mass-production, superior weapons—to persuade "primitives" of the validity of their opinions. For the most part unnoticed in the historical record are scraps and shreds of evidence that non-Western peoples had their own ethnocentric attitudes, and viewed Europeans as primitive. A Japanese chronicle, the *Yaita-ki*, includes their opinions about the first party of Portuguese seafarers to reach the small island of Tanegashima, near Kyushu:

> These men . . . understand to a certain degree the distinction between Superior and Inferior, but I do not know whether they have a proper system of ceremonial etiquette. They eat with their fingers instead of with chopsticks such as we use. They show their feelings without any self- control. They cannot understand the meaning of written characters. They are people who spend their lives roving hither and yon. They have no fixed abode and barter things which they have for those they do not, but withal they are a harmless sort of people (Boxer 1967:29).

Such insights, unfortunately, are rare. As regards the arts, relevant works were brought together by a distinguished German anthropologist named Julius E. Lips (1937) (as a reaction to the racial theories of the Nazis) in a book elegantly titled *The Savage Hits Back*.

It should be noted that the science of anthropology began in the nineteenth century as an aspect of European political and economic expansion, whereby access to the resources of colonial peoples was enhanced by an understanding of their social and cultural systems. Anthropological "understanding" was an aid to more efficient administration. The arts, along with traditional religion in particular, where noticed at all, were used as propaganda, as ethical justification for European control; they were not merely curiosities, but indicators of how low their producers fell on the evolutionary ladder.

Nineteenth-century European art was taken as the baseline—narrative and descriptive of external reality, characterized by accurate proportions and contours, correct color, and uplifting messages. Early in the twentieth century, however, advanced artists in France and Germany used "primitive" art as aesthetic battering rams with which to challenge this Classical heritage, which they believed to have become bloodless and decadent. Looked at another way, their use of "primitive" arts for this purpose was yet another form of exploitation. These arts were not used as sources of insight and information about the cultures of their producers. The reverse in fact was true: the less known about primitive art the better, in order to maximize their aesthetic impact by giving free rein to the imagination. In short, the French Cubists and German Expressionists used non-Western arts essentially as "found-objects," just as they used objects of mass-production and scraps of industrial materials (like newspapers) to make other points in their work. Nobody cared about the actual contexts for which the objects had been produced; and, moreover, their assumed association with cannibalism, human sacrifice, and other "unspeakable practices," while fascinating, was also repugnant. Anthropological investigations were no help, being skewed toward efficient administration rather than elucidation of coherent cultural systems, and few Europeans were motivated to examine art and material culture and try to explain why they look the way they do, to reconstruct their origins and evolutions in order to dissipate their aura of exoticism and threatening strangeness.

Calling the arts of the peoples of Africa, Oceania and Native America "primitive" can reasonably be regarded as propaganda in support of the exploitation of their makers. In art history, the term Primitive is not applied only to Africa, Oceania and Native America (which covers the entire spectrum from naked hunters and gatherers to sumptuous empires), which would be bad enough. Rather, it is extended to encompass, in contemporary Western industrial societies, the arts of children and the insane, and of "naive" artists like Grandma Moses; it is

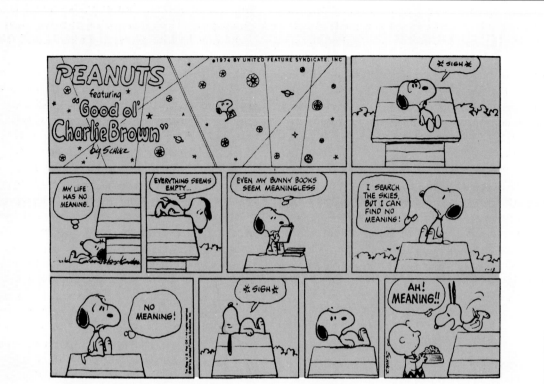

Figure 1. Peanuts by Charles Schulz, 1974. Reprinted by permission of UFS, Inc.

ETHNOCENTRISM AND STEREOTYPING

''I remember talking to an old cannibal who from missionary and administrator had heard news of the Great War [World War I] raging then in Europe. What he was most curious to know was how we Europeans managed to eat such enormous quantities of human flesh, as the casualties of a battle seemed to imply. When I told him indignantly that Europeans do not eat their slain foes, he looked at me with real horror and asked me what sort of barbarians we were to kill without any real object'' (Malinowski 1966:vii).

Each nation, group and culture believes that their way of interpreting the world is superior (ethnocentrism). Meaning is relative (figure 1).

Each nation, group and culture defines those who are ''other'' by employing conventional or standardized images of those outside the group (stereotypes).

''Phrases such as 'I know them,' 'that's the way they are,' show the maximum objectification [stereotyping] successfully achieved. . . . Exoticism is one of the forms of this simplification. It allows no cultural confrontation'' (Fanon 1967:34-5).

extended further to cave-art and to early periods of more fully realized traditions (such as thirteenth- century Italy). The only thing these categories have in common is that they are somehow considered to reflect untutored, intuitive "natural sensibility." As regards the arts of Africa, Oceania, and Native America at any rate, nothing could be further from the truth. Is there another term which is free of these associations?

Gerbrands (1957) gave good reasons for rejecting Primitive Art, Exotic Art, Traditional Art, Folk Art, Arts of Pre-Literate/Pre-Logical Peoples, and Tribal Art (since espoused by William Fagg, based on the frequency of exponential or "growth" curve in their art). Gerbrands provisionally accepts the designation "Non-European Art," with the stipulation that the "high" arts of Asia and the Islamic world are excluded. Other proposals include that by Haselberger (1961), "Ethnic or Ethnological Art," and that advocated by Carpenter (1968:72), "The Arts of the Non-Literate Peoples."

Don't all such terms tend to obscure the independent developmental history of the traditions they group together, unlike the shared features of Romanesque or Baroque art in Europe? Gerbrands (1957:138) reaches much the same conclusion:

> As to form, there is no single principle to be found in non- European art that can claim universal validity. These forms can vary from almost photographic realism to a completely non-figurative abstractness. . . .
> If form cannot help us, perhaps content may? Yet here again it is impossible to discover a single *fundamental* difference between European and non-European art.

In other words, the histories (and art histories) of the peoples we are about to study may or may not be recoverable, since much (or most) of their art was ephemeral and few left written records of their own. But they won't be recovered if we build into the terminology the assumption that there is nothing to recover. Geographical terms, which have the advantage of being neutral and relatively precise, are used here: The Arts of Africa, Oceania, and Native America. (It should, however, be noted that speaking of "The Art of Africa" involves many of the same limitations and distortions which the terms "European Art" or "Asian Art" would embody.)

Beyond terminological problems, Gerbrands (1957:139) also attempts to circumvent the limitations of previous definitions of art. His "objective" definition is as follows: "When a creative individual gives to cultural values a personal interpretation in matter, movement or sound of such a nature that the forms which result from this creative process comply with standards of beauty valid in his society, then we call this creative process, and the forms resulting therefrom *art*."

The social consensus required by Gerbrands evaporates when the object is taken from its original context, as when non-Western art is exhibited in a Western museum. True, a new consensus may emerge, but his definition has other flaws—notably its emphasis on uniquely individualistic statements and "standards of beauty." Does a Gothic cathedral conform to Gerbrands' definition? Whose "personal interpretation" is determinative? The architect's? The patron's? The stone-carver's? All of them? How does one deal with other synthetic media, such as opera? For the most part, the elements of opera have been isolated, so that one attends concerts for music, theaters for drama, recitals for dance. "Serious" students of the arts prefer to contemplate conceptually circumscribed phenomena, rather than participate in such an orgy of sensate experience. Yet opera survives, even flourishes, as a splendid anachronism in our society. Perhaps the sense of exaltation and uplift, the creation of a non-ordinary reality, may be the essential attribute of "aesthetic" experience.

As a starting point in understanding these complex, synthetic—or synaesthetic—mechanisms and procedures for suspending the normal ordering of experience, we may note that they tend to be normal rather than exceptional in the arts of Africa, Oceania and Native America. At their most effective, they can elevate people to another level of reality, and, as a result, sometimes take on the aspect of sacraments. They

involve transcendent states entered into (sometimes with chemical aids such as alcohol or drugs) under carefully controlled circumstances as *means* rather than as *ends*—not merely recreation, or a vague sense of cultural uplift, or aesthetic pleasure, but rather the enhancement of social solidarity, or to harness energy available in the environment for the benefit of the community. In such situations art may be said to be created by the entire group for the entire group, and the whole is greater than the sum of its parts.

> For traditional Africa, the accumulated wisdom of the past, represented by "formulae" in all aspects of culture, provided an acculturative and cohesive mechanism of enormous potency, to be tampered with only at the risk of potentially grave consequences. Art, in particular, served to define and focus group identity and to reinforce the sense of community which provided the only context in which individual identity was meaningful or even conceivable. Far from stifling the artistic impulse, we must conclude that these fundamentally conservative systems of shared values, emphasizing continuity and stability rather than change and challenge, have imbued the forms of African sculpture with an uncompromising and unequivocal sense of conviction which is the source of their often extraordinary impact. . . . The point, of course, is that social utility and esthetic quality are not—and never have been—necessarily incompatible; for most cultures, the positive role of the artist in objectifying and reinforcing the values of his community has been resolved in terms of a delicate and complex balance of esthetic and other priorities. Acceptance of and operation within conventional limits on "artistic freedom" usually carried compensation in the form of increased leverage in the social, political and economic spheres (Rubin 1975:36-7).

We can identify three broad areas of what art does in society as—apparently—universal. *First*, it establishes and proclaims the parameters of individual and group identity. For most of the peoples being studied in this book a sense of individual identity is difficult to extricate from the collectivity, the network of social relationships in which an individual participates. Not only through language and religion but also through dance and dress do a people define its distinctiveness, the patterns of belief and behavior which demarcate it from its neighbors. *Second*, art is didactic, a teaching system, a major means of enculturation, of instilling the concept of group-membership. It is a chain which links the generations in shared patterns of belief and behavior. *Third*, as implied in the Rothenberg quote given above, art may be described as a form of technology, a part of the system of tools and techniques by means of which peoples relate to their environment and secure their survival. For example, a solar eclipse is widely conceptualized as an attack on the sun by a cosmic monster of some sort. Many peoples of the world have articulated ways of restoring the order of nature—frightening off the monster—through ritual action, including songs, dances, and other arts. Cause and effect are adequately demonstrated through an unblemished record of success, and people are understandably reluctant to question or innovate, given the consequentiality of the task involved. Moreover, such procedures reinforce the notion that people have responsibility, are directly involved, in the workings of the universe. When dealing with the sanctions of tradition, it is less important to know *why* something works than *that* it works. Are "standards of beauty" and "personal interpretations" important, when the object is used to bring rain in its season, prevent disease, enhance fertility, or restore the sun to its proper brilliance? How much "artistic freedom" is worth how much social and cultural consequentiality? Perhaps we perceive as beautiful those objects which incorporate power as a reflection of their role as energizing nodes in and products of coherent, integrated, human societies.

> Four fundamental premises would seem to bear reiteration: *first*, that the forms of art, and whether or not a particular observer finds them moving, and why or why not, matter less than what they accomplish within the narrow and broad social contexts in which they were engendered; *second*, that, for present purposes, whether a particular work is great or minor, conventional or innovative, is a distinctly secondary consideration. In other words, the

ART AS TECHNOLOGY

TWO DEFINITIONS OF TECHNOLOGY
Rubin's definition: "the system of tools and techniques by means of which people relate to their environment and secure their survival."

Webster's definition: "the system by which a society provides its members with those things needed or desired."

ART AS TECHNOLOGY
Art can act as technology when it:

1. is a tool for interacting with other people or with environmental or universal forces
2. is a communicative (persuasive, instructive) device
3. is a tool for making the intangible concrete
4. is a form of entertainment or recreation
5. performs other functions.

The advantage of describing art as technology is that it removes bias and ethnocentrism. Viewed as such, art is no longer self-contained, gratifying by itself. A function is implicit. Due attention is now given to the purposes of art, which range from concrete (healing, influencing the environment) to more abstract (unifying the community, enculturation, individual entity). Artists are now introduced as technicians and they are acknowledged and expected to be individuals who contribute to the orderly functioning of the community.

As technology the two works seen here provide the following information. Both:

1. represent spiritual/psychological energy or being
2. are therapeutic for artist and audience in that frustrations and illness (internal/spiritual) can be released/expressed in concrete terms
3. are products of specialists for community consumption
4. serve the community (one through healing, the other through entertainment).

(continued on page 18)

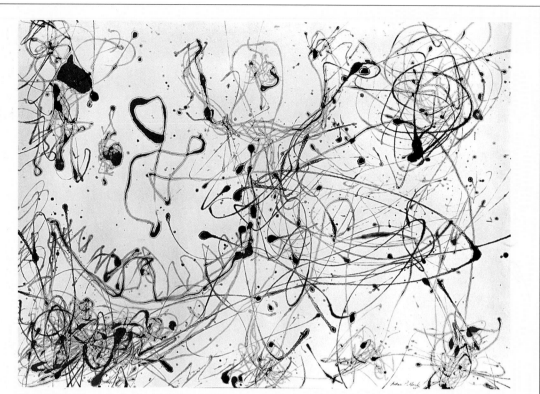

Figure 2. Jackson Pollock, #4,1948, 1948, enamel and gesso on paper, 22 5/8" x 30 7/8". Courtesy Frederick R. Weisman Collection. Collection photograph.

POLLOCK

Pollock as a twentieth-century Western artist is not generally seen to serve the community as a whole or to be particularly useful or participative. His efforts were introspective, self-reflective and highly individual.

1. The artist creates an enduring record of a particular individual and also an opportunity for continual contemplation.
2. His work "functions" on its own; neither artist nor audience changes it once it is finished.
3. The painting is a unique expression of a creative individual who sets himself against tradition and thus at the intellectual fore of his society.

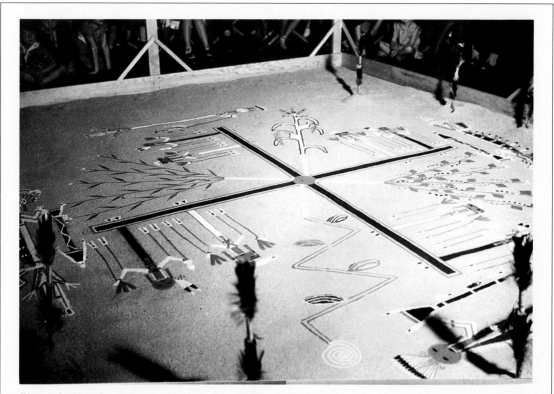

Figure 3. Navajo. Arizona. Drypainting of Thanksgiving. Courtesy of the Southwest Museum, Los Angeles, #33950. Museum photograph.

DRYPAINTING

The individual who produced the drypainting is regarded as a "healer" rather than an artist by the Navajo. The drypainting is actualizing patterns of vital energy to restore health and insure the well-being of the community. Drypainting can also be part of rituals to invoke rain and ensure fertility.

1. The drypainting is ephemeral; its value lies in its function which involves its destruction.
2. The "artist" of the drypainting actively controls supernatural forces and is in direct contact with both artwork and audience. The patron (patient) interacts with the work by sitting on it at its completion.
3. The drypainting must follow traditional formulae in order to be successful; it expresses continuity in time and in group belonging.

ephemeral - temporary; lasting or existing briefly; of interest for only a short time; topical

information and insights yielded by a Gothic cathedral on the one hand, and an illuminated initial letter from a manuscript produced during the same period on the other, may be different both in quantity and quality, but neither is negligible in the search for understanding of the period and its art. *Third*: consideration of art as technology presumes a condition of ethical neutrality; essentially similar structures and procedures are evident in an Easter service at St. Peter's in Rome, Hitler's Nürnberg rallies, a Rolling Stones concert, or an ancestral masquerade in a West African village. Artistic *means* can only be judged as efficient and effective, or inefficient and ineffective, in the accomplishment of particular social and cultural *ends*, a judgement entirely separate from the question of the worthiness of the ends themselves. And *fourth*: treatment of artists as technicians does not entail deprecation of their role or real loss of status. Rather, such an objective view acknowledges the substantial and important contribution artists can make to the orderly and effective functioning of their communities, in contrast to the "exalted" but essentially trivial position considered natural and normal in Euro-American industrial civilization (Rubin [1972]).

Art as technology has two aspects: *POWER* and *DISPLAY* (see pages 17–19). *POWER*-objects accumulate and concentrate cultural energy for the benefit of individuals or the larger community. *DISPLAY*-objects are the visible, tangible results of accumulated powers; the one, in other words, is about causes, the other about effects.

Certain forms and materials brought into conjunction and activated through appropriate procedures have the capacity to organize and concentrate what might be called "available capability." For the most part, [*POWER*] materials embody "signature elements" for the creature from which they have been taken, amounting to the distinctive survival equipment which characterizes each: for birds, their beaks, talons, or feathers; for the various types of antelopes, their horns; for snails or tortoises, their shells, and so on. Imitations in carved wood or other materials may, it seem, also serve. . . .

Incantations, blood sacrifices, and libations of "spiritous" liquors may be used to introduce additional essences. A tendency to multiply media in *POWER* contexts should probably be seen as intentional design redundancy, calculated to organize a wide spectrum of systematic responses to particular types of problems—health, prosperity, or social advancement, for example—through the employment of configurations and procedures which experience has indicated will achieve a desired result. Thus, activation of objects through this process of transfer and concentration of energies or capabilities is cumulative in intent as well as accumulative in aspect. The effectiveness of the principles involved is corroborated by the multiplication of elements and attributes unified by the residue of many sacrifices.

The investment of spirit principles in objects by invocation and convention, also frequently encountered in the art of Africa, has been stressed in the literature. The conceptions involved seem fundamentally different from systematic exploitations of qualitative phenomena in *POWER* contexts, however. Procedures followed (sacrifices, adjurations, etc.) and observable signs of their effectiveness (e.g. possession of devotees) may be similar in both cases; the spirit-principles in question are usually personalized in the form of deities or ancestors, however, and their symbolic presence in their particular ceremonial context usually implies invitation and some measure of willingness or volition. In contrast, *POWER* sculpture may be said to draw directly upon essences, its effects conceived as resulting automatically from proper procedures properly carried out.

DISPLAY materials (beads, bells, fabrics, mirrors, etc.) are primarily oriented towards enhancement of the splendor of the objects to which they are attached. They usually carry associations of prosperity and cosmopolitan sophistication for the individual or group on whose behalf such sculpture is created. . . . The second category of materials—horns, skulls, and sacrificial accumulations, for example—is connected with the organization and exploitation of *POWER* (Rubin 1975:39,40,42).

In sum, every work of art has three properties: 1. material—for example, jade, ivory, bark, clay (never accidental or random, materials are chosen according to the differing messages their properties communicate); 2. motif, or subject, whether representational (human, animal) or abstract; and 3. workmanship, the degree of capability which a creator brings to the execution of an object. How these elements are brought together in an object determines how its

intended audience will respond to it. Objects partake of the qualities of the person or thing represented according to two principles: *Sympathy*, wherein association leads to a transfer of qualities; for example, wearing a lion's mane gives the wearer the lion's ferocity and bravery. (It is according to this principle that a head-hunter or cannibal appropriates a victim's vital energies.) Compare with the Elvis haircut or "urban cowboy" regalia. According to the principle of *Identity*, an object is thought to partake of the qualities of the person or thing it represents; for example, an attack on an image of one's enemy or prey leads to control in actuality.

Now it is manifesto time. A fundamental premise of this text is that this material, these societies, are directly relevant to our lives, precisely because they existed (until recently) outside the European/Euro-American cultural stream. We need to know about the entire range of possibilities, of alternative systems of organizing human communities, as a basis for making intelligent choices about what changes to make in our own societies and how to go about making them.

> The evolution of the [Native Americans'] culture has shown that human societies around the world are something more than patchworks or haphazard end products of history. The study of the tribal organization of the Iroquois, for example, gives hints about the ancient Hebrews at the period when they, too, were organized as tribes. What is now known about the total power of the Aztec state tells modern man much about why the Assyrians acted the way they did. The varying responses of the [Native Americans] to the invading Whites sheds [sic] light on today's questions about colonialism in Africa and Asia, and its aftermath (Farb 1968:27).

The role of art is to convey us directly to the heart of a community's social and cultural values and show us how well or poorly it functions (see pages 22–23). By now it should be apparent that I will be trying to tell you about some things which we as a people, or a culture, or a civilization have largely forgotten, or been diverted from—about how art functions as an extremely potent mechanism for social coherence and cultural integration. Specialists in Western art, critics and aestheticians, have told us that what matters about art is the individual's search for order and truth, and that such a search can only take place in a situation of unrestrained freedom. I would be more inclined to believe that restrictions and limitations—the challenges posed by a *strong tradition*—are closer to the essence of artistic potency; that "artistic freedom" is generally bought at the price of social consequentiality; that when the artist retreats into his or her laboratory to pursue his or her solitary vision, the work tends to become increasingly esoteric and trivial and he or she is likely to have less and less impact on what happens in his or her community. This is in contrast to the sense of conviction, intensity, and "rightness" we sense in "Primitive" art. The arts we are about to study are typically situated at the *center* of the societies which produced them, encoding their beliefs and values and metaphysical and ontological structures. They represent techniques we need to know about, as social order becomes more and more tenuous in our own society, given our impulse toward introspection and the manipulation—for better or for worse—of social and cultural forms. In short, the genie is out of the bottle. In view of that fact, we need as much information and insight as we can get in order to make intelligent choices about designing our lives and communities. And it is altogether fitting and proper that we learn them from the peoples who are the subject of this course. Our ancestors—those of us who partake of a Euro-American heritage—have taken their bodies in slavery, their gold and ivory and spices, expropriated their land and destroyed their autonomy. But somehow their most valuable resources were missed—the resources of the mind and imagination and spirit, as epitomized by their arts, their music and dance and oral literature. (It should be clear that I am not now talking about the *objects* of art as such, but about achieving an understanding of how and why their art works in its social

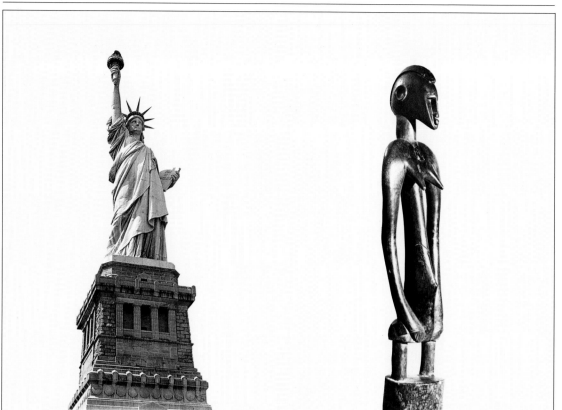

Figure 4. New York. Statue of Liberty. Photograph, Marvin Trachtenberg.

Figure 5. Senufo. Ivory Coast/Mali. Madebele. From Goldwater (1964:Fig.88).

CULTURAL CONTEXT

Since Euro-Americans are not of the social milieu that produced most of the art discussed in this book, the following comparison indicates how we must proceed in order to understand the art of other cultures. These two female forms illustrate the fact that Westerners must go beyond formal analyses and understand social and cultural contexts to grasp the significance of objects from unfamiliar cultures.

FORMAL ANALYSIS

African
1. This is a non-naturalistic depiction of the female form where certain physical features, such as the breasts, the torso and arms have been exaggerated.
2. The piece is constructed of wood which is less durable than the copper of the Euro-American sculpture.
3. The sculpture is thirty-six inches high and portable.

Euro-American
1. The Euro-American representation, a woman with an uplifted arm holding a torch, is colossal in size but shows attention to detail and is proportionally fairly accurate.
2. This piece, made of copper, will last longer than the African piece, if it is not older already.
3. The Euro-American example is 152 feet high and intended to be associated with one particular location.

Formal and stylistic analyses alone do not tell us anything about social context and function. Of art from an unfamiliar culture we must ask:
1. Where is it from—generally and specifically?
2. Who made it (the ethnic group and the artist, if known)?
3. Who uses it, actually and symbolically?
4. In what social context is it used, specifically and generally?
5. What is it called by the people who use it?

SOCIAL AND CULTURAL CONTEXT

African (see also page 103)
1. The piece was made by an artist of the Senufo people of the Ivory Coast. District of manufacture not known. Many Senufo artists produce this type of sculpture and pieces are manufactured frequently, on commission when the old one wears out.
2. It is used at funerals by both men's Poro and women's Sandogo societies.
3. Sculpture of this size (two-thirds life size) is called *pombibele*, "children of Poro," as well as *madebele*, "bush spirits," a generic term for all figurative images of supernatural reference.
4. This figure is one of many that have multiple layers of meaning including, according to Glaze (1981b:46-7), reference to "the primordial couple; the couple as the ideal social unit; the 'reborn' initiated man and woman as the social, moral and intellectual ideal; reverence for the ancestral lineages of Poro graduates who have 'suffered' for the group during their lifetimes; and the commemorative ritual act mourning the loss of an honoured Poro leader."

At the death of an important elder the initiates leave the sacred grove to visit the body lying in state. One member swings the sculpture slowly from side to side, striking the ground in synchronized beats (accompanied by drums and horns). They circle the body three times symbolizing the three arduous grades of the Poro cycle.

Euro-American
1. The copper woman was designed in France by F.A. Bartholdi and given as a gift to the United States. It was created to be a work of art and is a unique example.
2. Proposed to commemorate the French and American revolutions, the statue is intended to be seen by all peoples as a symbol of "Liberty." It was designated a national monument in 1924.
3. The piece is known as the "Statue of Liberty."
4. The statue as female may be seen in the Euro-American tradition of using women as symbols (muses, personifications). The overpowering importance or presence of liberty as an ideal may be implied from the size of the work.

and cultural context. Indeed, some of the most outrageous of the indignities I have just alluded to have been perpetrated in the scouring of these communities for the last material vestiges of their traditional past. Nor am I proposing that they and their systems are superior to us and ours—just different in potentially useful ways, if only to make us think more deeply and clearly about our own. In coming to know them, we might understand ourselves better.)

Nor are these artistic resources diminished in the sharing, although the sort of understanding I am talking about doesn't come easily. Further, in too many cases, the systems involved have vanished or have been drastically transformed by the expansion of Western social, religious, political and technical culture. So we take the fragments of information—anthropological, archaeological, and art historical—which are available and from them attempt to reconstruct the outlines of once viable, functioning societies. The present tense—called "the ethnographic present"—is used because developmental history and local diversity can usually be reconstructed only in broadest outline, if at all.

Each community typically relates to its natural, supernatural, and cultural environment with rigorous pragmatism and a notable lack of sentimentality. Things and ideas that no longer work are abandoned. Rarely is there any compunction, for example, about melting down and recasting bronze ornaments or other configurations which have gone out of fashion or are otherwise no longer relevant to any particular functional context. Nor does any serious distress accompany acknowledgement of the fact that, despite reasonable care, most masks and figures eventually have to be replaced owing to breakage, weathering, insect damage, or fire. Many types of objects are made for one period of use—often quite brief—and then discarded. Far from representing a tragedy, the fairly high rate of attrition of monuments in most African communities has had the effect of providing work for relatively large numbers of artists in each generation, for whom the products of only the preceding two or three generations are available as models and standards. In a broader sense, the entire body of inherited cultural patterns, representing the accumulated experiences, accomplishments, and wisdom of the past is typically evaluated in each generation and reinterpreted or adjusted where deemed desirable in the light of available options and altered circumstances (Rubin 1975:39).

Environmental and Cultural Factors

In 1871, Edward B. Tylor (1871:1) defined culture as "that complex whole which includes knowledge, belief, art, morals, law, custom, and any other capabilities acquired by man as a member of society."

The next step beyond a people's attempt to understand—and control—cause and effect relationships is to understand why and how things came to be. For those who participate in the Judeo-Christian heritage, such ideas as the Garden of Eden, Noah's Ark and the Parting of the Red Sea are fundamental to our sense of cultural roots—whether or not they actually happened. Taking the Northwest Coast Myth of the Raven as a point of departure, consider the question of whether scientific truth is incompatible with poetic truth, or whether (as implied by the Rothenberg quotation) they are about different ways of knowing:

> In that far-away time when the people of the earth had no light and wanted it they asked Raven to get it for them. Light was kept in the house of a supernatural being. Raven flew to the home of the supernatural and hid himself nearby and watched for several days.

Every day he saw the daughter of the supernatural being go to the stream for a cup of water. One day Raven changed himself into an evergreen needle and floated down the stream. When the daughter of the house came to the stream for a drink Raven floated into her cup. However, the daughter was suspicious and, thinking the needle might be Raven, brushed it out of the cup before drinking. The next day Raven changed himself into a grain of sand and this time when the daughter came to drink he rolled into her cup. Since he was so tiny, she did not see him and drank both the water and the grain of sand. Soon after the daughter of the supernatural gave birth to a child, which was Raven in disguise. The child grew rapidly, but one day he began to cry. He was given some bits of wood to play with, but continued to cry, all the time calling for the sun which was kept in a box in a corner of the house. Various playthings were offered the child, but he went on crying. Finally his grandfather relented and permitted the child to play with the sun. Now the child was happy as he rolled the sun around the floor, flooding the house with light. As time went by the sun became his plaything but it was put back in the box each night. One night, when all the supernaturals were asleep, Raven resumed his own form as a bird, and

taking the sun out of the box, started to fly out through the smoke hole in the roof. Unfortunately, the sudden burst of light awakened the grandfather who called to the flames of the fire to catch Raven and hold him. The flames leaped upward trying to hold Raven and he became so discolored by the smoke that he turned black. However, Raven managed to break free of the flames and flew toward the earth with the sun. The grandfather started in pursuit; since Raven was burdened by carrying the heavy sun, the grandfather gained on him, and came closer and closer. Just as he was about to be captured, Raven broke off a few bits of the sun to make it weigh less and threw the pieces into the sky, where they became stars. Again the grandfather drew closer and closer to Raven, and once more Raven broke off a piece of the sun, a large piece this time, and threw it into the sky, where it became the moon. With his last burst of strength the grandfather nearly reached Raven, but this time Raven threw the remaining piece of sun into the sky. All the pieces of the sun were now so scattered that they could never be put back together again, and Raven returned to the earth. It was in this way that Raven became black and all the people acquired the sun, moon, and stars (Inverarity 1950:33-4).

Perhaps the best comparison here would be Homeric epics, rich with insights into psychology and morality, rather than present-day theories about the origin of the solar system. History and science in ancient Greece had strong philosophical overtones, a humanistic bias which continued until the Renaissance, when a shift toward "objectivity" was set in motion. Yet many scholars today are coming to recognize that objectivity in history and science is itself a myth—that who decides what problems are confronted, what facts are used, by whom and from what point of view—and who benefits and to what extent—necessarily distorts the record from the outset. Thus the value-laden process of selection and emphasis means that certain interests are given preference and others are slighted.

The Raven was one of a series of Northwest Coast totems, usually a creature in the natural world (bird, animal, fish) which had a super-natural aid-relationship with a group's ancestors. For example, certain kin groups in Africa have the crocodile as their totem because they believe that at one time their ancestors escaped their enemies with the help of crocodiles who formed themselves into a bridge across a river. Since then, members of the group venerate the crocodile, will not kill them or eat their flesh. Such traditions may also mandate certain kinds of social relationships, wherein, for example, members of the same totem are not allowed to marry. Such cooperative relationships between human beings and the other creatures with which they share a particular environment may also be renewed and re-validated through re-enactment —masquerades, for example. In this way the members of a community are able to jump the generations which separate them from their origins and achieve a revitalization through contact with the cultural energies implicit in their traditions.

Euro-American culture has largely divested itself of these kinds of integrating rituals, being preoccupied with individualistic searches for order and truth. Similarly, it is rare that important objects among the peoples of Africa, Oceania, and Native America are valued for themselves and/or owned by individuals as is generally the case in late twentieth-century Euro-America; rather, they are valued as media, as containers for collective spiritual essences.

Ancestors are also typically involved with such rituals of integration. This is because death is usually understood as a change of state, the soul still imminent and "contactable." A parent who has cared for a child in life will continue to act on that child's behalf in the afterlife, only with enhanced power due to more direct access to primary spirit-principles. Thus, most societies we will study are gerontocratic—that is, the social order accords primacy to the oldest members of the group, and emphasizes the purity of inherited formulae—the value of tradition.

Some further comments on the nature of materials may be useful here:

Enduring and ephemeral art forms generally represent links to the past for particular

human communities. In the first instance, the actual physical object—the relic—has survived (or been handed down) through the generations. In the second, periodic re-enactments or re-creations by each generation in its turn, according to more or less rigidly codified patterns or scenarios, unify the living, the dead, and those yet unborn through a complex of shared experiences. Often, both enduring and ephemeral elements are orchestrated to produce such experiences, which may integrate architecture, painting, and sculpture, structured sound and movement, and unfold over extended time-periods. Thus they pose considerable difficulties for the investigator—as opposed to the participant—insofar as such multivalent phenomena are extremely difficult to record and describe. They are invariably time- and site-specific and leave little (if anything) in the way of tangible traces or residue as a basis for reconstruction if the investigator is not in the proper place at the proper time. Such art forms are difficult to experience vicariously and impossible to possess. Since the collaboration of a wide range of specialists is usually involved in producing them, and the distinction between creators and audience is usually difficult to draw, "the artist" in a conventional Western sense rarely emerges . . . (Rubin [1972]).

In other words, materials used in art may be grouped according to whether they are enduring—such as skulls or seashells—or ephemeral—such as feathers or flowers. In present-day Western society, skulls and skeletons are usually associated with morbidity and extinction. Among most of the peoples of Africa, Oceania, and Native America, however, skeletal materials are considered the irreducible core of a human being which, being reserved, can perpetuate his/her vital energies to the benefit of his/her survivors. Nowhere is this clearer than in beliefs associated with shamanism in North America. The shaman is a ritual specialist who, through ecstatic trances, projects his soul into the world of the spirits and negotiates for the survival (through ensuring subsistence resources, obtaining cures, and other means) of the group he represents. Before the helper-spirits, which are the sources of his power, will manifest themselves to an Inuit shaman:

He must be able to see himself as a skeleton. Though no shaman can explain to himself how and why, he can, by the power his brain derives from the supernatural, as it were by thought alone, divest his body of its flesh and blood, so that nothing remains but his bones. And he must then name all the parts of his body, mentioning every single bone by name; and in so doing, he must not use ordinary human speech, but only the special and sacred shaman's language which he has learned from his instructor. By thus seeing himself naked, altogether freed from the perishable and transient flesh and blood, he consecrates himself, in the sacred tongue of his body which will longest withstand the action of the sun, wind and weather, after he is dead (Rasmussen 1929:114).

It is not surprising that skeletal materials exert a powerful fascination in practically all cultures. Other phenomena in nature—such as sea shells or cast metal or natural crystals—partake of these same qualities, maintaining their structure despite environmental forces acting upon them. In art, enduring materials are carefully selected for just such intrinsic symbolic content.

Ephemeral phenomena in nature, such as lightning, the mating display of birds, or the blossoming of a flower, represent brief, intense interruptions of ordinary reality. Fireworks are a created version of this same phenomenon, a manifestation of energy which leaves no residue except in the collective memory of those who witness the display. Human beings often appropriate plumage and flowers—both of which are about sexual receptivity—in order to harness the energies they embody for social purposes. Such uses are highly developed in the Central Highlands of New Guinea, an area long considered to be "without art" because its peoples produced no painting or sculpture independent of their own bodies. These ideas are changing.

As has been noted, one of our important goals is to find out if there are any rules or principles associated with the arts at all times and places and in all human societies. One seems to be the exploitation, at some level, of both ephemeral and enduring materials and

configurations. Another is the impulse toward self-adornment, to alter the surface and structure which nature provides. Forms range from the ostentatious, such as prevails in Highland New Guinea (figure 46), to the camouflaged, typical of late twentieth-century Euro-American alterations of teeth and noses, facelifts and hair-transplants, intended to conform to widely disseminated aesthetic ideals (figure 6). (Such juxtapositions as these are fundamental to our objective of discerning artistic universals, seeking to recognize our common humanity in beliefs and practices which, at the outset, seem exotic and bizarre.) Body art also represents an excellent starting point for examining the social role of art, since such treatments are intimately bound up with conceptions of individual identity and group-membership. Thus, body art may be said to have an important transactional function in helping to choreograph relationships between individuals and groups—a major mode of non-verbal communication.

Whereas Western societies in the present day are primarily responsive to abstract formulations about justice, morality ("we hold these truths to be self-evident . . . ," "a government of laws, not men"), most of the societies we will study are more pragmatic, oriented first of all to social networks. For example, in the West witchcraft evokes Halloween masquerades and vague memories of trials involving torture and execution of people judged (according to prevailing religious doctrine) to be in league with the Devil. Conceptions of witchcraft in non-Western societies are generally applied to persons who attempt to aggrandize themselves by gaining control, through magical techniques, of the resources of the community (and of the individuals who make it up), turning them to their own selfish purposes. Thus, people are primarily sensitive to deviant behavior which threatens the principles of reciprocity and social responsibility upon which the survival of the community depends.

The environment offers resources for coping with such threats, as seen with special clarity in one particular African tradition: the Senufo *kponyugu* mask (figure 7). As we have noted,

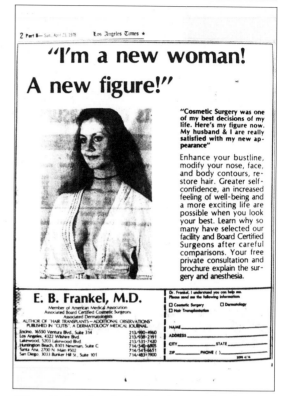

Figure 6. Los Angeles. Advertisement for Cosmetic Surgery. Los Angeles Times, *April 23, 1972.*

the attributes of powerful creatures are frequent sources for motifs in art, either singly or in combination. For example, the hyena has a powerful body, huge jaws, and a spotted pelt which camouflages it in high grass. The hyena is also a highly social, very intelligent animal which attacks its prey in well-organized packs. The African buffalo is regarded with comparable (or even greater) respect, by virtue of its combination of bulk, quickness, intelligence, and massive horns. The Senufo combine signature elements of the hyena and buffalo in the *kponyugu* mask for dealing with witches. (Representations of a chameleon and a hornbill may be carved on the forehead of the mask. The hornbill is a model of domestic, that is, social, responsibility. The chameleon is a slow-moving lizard which eats insects and has a marvelous arsenal of survival equipment, including a very quick tongue with a sticky tip, eyes which can move independently for almost 360-degree

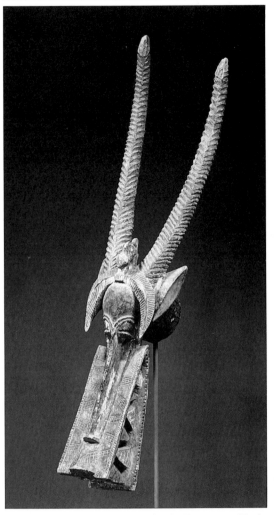

Figure 7. Senufo. Ivory Coast/Mali. Kponyugu Mask. The Metropolitan Museum of Art #1978.412.490. The Michael C. Rockefeller Memorial Collection, Purchase, Mrs. Gertrud A. Mellon Gift, 1964. Museum photograph.

vision and the capacity to change color for camouflage.)

Periodically, when things are going badly in the community (sickness, dissension, "bad luck"), the malevolent spirits of the witches—whose activities are to blame—must be driven out. Young men wearing the masks engage in a mock battle with evil forces, culminating in a display of fire- breathing, before which these anti-social elements can only flee, leaving the community purged and purified.

Shamanism in Native America is an even more extensive package of beliefs, intimately bound up with the ideology of hunting and gathering but with the power to persist into later stages of economic and political evolution. The shaman is quintessentially a successful warrior and hunter, but may also be outside the mainstream social order in some way; he functions (as noted earlier) as intermediary between his community and the world of the spirits, where the events and circumstances of the mundane world are determined. We might view the shaman, at one level, as an ecological manager whose capabilities have given him special insights into the management of crucial resources, such as stocks of animal or plant foods. He tells people when and under what conditions to hunt or gather. His skills as warrior protect his soul during out-of-body experiences—"spirit flights"—ecstatic trance states which can be brought on by prolonged fasts, long episodes of drumming or dancing, or the use of hallucinogenic substances. (The peoples of Europe traditionally exploited only three psychoactive substances; for the peoples of the Pacific Basin, the number is around eighty-five and still counting.) In order to accomplish these transmigrations, the shaman strips away his superficial self and reconstitutes as one of the significantly endowed creatures in his environment, such as bear, jaguar, crocodile, or raptorial bird (such as eagle or owl). A wide range of power materials and configurations aids in these procedures.

In short, art in Africa, Oceania, and Native America, in one way or another, tends to be about—and to reinforce—networks of collective responsibility, however strange the forms may appear to us. It is worth noting that forms in our own society with a comparably high charge of symbolic meaning would be hard to rationalize for a visitor from New Guinea. For example the relationship between the form of the Washington Monument—a gargantuan obelisk—and the "father of our country" is, to say the least, not immediately apparent. Nor would it be easy to explain why "Liberty" should be embodied both in a colossal statue of a woman in classical garb holding a torch (figure 4), and in a cracked

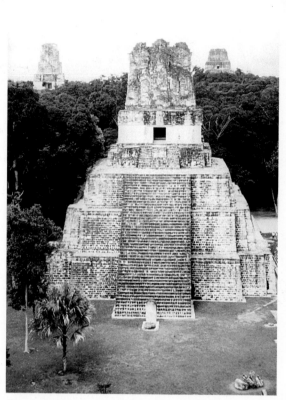

Figure 8. Maya. Tikal, Guatemala. Temple II. Photograph, Zena Pearlstone, 1972.

ENVIRONMENTAL AND CULTURAL FACTORS

The physical environment influences, in varying degrees, the development of culture and artistic patterns. The most important aspects of an environment in these regards are geomorphology (landforms), climate (temperature, seasons, annual rainfall) and resources (flora and fauna and minerals).

Environment provides choices and limits to cultures. Raw materials and natural conditions affect culture as it defines and develops a viable social system. At the same time, cultures make their own impact on the environment, either negative or positive or both. Thus environment only influences culture and does not determine it. Moreover, the interaction between environment and culture is dynamic, constantly changing in time and space.

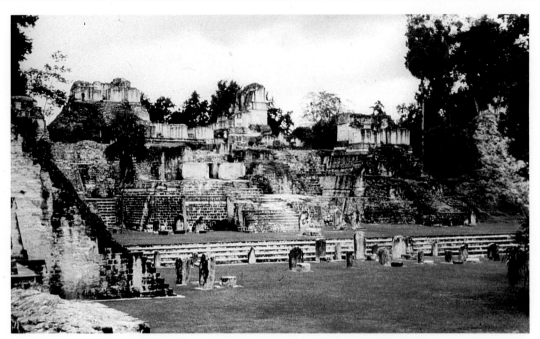

Figure 9. Maya. Tikal, Guatemala. North Acropolis and Great Plaza. Photograph, Zena Pearlstone, 1972.

At the Maya site of Tikal (figures 8, 9) monumental stone architecture has been erected in a forest. The permanence of the Tikal structures indicates that the Maya were sedentary agriculturalists, employed specialization of labor, and built funerary monuments for the elite. The Maya environment, however, is not typical of tropical forests; there is a severe dry season, porous limestone bedrock, and few permanent rivers and lakes. Thus, there were bound to be frequent water shortages. The Maya fared well in such an unfavorable environment because of:

1. the influence of preexisting states in the region with advanced technology that they could draw upon
2. a complex trade system
3. advanced technology (artificial cisterns, canals, moats, raised field agriculture which irrigated itself and a sophisticated calendrical system which directed the agricultural season)
4. a supplementary subsistence base in breadnut tree groves and house gardens
5. an organized labor force
6. management of resources.

The Maya show us that the extent to which environmental factors influence culture is variable. In their case, the environment seemed incidental to cultural existence. Even if environmental conditions are the same or similar in different parts of the world, the cultural solutions of each group will differ to some degree. Furthermore, even with the same subsistence and other strategies, arts will appear differently and will be put to different uses.

bronze bell. These configurations are necessarily arbitrary, only to be understood in historical and cultural terms, with no logical relationship to the personages or principles with whose essences they are invested. Nevertheless, as enduring configurations, they play crucial roles in defining our sense of collective identity. Similarly, ephemeral phenomena such as Bicentennial re-enactments of Revolutionary War battles and visits to Niagara Falls or Old Faithful in Yellowstone Park provide access to the cultural and natural energies which they release.

Novices will probably have a negative reaction to many of the works we are about to see by virtue of their deviation from our (culturally programmed) expectations of what representations of human beings should look like. Often, the body is "disproportionate," with large head, hands, genitalia and feet. Studies of the amounts of the brain's function given over to processing stimuli from the different parts of the body indicate a comparable weighting of these parts. Hence, artists in these cultures may not be showing us what a body *looks* like, but rather what a body *feels* like. Even in cases where portraiture is intended—of known, recently deceased ancestors, for example—the external aspects of a painting or sculpture of him/her may differ only in nominal details—coiffure or scarification, for example. Again, the inner attributes of the subject are what preoccupy the artists and their patrons, not the external features which are, for all intents and purposes, identical for all members of the group. Which is precisely the point: these individuals are now important *as ancestors*, and must be shown as is appropriate for members of that category of humanity. What we read as distortion and extreme stylization in art is also another means by which people demarcate themselves from their neighbors and reinforce their sense of group solidarity.

The environmental setting of culture (including art) must also be understood:

> Of course the natural surroundings do influence the broad outlines of a culture: An [Inuit] inhabitant of the Arctic ice could no more become an agriculturalist than a [Puebloan] of the Southwestern desert could ever base his economy on harpooning walruses. The environment does not determine man's culture; it merely sets the outer limits and at the same time offers opportunities. . . . The limits and opportunities of the physical environment are felt in differing ways by different peoples, depending upon their level of culture (Farb 1968:60; see pages 30–31).

Three basic categories of environmental features are relevant to our discussions: LAND-FORMS (mountains, rivers, swamps, deserts), CLIMATE (rainfall amounts and distributions, wind patterns, annual temperature ranges) and RESOURCES (soils for cultivation, clays for pottery, stone for tools, sodium chloride, metals, and the biota—the plants and animals, including microscopic ones). Competition is often the framework within which resources are exploited, as seen in the following chronicle of the early years of Euro-American settlement in North America:

> Of the wonderful preparation the Lord Christ by his Providence, wrought for his peoples abode in this Western world. Who by a more admirable act of his Providence prepared for his peoples' arrival as followeth. . . . A little before (the settlement of plimouth colony) . . . there befell a great mortality among [Native Americans], the greatest that ever the memory of father to sonne tooke notice of, chiefly desolating those places, where the English afterwards planted. . . . Their disease being a sore consumption, sweeping away whole families, but chiefly young men and children, the very seeds of increase . . . by this means Christ (whose great and glourious works the earth throughout are altogether for the benefit of his Churches and chosen) not only made room for his people to plant; but also tamed the hard and cruell hearts of these barbarous Indians . . . (Johnson 1654).

Certain genetic diseases are also linked to geography. Sickle-cell anemia is prevalent among peoples inhabiting malarial zones of the world, because (it seems) the trait (when recessive) confers a partial immunity to the disease. Conversely, since it enhances their survival-potential in the tropics, such peoples were avidly sought

for agriculture, mining, and other hard labor in situations where Europeans had a high rate of mortality. Indigenous and introduced animal stocks also intersect with cultural and historical patterns in important ways; for example, the introduction of the camel into North Africa around the time of Christ brought about abandonment of that *sine qua non* of civilization, wheeled transport. As another example, when horses were introduced among the hunting and gathering peoples of the Great Basin of North America, they were eaten. In the Plains area to the east, with its longstanding tradition of bison hunting (on foot), the horse was recognized as a source of enhanced mobility which would allow more efficient exploitation of these subsistence resources. Such complications must be accounted for literally on a case-by-case basis:

> How, then, do cultures evolve? Why have some progressed from small bands to larger tribes, while others have become different kinds of tribes or chiefdoms or states? The answers to questions about different human societies usually cannot be found solely by looking at the environments they inhabit, nor by noting great historical events or the arrival on the scene of great men. Rather, an analysis must be made of the structures of the cultures themselves. Every culture is composed of multitudes of cultural elements such as different kinds of baskets, religious beliefs and social practices, tools, weapons, and so forth. . . .
>
> These cultural elements are in a continual process of interaction; new syntheses and combinations are constantly being produced. But whether or not the new combinations survive in a human group depends on whether or not they work in the existing cultural context (Farb 1968:28-9).

Our ethnocentric perceptions of hunters and gatherers has often led to the conclusion that they were not only technologically and culturally impoverished (see Farb [1968:36-55] regarding the "Digger Indians"), but that they were actually an inferior form of humanity. More recent thinking credits them with a very efficient adaptation to their environment, obtaining a daily intake of calories adequate for their needs without great expenditure of energy. They were,

in effect, very well endowed with leisure-time, generally considered a criterion of civilized life. Going further with this heretical line of analysis: While plant domestication was almost certainly based on gathering activities, it may not originally have been associated with primary food crops. Rather, the earliest domesticates may have been crops which enhanced people's lives in other ways, such as spices, drugs, dyes, and containers (such as fibers for textiles, or gourds).

The concept of resources used here, then, is very broad, even extending to include survival-oriented phenomena of a conceptual sort. For example, the idea of POWER imagery draws upon environmental resources in a special way. The design-sources of the Senufo *kponyugu* mask have been described above (page 28; figure 7). As another example, leopards and jaguars are spotted creatures of great hunting prowess, speed, and intelligence; according to the principle of sympathy, it does not seem coincidental that many of the groups who occupy environments in which these creatures are present either appropriate their skins OR apply spots to the bodies or garments of key members of society at important stages in the life-cycle, OR to representations of them in art, as a way of borrowing the energy they embody.

Now we begin a highly simplified, but still most ambitious summary of African, Oceanic, and Native American history, culture and geography as a way of highlighting environmental and cultural factors. (Eurocentric bias must be overcome—even in the maps we use, where the "important" land areas are shown centrally and undivided, the less important areas, for example, Pacific Islands, are relegated to the extremities and divided, which would understandably affront *their* ethnocentric sense.) We shall at least touch upon the full range of environments exploited by human communities, including the "more interesting" ones: the tropical forests (Meso-America, parts of sub-Saharan Africa, and certain of the islands of Oceania), several of the world's great deserts (the Sahara of Africa, North America's Great Basin, and central Australia), the snowy terrain of the Far North, and the vast stretches of open water of the Pacific. Each

Locations of Cultures Considered

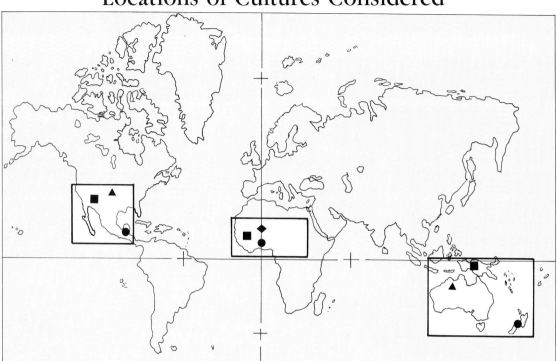

Legend

▲ Hunting/Foodgathering (*Aborigines, Plains People*)

◆ Herders/Predators (*Fulani*)

■ Non-Centralized Sedentary Cultivators (*Pueblos, Senufo, Asmat*)

● Centralized Sedentary Cultivators (*Maya, Maori, Asante*)

offers distinctive resources and poses special challenges. A wide variety of technological—and social, and artistic—solutions was developed by the inhabitants of each:

> All men everywhere exist as members of social groups, however small. A group . . . is much more than a random collection of individuals who accidentally happen to share particular customs. . . . Social organizations are simple or complex, with many gradations in between, for the reason that a culture composed of many elements has more parts and requires a more effective degree of integration than a culture with few elements. A complex society is not necessarily more advanced than a simple one; it has just adapted to conditions in a more complicated way.
>
> In arriving at their varying ways of life,

societies do not make conscious choices. Rather, they make unconscious adaptations. Not all societies are presented with the same set of environmental conditions, nor are all societies at the same stage when these choices are presented. For various reasons, some societies adapt to conditions in a certain way, some in a different way, and others not at all. Adaptation is not a conscious choice, and the people who make up a society do not quite understand what they are doing; they know only that a particular choice works, even though it may appear bizarre to an outsider (Farb 1968:32-3).

Environmental zones tend to be symmetrical around the Equator except as modified by local conditions. Let us take Africa as the clearest example: to the north and south of the continent there are mild, temperate climates. A desert zone

is next—the Sahara in the north, the Kalahari in the south. Next is a belt of open grasslands, called savanna, giving way to the tropical rain forest through which the Equator is drawn. Thus, although the tropical rain forest covers a comparatively small fraction of the African continent, it has nevertheless come to be the prevailing stereotype of vegetation patterns—part of the Tarzan syndrome. The majority of Africa's population is located in the savanna zone, and drought rather than jungle represents the most significant threat to human survival. The African savanna has sustained a remarkably wide range of cultural adaptation—including diverse arts—which we shall be examining.

Archaeology indicates that the ancestors of modern man emerged in east- central Africa, beginning the process of physical and cultural differentiation which we see today. Correlating geographical factors with art can correct distortions in the historical record. For example, sub-Saharan Africa came to be considered as isolated from the outside world. Recent research has shown that the Sahara was relatively easy to cross until about 500 B.C., and there is tantalizing evidence from art and archaeology of economic and other interaction between the peoples of North and West Africa before that time. Shortly thereafter, as the Sahara began to dry out, the introduction of camels from the Middle East allowed trade to continue—gold coming out of West Africa, salt going in.

In East Africa, a different set of historical experiences and cultural patterns are also intimately related to environmental considerations. Unlike West Africa, which was in contact with the Mediterranean Basin, East Africa was oriented toward the Indian Ocean. Prevailing winds in the Indian Ocean sweep down the East African Coast from India for about six months of the year, and for the other six months they blow in the opposite direction. This pattern was apparently known to navigators before the time of Christ, and trade and other contacts with Arabia, India, and other parts of the Indian Ocean littoral had major influence on East African culture.

By about 1,000 B.C., agriculture appears to have been independently developed in the West

African savanna. Not only did the savanna peoples know about farming, but ironworking had been introduced (from North Africa or Nubia), as had Indonesian crops suitable for cultivation in the forest environment. Indeed, linguists, using a technique called glottochronology, tell us that peoples occupying the southern half of the African continent speak languages of a family called Bantu which began to diverge from an area of east-central Nigeria about 2,500 years ago. Not far from this Bantu homeland the earliest African sculpture yet known was recovered, dating to the period between 500 B.C. and A.D. 200, approximately. In short, by about 500 B.C. conditions were ripe for an expansion of peoples from the savanna zone into the rain forest, previously occupied by scattered bands of hunting and foodgathering Pygmies. The Pygmies, and the Khoisan peoples of southern Africa, were pushed into the less hospitable areas or absorbed by the expanding Bantu-speaking immigrants.

The migration of the Bantu was long preceded by the peopling of the Americas. From about 40,000 B.C. until about 10,000 B.C., there is evidence for hunting and foodgathering populations crossing between Siberia and Alaska; during the Ice Ages, when much of the earth's water was locked up in expanded polar ice-caps and the level of the oceans fell dramatically, it was literally possible to walk from Asia to the New World. By about 9,000 B.C., these immigrants had dispersed as far as the remotest tip of South America. It is worth emphasizing that these aboriginal peoples of North and South America were of pre-agricultural Asiatic stock; hence study of the "Indians" of the Americas may make it possible to reconstruct something of the mental baggage with which their ancestors started out. Agriculture, it appears, was subsequently developed in Mexico (maize) and the Andean region of South America (potatoes and other crops).

Oceania is also relevant to understanding the cultural evolution of Eastern and Southeastern Asian culture. The ancestors of the Aboriginal peoples of Australia appear to have left the Indo-Chinese peninsula about 40,000 B.C., reaching

the subcontinent by walking and rafting (see above) down the Indonesian and Melanesian archipelagos; there, they developed substantially in isolation until European contact. From the same area of origin, between about 3,000 and 1,500 B.C., highly developed seagoing canoes carried the first settlers to the other island groupings of Oceania, venturing enormous stretches of open water some 2,000 years before Columbus' three creaky tubs left Spain to seek a direct route to the Indies, their crews full of anxiety about falling off the edge of the earth!

Thus, it becomes apparent that the entire Pacific Basin—Eastern Asia, Oceania, and Native America—must be understood as deriving from a single, very old ethnic heritage, first via overland migrations, subsequently over water. Those of us interested in the Americas or Oceania must ultimately confront the Asian data—and vice versa. Other implications of these seagoing migrations, in particular, are significant. For example, the peoples of Madagascar, off the southeast coast of Africa, are mostly of Indonesian stock—physically, in terms of language, in forms of political organization, and even in the way they tune their xylophones. If such traits can be shown to persist for 3,500 years, material culture (including the arts) might also be used to establish continuities between present-day peoples, or with cultures known only through archaeology. In particular, studies of material culture (including the arts) must be correlated with the work of linguists and others whose objective is concrete history, rather than theories of cultural evolution or historical fantasy, particularly in situations where written records are non-existent and archaeological preservation sporadic.

Primarily because I know the material best, it is convenient to start with Africa as our framework for exploring the correlation between subsistence concerns—rooted in environmental and cultural factors—with the utilitarian and transactional functions of art. Africans subsist by hunting and gathering, predation, herding, and cultivation. Scholars have pointed out that the production of African sculpture is confined to cultivating peoples, which is something less than

a surprise; hunters, predators and herders are almost constantly on the move, hence unlikely to develop an art oriented toward cumbersome, heavy, and/or fragile objects. Their arts take other forms—primarily painting and other media oriented toward the decoration of useful objects and their own bodies. (That we leave music, dance, and the verbal arts out of consideration here derives from our system of compartmentalizing knowledge and, in essence, cheats us of an opportunity to comprehend the totality of creativity in the cultures under consideration.)

A regular annual pattern characterizes life among the cultivators of sub-Saharan Africa. From approximately April to September (more or less, depending on latitude)—the rainy season—almost everyone is involved in food production. From October to March—the dry season—people engage in other kinds of activities: part-time economic specializations (blacksmithing, weaving), domestic maintenance, warfare, hunting, marriages, funerals, and other ceremonies. Although their level of technology may seem simple and life relatively monotonous and harsh, these peoples enjoy an independence which we have lost; in making or obtaining locally practically everything they need, they are, in effect, in control of their lives. Individuals and groups also benefit from the primacy of social relationships based on regular face-to-face contact. Surpluses cannot be stored beyond each year's needs, so that it makes no sense to produce more than is needed—except that a surplus can be shared with one's less fortunate neighbors. Similar conditions prevail in the Arctic:

> An important thing about exchange in the life of the [Inuit] is that he alternates between feast and famine. One [Inuit] hunter may be successful in killing seal after seal while another hunter is having a long streak of bad luck. Anyone who has been molded by a capitalistic culture knows what he might well do in similar circumstances—if he were the fortunate hunter and the others were in need. He would jack up prices. Such a thing could never happen in [Inuit] society—not because an [Inuit] is innately nobler than you or I, but because an [Inuit] knows that despite his plenty today,

Figure 10. Asante. Ghana. Kente. Courtesy UCLA Museum of Cultural History, #X86-1988. Photograph, Richard Todd.

assuredly he will be in want tomorrow. He knows also that the best place for him to store his surplus is in someone else's stomach, because sooner or later he will want his gift repaid. Pure selfishness has given the [Inuit] a reputation for generosity and earned him the good opinion of missionaries and of all others who hunger and thirst after proof of the innate goodness of man (Farb 1968:66).

Yet, as indicated earlier, Africans were emphatically not sealed off from the rest of the world. Salt, in particular, was always in short supply; sometimes gold was given in equal weight for salt brought down from the Sahara. But there was long-distance trade as well; in historic times (and possibly earlier?) West African kings wore agate beads which originated in northwestern India and silken garments from the markets of south China. These facts serve to introduce the two modes which human beings

have developed for coping with the discontinuous distribution of resources: cooperation, through exchange, and competition.

The silks in question were worn by the kings of the Akan states of Ghana, formerly called the Gold Coast. They functioned as one element in an extensive complex of "markers"—*DISPLAY-*objects which proclaim the social status of the wearer. The cloths in question, called *kente*, were manufactured from thread picked out of Chinese silks and re-woven (figure 10). In the late fifteenth and early sixteenth centuries, the Portuguese opened up marine trade with the West African coast, circumventing what had previously been a Muslim monopoly; tropical diseases and the distances involved in the overland trade (not to mention Muslim hostility) precluded direct overland access to the goldfields of West Africa. Eventually extending into the Indian Ocean, the Portuguese tapped into

and expanded an earlier Islamic Indian Ocean network of trade-routes, including the silk markets of southern China, whose products (among other things) were exchanged by the Portuguese for Akan gold. The cloth is particularly interesting, however, because it was literally broken down into its components and reconstituted for incorporation into the African context. In one form or another, such a process of transformation, of reinterpretation, of synthesis, is the rule, rather than direct translation of introduced cultural elements.

By virtue of the network of migrations which populated them, the Americas have been characterized as a kind of laboratory for studying the interaction of environment and culture. As in Africa, several distinct zones fostered the development of quite different patterns of culture. In eastern North America, a temperate forest environment was so richly endowed with game and other resources that hunting and gathering remained a primary subsistence mode until very late, even providing the economic basis for the emergence of complex social and political structures and their associated arts (although cultivation of maize and other crops was expanding at the time of European contact). In the Southwest, however, an arid, relatively precarious environment encouraged an early shift to collective farming through irrigation. This pattern of subsistence gave rise to sedentary, integrated communities focused on communal dwellings called Pueblos, and an extensively elaborated complex of ceramics and other arts. In the Great Plains area, the thick turf and matted grasses made farming difficult. These grasses provided subsistence for vast herds of bison which, however, could not be fully exploited because of their numbers, size, and speed. Only when horses and firearms were introduced (between A.D. 1,700 and 1,850, approximately) could a Plains culture (and a complex of distinctive art-forms), based on highly efficient exploitation of the bison, emerge. The cultures of the Far West and the Far North—California, the Great Basin, the Northwest Coast and the Arctic—were all based on hunting and food gathering, but with enormous differences in available resources and the social

and cultural forms which resulted. The Northwest Coast, for example, was one of the most richly endowed regions of the earth's surface, the adjacent Arctic one of the least:

> An evolutionary sequence that has been popular from time to time shows human groups progressing from hunting to agriculture and finally to civilization. But such a broad sequence is too generalized to be meaningful, as a comparison of the Northwest Coast [Peoples] with the neighboring [Inuit] demonstrates. They lived close to each other and the societies of both were based on hunting—but that was about all they had in common. The Northwest Coast [Peoples] were organized as wealthy and elaborate chiefdoms, whereas the [Inuit] lived as impoverished and very small bands. The two groups differed also in settlement patterns, social organization, religion, crafts, and practically everything else. So lumping two such diverse cultures into the single broad category of Hunters explains nothing (Farb 1968:25-6).

Evidence of the varied environments afforded by North America and the diverse adaptations to them which emerged is clearly seen in housing forms, from the long houses sheathed in bark of the Iroquois of the Northeast to the earth lodges and skin tents (tipis) of the Plains to the brushwood shelters of the Great Basin to the adobe and stone tenements of the Southwest. In the Northwest Coast, abundant supplies of wood were used, in the Arctic (depending on the season) skin shelters or houses of snow. Despite these particularized solutions, the cultures which used them did not exist in isolation. As in Africa, short- and long-distance trade routes helped to resolve the unequal distribution of resources: high-status burials of hunting and gathering peoples in the Great Lakes area dating to the middle of the first millennium B.C. included local copper, marine shells from the Gulf of Mexico, grizzly bear teeth from the Rocky Mountains, and fresh-water pearls from the Southeast, among other things. And there is evidence that these exotic materials were valued and exchanged not as items of wealth in an economic sense; rather they seem to have functioned as protective

Power materials within an evolved shamanic framework.

As noted earlier, the primary role of the shaman in hunting and gathering communities was that of managing subsistence resources. In the shift to cultivation, a community's structure and needs change drastically. At approximately 1,000 B.C., there is abundant evidence of dramatic changes in cultural and economic patterns among groups which adopted food- cultivation as their subsistence base and its concomitant sedentary life- style. These communities (in southern Mexico, Guatemala, and the Andean region of Peru) developed the cultural forms which we are prone to call ''attributes of civilization'': monumental architecture and sculpture in stone, the beginnings of cities and systems of writing, and metalworking technology. These regions have come to be regarded as nodes of ''high culture,'' which tends to deprecate the rest of Native America. Moreover, the forms of ''civilization'' were attained at a certain price. Most members of the community had to sacrifice a considerable measure of their independence and autonomy in the interest of providing a stable and predictable labor force—including production of enough surplus food to support the emerging class of full-time religious, political and other specialists (apparently including artists) needed to create and maintain these structures. Growing out of the shaman's role as ecological manager, these specialists took control of the human and subsistence resources of the group by shifting their activities to those associated with cultivation—notably, predicting optimum times for planting and harvest. For these services they exacted taxes in produce and labor. On the other hand, the workers were given the opportunity to participate, under the guidance of this elite, in vast and splendid projects which testified to the surplus wealth they had created and their skill as artists and craftsmen. (These projects can be contrasted to the more modest works of smaller-scale societies in which all individuals have equal and direct access to all resources and all technologies, and sharing takes place horizontally between equals rather than vertically across social strata.)

The great stone cities of Meso-America are easy for us to relate to, as they (and the conditions under which they were produced) resemble our own. It is more difficult for us to relate to the smaller-scale, more mystical attributes of shamanism at the hunting and gathering level—such as beads, bits of metal, skins—because they derive from such a strikingly different social, economic, and political milieu. Yet the artistic ensemble represented by the shaman's kit is no less profound than the most extensive configurations produced by their successors who had made the shift to subsistence based on sedentary cultivation. In short, agriculture gave communities the capacity to store wealth through the creation of a predictable surplus of food supplies, and to convert that surplus into tangible objects through the activities of full-time specialists thus freed from having to engage in subsistence activities. Their activities therefore served to reinforce the status of the elite group of which they formed a part. While this scenario is hypothetical and speculative, it seems basic to understanding the arts of the ''high-culture'' areas of Meso-America and Peru. While these ''high-culture'' areas exhibit many elements of symbolism and the rhetoric of materials, for example, in common with shamanic conventions, the scale of the work is distinctively grand.

Mexico and Guatemala are ecologically diverse, ranging from the tropical forests of the Maya Lowlands and the Vera Cruz Coast to the arid region of north-central Mexico. The great stone pyramids of Tikal resulted from the availability of superior raw-materials—fine-grained limestone—nearby. Smaller works were created in hard stone (several colors of jade, hematite, and obsidian), mostly imported. The Olmec, on the other hand, constructed their main ceremonial sites in an unlikely location, the dense tropical forest of the Vera Cruz coast, where all building materials—colored clays and sands, and stone—had to be imported, along with the same sorts of hard stones used by the Maya for smaller works.

Jade, in particular, holds an edge or point well and is good for tools, but even though tool-shapes were frequently produced in jade, they

shamanism- religion characterized by belief that unseen world of gods, demons & ancestral spirits is responsive only to shamans

shaman - priest-doctor who uses magic to cure sick, divine hidden & control events that affect welfare of people

39

were almost never used as such. Rather, these objects appear to have been used in POWER contexts, incorporating super-predatory iconography—particularly imagery associated with the jaguar. For Mexico and the Mayan area, the jaguar was the nodal image: it has fierce fangs and claws, keen sight and hearing, camouflage, and is not averse to swimming. Thus, even though the subsistence importance of hunting and gathering had diminished, the new elite perpetuated hunting and gathering ideology as propaganda to reinforce its status through POWER materials (notably jade) and super-predatory imagery (primarily jaguar, but also rattlesnake, crocodile, and raptorial bird) in transformational contexts.

We have considered some aspects of the interaction of cultural and environmental factors in Africa and Native America. Oceania also poses a number of special problems in this regard. To recapitulate: Australia was populated during the last great ice-age—around 40,000 B.C.—when the drop in sea level meant that people could walk (and raft) across from southeastern Asia. Most of this great landmass was cut off from subsequent contact (except in the far north) and, by virtue of this isolation (particularly in the interior), early forms of traditional cultures survived substantially intact until recently. Melanesia, ''black islands,'' refers to New Guinea, the Solomons, New Ireland, and neighboring (mostly volcanic) islands covered with tropical vegetation and predominantly occupied by dark peoples related to the Aborigines of Australia. The third major cultural unit is Polynesia, ''many islands,'' which forms a triangle with Hawaii in the north, New Zealand in the southwest and Easter Island in the southeast; a cluster of island-groups (the Society Islands, including Tahiti, and the Marquesas, among others) is located at the center of this triangle. The population of Polynesia seems to have begun around 3,000 B.C., with lighter-pigmented peoples travelling via Melanesia to ''Marginal Polynesia'' (Fiji, Tonga, Samoa), thence to Central Polynesia and finally to the outlyers. Micronesia, ''small islands,'' refers to the scattering of coral atolls—stunningly poor in resources—spread across the north-

Figure 11. Gilbert Islands, Micronesia. Sennit-fiber Armor. Courtesy UCLA Museum of Cultural History, # X65-4199. Photograph, Richard Todd.

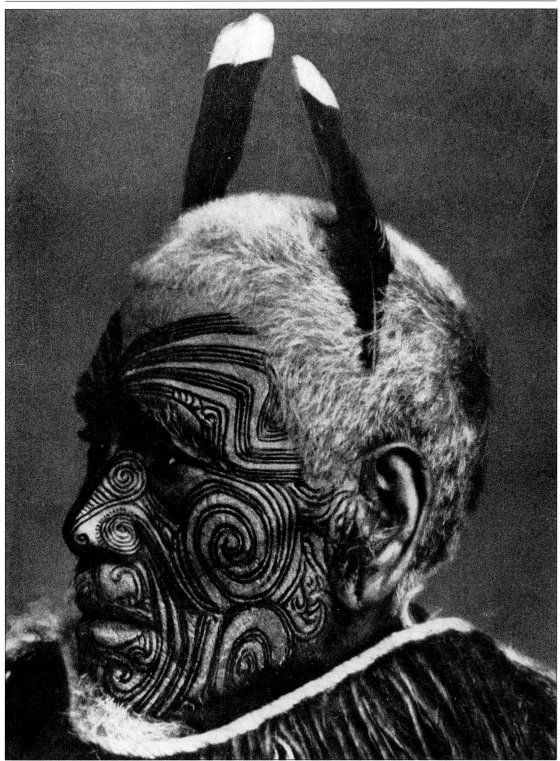

Figure 12. Maori. New Zealand. Chief with Moko. From Anonymous (1953:381).

central Pacific. (Indonesia is considered to belong, for present purposes, to southeast Asia.)

The enormous landmass, varied terrain, and endemic tropical diseases of sub-Saharan Africa precluded large-scale European penetration (not to mention colonization) until the nineteenth century. Much of North and South America experienced a similar pattern of contact. Most of the islands of Oceania, however, were comparatively hospitable to Europeans in terms of climate, freedom from disease, and easily controlled territory. As a result, European contact had a profound effect at a very early date—particularly in Polynesia and Micronesia, less so in Melanesia, where traditional cultures persisted in many isolated locations until recently.

The case of Oceania—particularly Polynesia and Micronesia—raises the issue of carrying capacity, the amount and mix of particular types of living things (in this context, especially human beings) which a specific environment can support. It seems reasonable to propose that the peopling of Oceania through successive migrations may have been a response to overpopulation due to the growth of communities beyond the carrying capacity of the environment they occupied. Whether through coerced or voluntary migration, a section of the population would set out to find new land. Although Polynesia, in particular, epitomized for Europeans the idea of a terrestrial paradise, such an ideal environment is actually very rare in Polynesia, with very limited food and water resources prevailing across large areas. Micronesia had even more meager endowments. Institutionalized competition at a high level of sophistication resulted, as seen, for example, in the shark's

tooth weapons and coconut-fiber armor of the Gilbert Islands (figure 11).

The Maori of Polynesia offer perhaps the clearest instance of people investing objects, places, people, even certain types of behavior, with vital force or energy—a non-personalized essence which is called *mana*. *Mana* is associated with objects which have served successfully in the purpose for which they were intended—a canoe which has brought in many fish, for example, or a weapon which has killed many enemies. For humans, *mana* is first of all a function of birth; the higher the status of one's parents, the higher one's initial charge of *mana*, but a person can also add to (or dissipate) one's *mana* by one's own actions. Certain activities are prohibited (*tapu*), lest they contaminate (and thus deplete) an individual of high *mana*, or blast an individual of low *mana* through contact with high *mana*. For example, a Maori who has received facial markings (*moko*, figure 12), is believed to be in a state of extreme vulnerability; for him (or her) having the body come into contact with cooked food is *tapu*. For this reason the patient is fed through a funnel or by means of a long skewer until the wounds have healed.

For the Maori, then, one function of *mana* is to reinforce cultural practices which have proven successful in utilizing environmental resources. For any people, the limits imposed by the environment and how environmental factors are interpreted are basic to the way they shape their world and determine the kinds of objects which are meaningful. The ways that these objects can function within a culture can now be considered.

Utilitarian and Transactional Functions

We divide *FUNCTION*—what an object does in its social context—into two categories: *UTILITARIAN* and *TRANSACTIONAL*. These categories can be divided into two and three sub-categories, respectively: *UTILITARIAN* functions include *CONTAINERS*, *IMPLEMENTS*, and *SUPPORTS*; *TRANSACTIONAL* functions include *MARKERS* (or *COMMUNICATORS*) and *TRANSFORMERS* (see page 44). The arms and armor of a Gilbert Islands warrior may be taken as an example of the application of these categories (figure 11). His fiber armor is first of all a *CONTAINER*; it creates a protected space for the person it encloses. His lance is an *IMPLEMENT*, deriving its function from the properties of the materials from which it is made, as an extension of human capability. Together they function as a *MARKER*, proclaiming role and status within the social context in which they are used. Thus, the ensemble is both *UTILITARIAN* and *TRANSACTIONAL*. The remaining *TRANSACTIONAL* sub-category, *TRANSFORMERS*, serves in a psychic sense to convey the souls/spirits of human beings to another realm of consciousness or symbolically to actualize other-worldly phenomena in this world.

UTILITARIAN functions as used here require little additional comment, but *CONTAINERS*, in particular, pose some interesting problems. Throughout the world, *CONTAINERS* are associated with women's activities: baskets, pots, garments (woven, skin), often extending to primary responsibility for shelter as well. Also strikingly consistent is the geometric, non-representational character of the ornamentation applied to these *CONTAINERS*. According to Western standards of value, *CONTAINERS* of all types (except perhaps architecture, which is practiced by males in our society), tend to be relegated to a second level of significance, as craft rather than art. According to this position, "true" art should first of all be without a *UTILITARIAN* function, preferably narrative (or at least descriptive of some external reality), in contrast to the highly abstract/geometric character of the decoration women apply to *CONTAINERS*. (It may not be coincidental that most of the critics have been male, and most of the producers of such *CONTAINERS*, female.)

Rather than being trivial, "mere decoration," it can be argued that women's art appears to

Figure 13. United States Penny. Photograph, Frances Farrell.

UTILITARIAN AND TRANSACTIONAL FUNCTIONS

UTILITARIAN FUNCTIONS
1. As a monetary unit a penny simplifies the task of acquiring a desired object: for example, if you wish to buy a loaf of bread, you exchange money instead of taking wheat, eggs, yeast, etc. to the baker.
2. As an implement a penny can be used to free a jammed slide carousel.

TRANSACTIONAL FUNCTIONS
1. As transformer a penny alludes to 'higher ideals': "In God We Trust," "Liberty," "E Pluribus Unum" (consider the reason for associating ourselves with the Classical world) and "The United States of America."
2. A penny is connected with proverbs: "See a penny; pick it up; all the day you'll have good luck."
3. As marker a penny worn in "penny-loafers" is associated with a particular mode of fashion and lifestyle.

Figure 14. Ga'anda, Nigeria. Mud Granary. Photograph, Marla C. Berns.

derive from an articulated, almost diagrammatic, sense of social relationships, with the woman and her children at the center. In the weaving of an ornamented basket, for example, the consequences of introducing design-elements near the center will be resolved many thousands of steps later in the form of a complex, balanced pattern (see figure 51). Perhaps this visualized design (for which no external pattern or model exists) relates to the artist's understanding of the consequences of relationships between parts within a unifying framework, analogous to the network of social relationships in which she is a participant. Men's art, narrative and descriptive, commemorates their roles as adventurers, as participants in unpredictable, often high-risk situations, whether hunting, warfare, or competition for social status or economic advantage (see figure 100).

This analysis is not intended to establish women's art as superior to men's, but to suggest that they are fundamentally different in nature. It is, however, a fact that in art history men's art has been studied in depth, women's art all but neglected. Perhaps it is time to work toward a balance in the record.

As noted, shelter falls within our category of *CONTAINERS*; this is particularly clear when house-types, for example, take the form of huge, inverted baskets or pots as is typical of some traditions (figure 14). Widely in Africa, ceramic and basketry techniques are combined for structural efficiency, weather-tightness, and comfort. A cylindrical base is built up of clay, course by course, like a pot. This very efficient shape is capped by a conical thatch roof whose only weak point—the peak—is often covered by an inverted pot. In areas where the daily temperature variation can be as much as sixty degrees, the houses remain cool during the day when it is hot outside. At night, the heat stored in the conical airspace and in the clay walls is given

Figure 15. Olmec. Mexico. Hollow figure. Private collection.

Figure 16. Olmec. Mexico. Jadeite votive axe. Courtesy Trustees of the British Museum (Museum of Mankind #STS36). Museum Photograph.

back against the chill. It is worth emphasizing that all members of society have access to this technology, using generally available materials; the only difference between the compound of a wealthy, powerful person and a humble one is in the number of houses, not their quality. Moreover, these structures are biodegradable; when a village moves, as will be necessary after fifty years or so (when the fertility of nearby farmland is depleted), the houses return to the earth in a short time.

CONTAINERS have other interesting dimensions. The Olmec made many hollow ceramic representations of infants (figure 15). Only one opening to the outside is necessary to equalize pressure during firing, but here there is a multiplicity of openings: in the navel (or solar plexus), the fontanel at the back of the head, ears, nostrils, mouth. The fontanel, in particular, seems to be tied up with soul-flight, the solar

plexus is conceived as the center of being. Given the frequency of similar configurations in Meso- and South America, it seems reasonable to suspect that these images should be understood as containers for spiritual essences, analogous to the human body as container for the soul. Whistles and incense-burners appear frequently in ceremonial contexts in Pre-Columbian America; their functions are (intangibly) manifested at a distance, perhaps as a metaphor for the idea of spirit-flight. "Why babies?" is difficult to answer. Among the Aztecs, human babies were sacrificed to the rain-god Tlaloc; the more they wept, the more auspicious the sacrifice, their tears being likened to the rains upon which a successful crop depended. Also, in babies, the fontanel is palpably open.

IMPLEMENTS undergo similar inflections and transformations. In the Paleolithic Era (Old Stone Age), chipped stone blades were sometimes

Figure 17. Asante. Ghana. Kumawu state sword with depiction of a crocodile holding a mudfish in its mouth. Photograph, Doran H. Ross, 1976.

hafted to make axes for increased efficiency. The Neolithic Era was characterized by polished stone blades, typical of all of Oceania and most of Native America at the time of contact. (In Africa iron had been in use for approximately 2,000 years by then.) By turning the blade ninety degrees to the handle (producing an adze), it could be more comfortably used for carving. In some traditions, such as the Olmec, stone blades were created which were never intended to be used for any *UTILITARIAN* purpose—they were elevated, so to speak, to uselessness, shifting from *IMPLEMENT/MARKER* to a purely *TRANSACTIONAL* function (figure 16). Another example can be cited from the Asante of Ghana, for whom the cutlass was the key to their rise to political preeminence in the region (figure 17). Over time, the *UTILITARIAN* form underwent transformation into pure political symbol; its iron blade was pierced to become a fragile lattice, and the single dumbbell-shaped

single dumbbell-shaped handle became four, a commentary on the fragility of political power and the necessity for collaborative action in running the state (see page 129). *SUPPORTS* include most forms of what we call furniture, such as chairs, tables, and beds.

By now it should be clear that objects may embody two or even three levels of function which, among other things, challenge traditional Euro-American divisions of material culture into such categories as "art" and "craft," "high art" and "low art." Further, we have begun the shift in our discussion from the comparatively low-level *UTILITARIAN* functions of objects to their richer and more complex *TRANSACTIONAL* functions. Pure *MARKERS* do not embody a utilitarian function in the way that *IMPLEMENTS* do; they may denote territory, while also (as among the Aboriginal peoples of Australia) through renewal, revitalize the powerful forces which maintain the order of the world.

*Figure 18. British Columbia, Canada. Kwakiutl Eagle/Human Mask,
closed and open. From Waite (1966:Fig.8), Courtesy Department of Library
Services, American Museum of Natural History, New York.*

*Figure 19. British Columbia, Canada. Haida Village of Skidegate. Courtesy of the Southwest Museum, Los
Angeles, #33954. Photograph, Richard Maynard, 1890.*

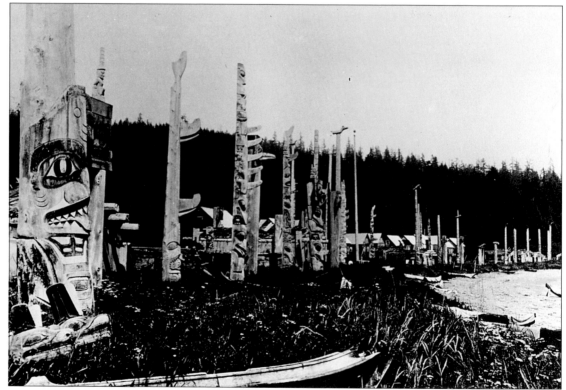

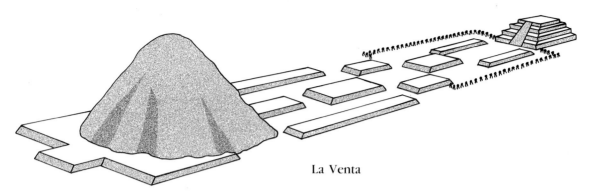

La Venta

Figure 20. Olmec site of La Venta, Mexico. Drawing, Mary Ann Fraser.

On the Northwest Coast of North America, MARKERS were highly developed ways of conveying important information about social role and status. The Northwest Coast was richly endowed with resources from the sea and land. The region was populated by successive waves of peoples immigrating from the interior, and they continued a hunting and gathering pattern of subsistence; the richness of the natural environment made agriculture unnecessary, providing all the appurtenances of a sedentary way of life with the sorts of regular and substantial surpluses elsewhere only feasible through farming. The population devoted its considerable leisure to competition, both through warfare and psychologically through art and ceremonies. Although the environment was rich, its bounty was not infinite, and competition for space and resources was vigorous. Villages took on the aspect of billboards, with powerful images, richly carved and painted, proclaiming to passing canoes the wealth and spiritual vigor of their inhabitants, and their rights to the resources they controlled (figure 19).

TRANSFORMERS, as indicated, are involved with levels of reality beyond the normal and everyday, being concerned with revealing—and tapping into—the hidden order and structure of the universe. Sometimes this revelation is evoked literally, as with the transformation masks of the Northwest Coast (figure 18). The dichotomy previously sketched between ephemeral—a brief, intense, shared experience—and enduring modes of art is useful here.

The temple complex at La Venta and the *hevehe* festival of Orokolo on the Papuan Gulf of New Guinea reveal resolutions of these modes in their pure forms with special clarity, although usually (as was probably the case at La Venta) they are blended in some proportions.

La Venta was mentioned earlier as a major Olmec ceremonial center, situated on an island in the swamps of the Vera Cruz coast of Mexico. Construction appears to have gone on intermittently over a period of 600–800 years, from perhaps 1,200 B.C. until ca. 400 B.C. La Venta is extraordinary for several reasons: 1. the island is difficult to reach; 2. its structures were made of materials which had to be brought from sixty-plus miles away over rough terrain; and 3. there is an extremely close alignment of the central axis of the complex with true north. A large earth mound with undulating contour dominated the site, balanced by a symmetrical array of smaller mounds, plazas, and walls, including constructions below ground as well (figure 20). Layer after layer of marble blocks and colored sands and clays were laid down, each covering the one below. Along the center line of the site was discovered a number of burials of valuable offerings, with polished stone axes—none of which showed any signs of use—being especially frequent. One particularly important cache consisted of a group of small figures, all but one flawlessly crafted of polished, hard stone, with elongated heads and highly stylized features (figure 21). The deviant figure, placed at the center of the semicircle formed by the others,

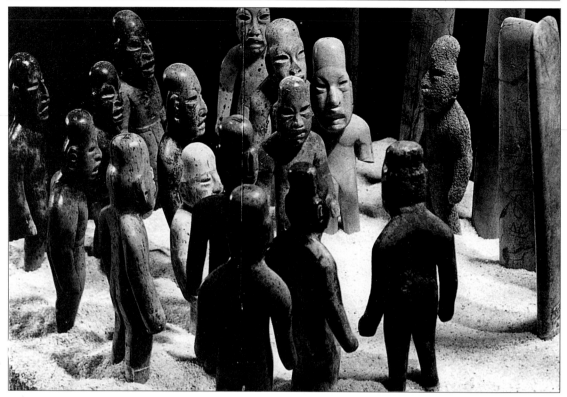

Figure 21. Olmec. La Venta, Mexico. Cache of Figures. From Anonymous (1970:30). Courtesy Instituto Nacional De Antropologia E Historia, Mexico D.F.

was of coarse sandstone; it was backed up against a palisade of polished stone axes. Archaeologists calculate that approximately one hundred years after their original burial, someone dug a hole down to them, ascertained that they were still in place, and covered them up again.

In view of the prodigious investment of resources in the site over centuries, and the character of the structures created there, La Venta may be understood as a kind of cosmic storage-battery, a place to accumulate the material surplus and to render in visible (and invisible), tangible form the metaphysics (and, one suspects, the political ideology) of the group which constructed it. At La Venta, and generally in the record of Meso-American architecture and planning, a continuing concern with aggregating energies derived from earlier generations is seen in incorporating earlier structures in later ones as ceremonial requirements changed. La Venta thus

epitomizes a permanent TRANSFORMER; over time it was invested with more and more of the economic surplus and creativity of the community focused upon it, invigorating subsequent generations through contact with the accomplishments of the past and, coincidentally, reinforcing the prerogatives of the elite.

Two particularly compelling accounts of ephemeral TRANSFORMERS are available and will be quoted here. First, Pastier (1975, IV:9-10) describes a Rolling Stones concert at the Los Angeles Forum:

Within the loose theme of a Chinese New Year, long looping banners and huge Chinese kites were hung from the roof supports, along with a galaxy of tiny twinkling lights. A giant dragon running through the hall also helped set the stage for the main performance. The special setting and the audience's mood of anticipation were strong enough to turn the interior of the Forum into a far better place than it

Figure 22. Orokolo Village, Papuan Gulf, New Guinea. Eravo. From Williams (1940:Pl.9). Courtesy Oxford University Press.

ever was on [the architects'] drawing boards. But once the Stones' act got under way, an even greater quantum jump occurred . . . [and] there was very little of the visual about it—it was pure energy overload. The amplification was one decibel short of ear-shattering, and the music was as thick as Turkish coffee, filling up every cubic inch of the air as though it were nearly solid. Jagger was almost always moving, . more with menace than grace, and this pumped up the energy level that much higher.

The audience, although lacking the performers' spotlights and amplification, still pulled its own weight in the process. Everyone, it seemed, was screaming, clapping, jumping to their feet and then standing on their seats, swaying and dancing. . . .

And that was just the physical energy. The brain waves must have been something, what with roughly 20,000 overloaded sets of mental circuits, a goodly share of which were re-programmed by various legal and illegal mind-altering substances, both singly and in combination.

After a few minutes of this—and the show went on for more than two hours—the physical dimension effectively ceased to exist. All matter had been transformed into energy, just as Einstein said was possible. It bounced off the crowd back to the performers, and vice-versa, and it bounced off the dematerialized kites, banners, stars, roof, walls, and seats.

Like good hypnotists, the Stones brought the tangible universe back just before it was time to leave. By the time the lights went back on in the Forum, the Forum had been reconstituted to give the lights something to shine on, and to give everyone someplace from which to go home.

The *hevehe* cycle performed by the Elema people of Orokolo Bay in the Papuan Gulf region of New Guinea is another example of an ephemeral *TRANSFORMER*. Like La Venta, the tropical forest situation of the village of Orokolo would not be expected to foster much in the way of artistic elaboration. A detailed report of the preparations for the festival and its culmination was provided by Williams (1940:356-7), a missionary anthropologist:

The *hevehe* cycle begins in Orokolo when the members of an *eravo* [men's house] perform a brief and fairly casual ceremony in which a coconut is split in two and a little magic is made [figure 22]. But this launches what will become a major effort of the whole community, lasting anything from ten to twenty years. This is partly because work is sporadic. Not only must large numbers of huge masks be constructed; wealth must be acquired and pigs fattened to provide for numerous feasts, and payments be made for various privileges, which enliven the community and stimulate its economic life. Furthermore, mourning, quarrels, and sorcery may all hold up the proceedings for indefinitely prolonged periods. In theory, the building of an *eravo* inaugurates a *hevehe* cycle, and the whole cycle should be carried out from it; in practice the invariable delays mean that a cycle is likely to outwear several *eravo*.

The first important act of the *hevehe* cycle is an expedition into the bush to cut loops of cane for the framework of the first two masks. . . . These are brought into the *eravo* on a moonless night after the women have been warned indoors. A crowd of men—shouting,

Figure 23. Papuan Gulf, New Guinea. Elema Eharo Mask. Courtesy, UCLA Museum of Cultural History #X65-4344. Photograph, Richard Todd.

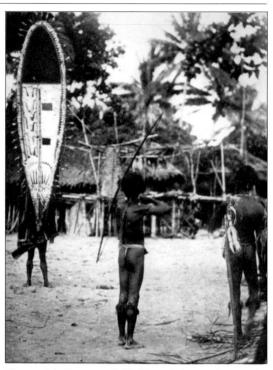

Figure 24. Papuan Gulf, New Guinea. Slaying the Hevehe. From Williams (1940:Pl.58). Courtesy Oxford University Press.

sounding shell trumpets and drums—swarms along the beach to the *eravo*, then back the way they came. The purpose of this demonstration is to carry in the cane; it symbolizes the visit of a *ma-hevehe* [water spirit] from the sea bringing with him two of his daughters whom he leaves in the care of the men. Time and again the monster visits his children, bringing others to keep the first pair company, and ornaments for all of them; and each of these occasions is marked by the acting-out of the *ma-hevehe's* turbulent invasions of the village from the sea. . . .

Eventually, the *ma-hevehe's* daughters are ready to emerge from the seclusion of the *eravo* in which they have been sheltered for so many years. Through the night of tense anticipation which precedes this, the revelation, the village women dance. Early in the morning, the shell trumpets sound from the *eravo* and the *ma-hevehe* answers the signal by coming up from the sea for the last time, carrying drums for his children. For several hours the men beat the drums in the ceremonial house, while the women standing outside call on *hevehe* to show themselves.

It was still dusk, nearly an hour before sunrise, and the tall front of [the *eravo*] hardly more than a black outline against the sky, when they began to open the door. But in the course of years the *eravo* had canted to the right . . . [and] the thirty foot door had consequently jammed. . . . A number of men standing on the ground to the left front of the building hauled on the lower vines attached to the farther edge of the door, but while it began to come clear at the bottom, it still stuck at the top corner. The women's cries had died away and a hush of expectancy had fallen over the crowd of watchers. Several men sprang up the scaffolding. . . . One of the climbers, a splendid, powerful figure, reached the topmost rung and in that precarious position threw his whole weight onto the line. At that, with a rending of wood and bamboo, the topmost corner was released and the *eravo* door swung open. Even as it did so the first of the *hevehe* was standing on the threshold [figure 23].

There are many dramatic situations in the cycle, but none can compare with this supreme moment when the *hevehe*, after well-nigh twenty years of confinement, issue forth to commence the brief fulfillment of their

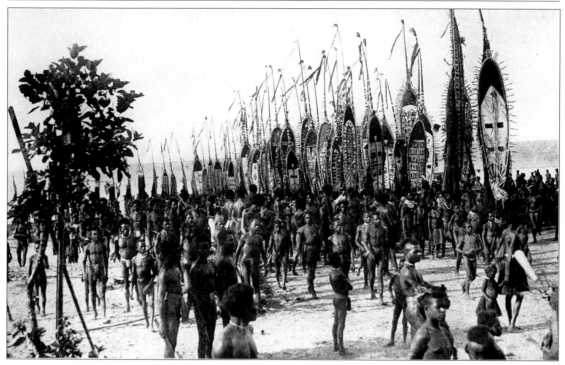

Figure 25. Papuan Gulf, New Guinea. The Final Procession, approaching the Eravo from the Beach. From Williams (1940:Pl.55). Courtesy Oxford University Press.

Figure 26. Papuan Gulf, New Guinea. Dismantling the Masks. From Williams (1940:Pl.59). Courtesy Oxford University Press.

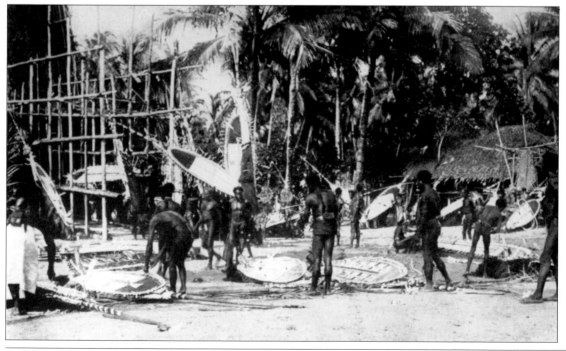

existence. In the grey light of early morning the first of them . . . stood framed against the blackness of the open door—a tall, fantastic figure, silvery white, its colored patterns in the atmosphere of dawn appearing pale and very delicate. The garishness, the grotesquerie, that full daylight and a near view might discover were now blurred; they faded into something fairylike. One of the spirits—of forest, sea or air—one of the Magic People . . . was about to lead its companions out of their long immurement to dance and make merry in the village. A strange, other worldly figure, and a heathenish one, no doubt; but none who saw it poised on that dark threshold could have failed to call it beautiful.

For a brief moment, [the masquerader] stood there, the great crowd of spectators gazing in silence. Then, with a thump of the drum and a prodigious rattling of . . . (seed anklets), it started down the gangway. Immediately behind it came [another] and after that, in crowded succession, 120 others [figure 25].

Newton (1961:28) summarizes the completion of the festival:

All the months which follow, the *hevehe* ceaselessly dance and play their drums on the beach, accompanied by bands of dancing women for whom this is a period of gaiety and pride. At the end of this time, the masks vanish into the *eravo* in ceremonial procession. Later they are ritually shot to death with arrows—the women lamenting passionately meanwhile—after which the masks are secretly dismantled and burned, away in the bush [figures 24, 26].

Newton (1961:33) then provides a trenchant footnote to this quintessential description of an ephemeral *TRANSFORMER*:

We can hardly imagine the low degree of man-made stimulation to the visual sense among these people. It was less than could be found in other areas of New Guinea (where so often almost every household object was brilliantly decorated), and infinitely lower than it is among ourselves. . . . During the appearances of the masks . . . the aesthetic experience must have been almost overwhelmingly rich, and the sense of human accomplishment conveyed by these objects far greater than it can be to us. We can guess, if we cannot participate in, the impact of these sights on people whose day-to-day experience of aesthetically shaped objects did not go much beyond the carving on a stool or a club. Without exaggerating, we should probably remember that the first revelation of art to the Papuan Gulf man or woman was usually an emotionally and physically tumultuous one which was renewed occasionally for the women, and gradually wore off for the men as they became habituated to adult life.

Art as technology can thus address everyday (*UTILITARIAN* functions) as well as metaphysical concerns (*TRANSACTIONAL* functions). With this understanding of what art can accomplish, we begin our survey of specific cultures selected because of their diverse social, political and economic orientations.

Itinerant Hunters and Food Gatherers

Australian Aborigines*

The arts of the Aboriginal peoples of Australia are taken here to represent an example of those of hunting and food gathering peoples (see map, page 56). The interior of Australia is arid and offers a very limited range of vegetable and animal resources, but has long been occupied by hunters and food gatherers. Only in the far north—Arnhem Land and adjacent areas—and south are the resource base and climate more congenial. Arnhem Land, in particular, has had a comparatively high population density and was stimulated by intermittent contact with maritime traders coming from Indonesia and Melanesia. Nor was Central Australia entirely isolated, since the wide distribution of marine shell ornaments indicates exchange with coastal peoples, in some cases involving distances of 500 miles. The interior is essentially a level plain, with infrequent interruptions by volcanic cores of basalt, natural wells, seasonal swamps and streams, and groves of trees. These features stand out dramatically against the plain and take on a special significance for the groups inhabiting the areas in which they are situated, a significance which relates them to "Dreamings" and "Dreamtime." The Dreamtime refers to the ever-present, a present reality as well as the time of creation, when the environment existed as a vast featureless plain; the Dreamings are the demiurges whose movements and activities produced the features of the landscape, as seen in the following Aranda (an Aboriginal Australian language group) creation myth:

> In the very beginning everything was resting in perpetual darkness; night oppressed all the earth like an impregnable thicket.
> (And) Karora was lying asleep, in everlasting night, at the very bottom of the soak* of Ilbalintja; as yet there was no water in it, but all was dry ground.
> Over him the soil was red with flowers and

*The film *Emu Ritual at Ruguri* (1966-67) was shown in conjunction with this section. Aboriginal Studies Series. Distributed by University of California Extension Media Center, Berkeley, CA.

*A depression that holds water after a rain.

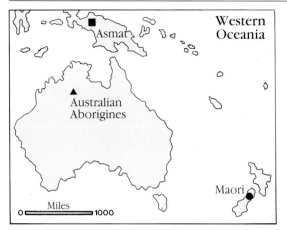

overgrown with many grasses and a great pole was swaying above him.

And Karora's head lay at the root of the great pole; he had rested thus ever from the beginning.

And Karora was thinking, and wishes and desires flashed through his mind. Bandicoots* began to come out from his navel and from his armpits. They burst through the sod above and sprang into life.

And now dawn was beginning to break.

From all quarters men saw a new light appearing; the sun itself began to rise at Ilbalintja and flooded everything with its light.

Then the Gurra ancestor was minded to rise, now that the sun was mounting higher.

He burst through the crust that had covered him; and the gaping hole that he had left behind became the Ilbalintja Soak, filled with the sweet dark juice of honeysuckle buds (Rothenberg 1969:9).

The coming of the rains is one opportunity for people to gather for ceremonial events. Bands which had separated into family groups in order to seek food during the long dry season would come together for rites whose intent was (and is) to restore the land through renewal of the traces of the activities of the Dreamings. Through direct association with these nodal sites, contact with the ancestors and with the sources of creation are reinforced; songs are sung, paintings are restored, and cosmic phenomena re-enacted whose objective is to ensure the survival and

continuity of the broader social group. At another level, the paintings on the rocks and on peoples' bodies which renew and revitalize the Dreamings can be considered an expression of territoriality, or a cultural/historical primer through which each generation conveys its heritage to its children (see figures 27, 28, 29). Because the features of the landscape have spiritual meaning, the Aboriginal peoples of Australia can be said to occupy the book in which their history is written. This is seen in the character of the symbols which make up their art, and how those symbols are used.

Munn (1973:193-8) offers the following analysis of the Walbiri:

It would appear that in some cultures one can abstract underlying, simple visual shapes and arrangements such as circles, crosses or concentric structures, etc., which are reiterated throughout a range of media and behavioural contexts, and to which are bound cultural notions about order in the world as a whole.

The way in which a people organize visual forms in space is a subject central to aesthetics; thus one task of anthropologists concerned with aesthetic phenomena is the examination of different spatial arrays in a given culture so as to determine basic visual ordering patterns.

They [the Walbiri] have a typical central Australian totemic ideology involving belief in innumerable ancestral beings whose travels created the topography of the country. Many of these are personified aspects of the environment such as rain or honey-ant; but others are wholly human or non-human.

The ancestors and the time in which they travelled are called *djugurba*, a term that also means 'dream.' Walbiri men say that the ancestors, sleeping in their camps at different sites, dreamed their songs, graphic designs, and ceremonial paraphernalia. These phenomena record their travels; as one man suggested, they dreamed their track (*yiriyi*). To translate the Walbiri term *djugurba*, I use the label common in the literature on Aborigines, 'Dreaming;' the ancestors I call 'Dreamings,' and the ancestral period as an historical locus, the 'Dreamtime.'

Ritual rights over Dreamings are vested in patrilineal lodges of men, who are responsible for the maintenance of a number of Dreamings

*A kind of marsupial, about the size of a large rat.

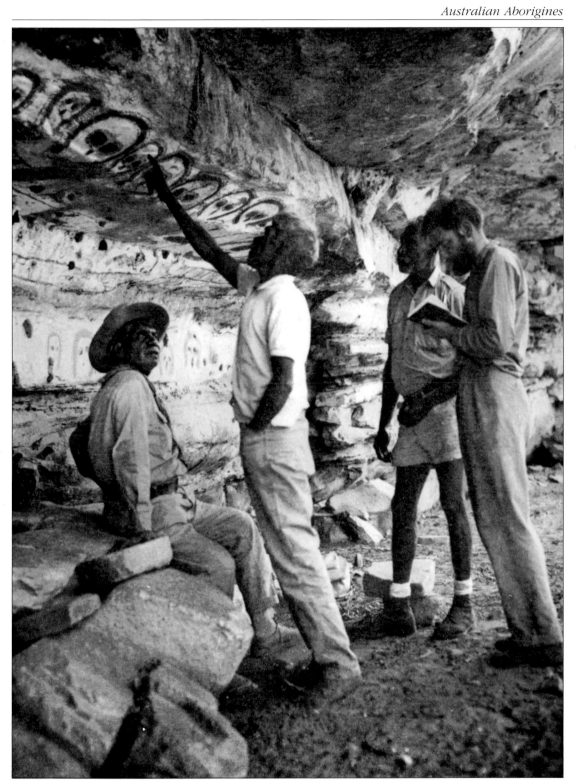

Figure 27. Wanalirri, Northwestern Australia. Paintings in Rock Shelter. From Crawford (1968:14).

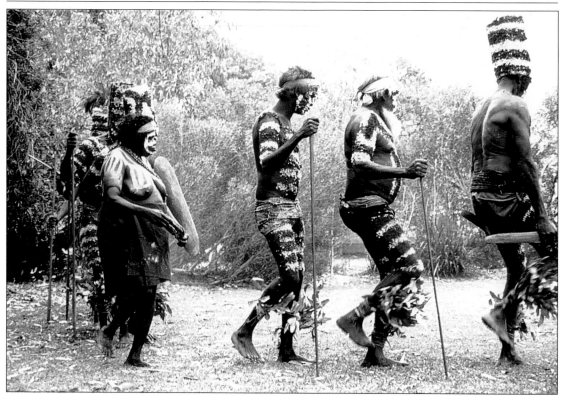

Figure 28. Balgo Hills, Southern Kimberley, Western Australia. Dancers in Ceremony Associated with the Mythological Emu. Courtesy Anthropology Research Museum, The University of Western Australia, #WU/P2941.(JES3024). Photograph, John E. Stanton, 1979.

within a given segment of the country . . . and the care of the symbolic paraphernalia and ritual associated with them. [The Walbiri social structure includes exogamous patri- and matri-moieties, eight subsections, and an Aranda type kinship terminology.]

Walbiri representations consist of elements such as circles, arcs, and lines that can be combined into larger configurations of varying complexity. Both men and women may draw these graphs in the sand during storytelling to illustrate narrative meanings. . . .

Certain classes of graphs are associated with different Dreamings; these are presented on various media during ceremonial. . . . I call these graphs 'designs' because, unlike the usual transient assemblages of storytelling, Walbiri regard them as more or less fixed configurations of elements remembered over time and linked with specific Dreamings whose characteristics and/or activities they depict. . . .

Men's designs [with which I am here concerned] are incised on sacred boards and stones (*churinga*) [figure 30] and are variously materialized in ceremonial as, for example, in body decorations with bird or vegetable fluff, or with ochres [figures 28, 29]; in ground paintings of red and white fluff [figure 31]; on painted designs on shields, etc.

There is a single graphic art or 'language' of which men's and women's Dreaming designs constitute different genres. This language has a characteristic internal structure involving a stock of visual elements and implicit rules governing their combination. In any given usage each element has a specific referential meaning and provides a simple pictorial likeness in linear, two dimensional terms of the object to which it refers.

The relative positions of elements in larger assemblages are usually pictorial: i.e. they depict spatial arrangements of objects in three-dimensional space. For example, two people lying down next to each other in camp can be represented by two parallel lines with an arc (the windbreak) placed at one end of the

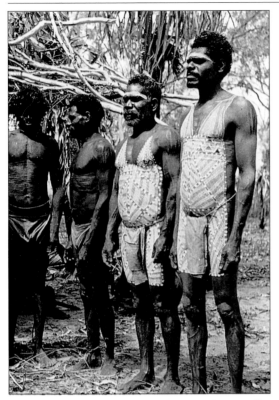

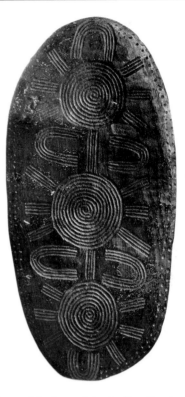

Figure 29. Liverpool River, Arnhem Land, Australia. Body Painting Marking the Lifting of a Taboo. From Thévoz (1984:37). Photograph, Axel Poignant.

Figure 30. Central Australia. Churinga. Courtesy UCLA Museum of Cultural History #X65-4864. Photograph, Richard Todd.

lines. This represents the windbreak behind the heads of the sleepers, as in the actual spatial organization of the camp. Thus the rules for combining the elements embody iconic principles. . . .

The elements and combinations of Walbiri art can be used to generate an indefinite number of messages; the art is characterized by what linguists call 'productivity.' Another important feature is that the one system embraces a range of functions sometimes separated out into distinct systems in other cultures: it provides pictures of various phenomena and also diagrams of a map-like kind; in addition, some of the elements and element combinations function as visual symbols of the cosmic order.

If we examine Walbiri statements and narratives about the Dreaming, we find that a particular kind of process in which phenomena 'come out' . . . and 'go in' . . . recurs in a variety of contexts and is figured in different concrete images.

As we shall see, 'coming out-going in,' with its correlative positions, 'outside-inside,' is extended as a general principle over the whole of existence to explain the structure and maintenance of the spatio-temporal order. We might call it . . . a 'world theory.' My contention is that this theory is stored and communicated in direct, immediately perceivable form by a visual model elaborated within the iconography of Walbiri men. . . .

[Figure 32] is an informant's depiction of the typical elements of a . . . design showing how a Dreaming might travel through the country. The Dreaming came out . . . from circle A, stood up, and travelled to nearby B, then on around to C,D,E,F and back again to the first circle where he finally went in the ground forever. Each circle represents a camp or campsite . . . where he 'sat down.'

The design gives visible form to the Dreaming track. The final 'going in' of the Dreaming

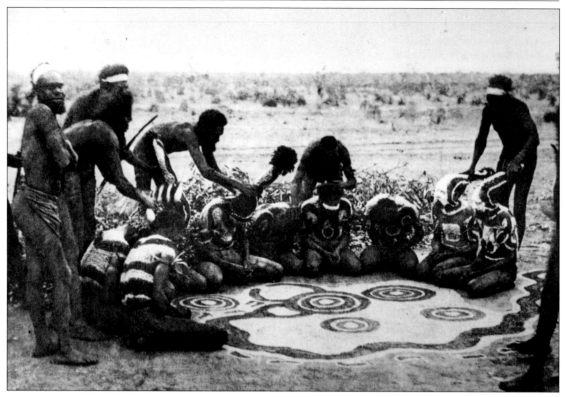

Figure 31. Australia. Ground Painting.

to the original site is not an irreversible process. The Dreamings still exist under the ground at the present day. They are inside the country in the sense of underneath, covered over, or at the bottom. When rituals are performed in which dancers decorated with designs invoke Dreamings, the latter are reembodied for the period of the performance. Thus they come out again. At each place to which they travelled the Dreamings left their generative powers. Men sometimes express this notion by saying that children are conceived at these power sites. In this sense, the Dreaming is continually coming out of the ground and being reembodied as a living entity, as well as continually returning to the ground. "Coming out-going in" is a "metaphor of repetition" which provides a way of thinking about the socio-natural order as an on-going continuum.

Munn (1973:215-6) concludes:

Implicit in my approach is the assumption that

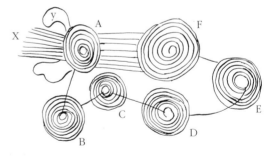

Figure 32. Australia. Site-path Figure: Typical Elements of a Gruwari Design. From Munn (1973:194), after Walbiri paper drawing.

O = *camp sites*

| = *paths. Some paths are shown joined directly to the center of the circle. The lines at "X" represent the Dreaming standing up from the waterhole.*

y = *?. Meaning not given.*

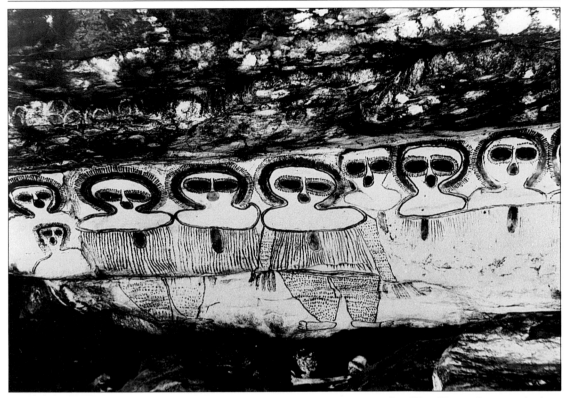

Figure 33. Napier Range, Kimberley Region, Northwest Western Australia. Wandjinas. Courtesy Anthropology Research Museum, The University of Western Australia, #WU/P412 (or WU P470). Photograph, A.O. Neville Collection, ca.1936.

analysis of the internal structure of visual forms as part of larger visual systems (and by this I do not mean 'stylistic' analysis as it is currently practiced, but rather analysis of the underlying rules showing us how a system 'works') is prerequisite to other approaches to the interpretation of form and meaning. In this I hold with the view expressed by Hymes for myth—one that can be extended to the visual arts: we cannot 'assume that a purportedly universal theory, be it psychoanalytical . . . dialectical, or whatever, can go straight to the heart of a myth (read here 'visual art form') before having considered its place in a genre structurally defined and functionally integrated in ways perhaps particular to the culture in question. . . .

. . . through the circle-line configuration the notions of 'world order' I have described are bound up with manipulative and tactile as well as visual perception, and thus imbedded in immediate sense experience. Philosophical premises about the macrocosmic order are continually brought into the sense experience of the individual Walbiri man through the agency of their iconic symbolism. The symbols thus articulate the relationship between the individual or microcosm and the macrocosm, and through the immediacy of touch and sight bind the two together.

Different kinds of power sites exist in the north where there are three main categories of spirit-representations in rock-art—that is, art which is in a fixed location, visited, renewed by the responsible group and left (figure 27). Sometimes the bones of important ancestors are left in rock shelters to interact with the power associated with the paintings, or pictographs. (Portable objects—carried from place to place —will be discussed later.) The three categories are:

1. Representations of *beneficent* spirits, usually

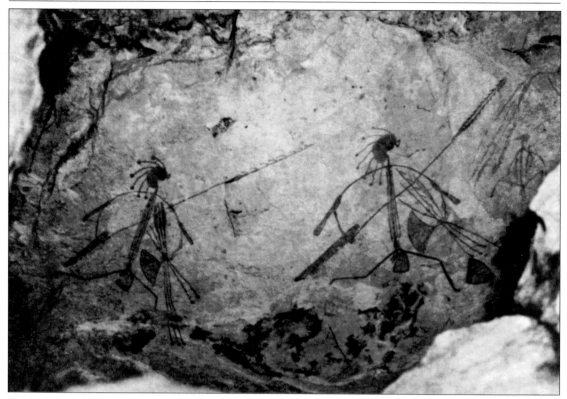

Figure 34. Inagurdurwil, Australia. Mimis with Weapons. From Mountford (1964:Pl.7). Reproduced by permission of UNESCO, Copyright UNESCO 1964.

related to Dreamings, often represented as snakes, fish or animals. The Wandjina, common only in the northwest of Western Australia, painted in soft shapes (like clouds), with rainbow halo and linear definition of body forms, has a special relationship to rain and the arrival of the summer monsoon (figures 27, 33).

2. *Neutral* beings, which coexist with people, and cause no trouble; for example, Mimis, from western Arnhem Land, are very thin and extremely sensitive (figure 34). On hearing humans approach, they may run into cracks in the rocks and hide. Mimis are represented in paintings as linear figures, but with close attention to details of adornment and material culture.

3. *Harmful* spirits, such as Namarakain, malevolent spirits which seek to trap or kill people through attacks on their souls (figure 35). A consistent feature of Namarakain iconography is the loops of string they hold, which allow them to travel at great speed.

The intent of these paintings is to make visible that which is invisible, to provide a place from which to control the beings which occupy the same environment as the Aborigines. This rendering visible underlying structures (or principles) is also seen in the "X-Ray" art of western Arnhem Land, probably not merely a demonstration of the artist's knowledge of anatomy (figure 36). Rather, such compositions are more likely intended to reveal, express, and ultimately concretize the underlying structures of reality.

A related but ephemeral painting tradition, using sheets of tree-bark, is produced in Arnhem Land. Temperatures are high during the rainy season, and groups build bark shelters for use as dwellings during this period. Sometimes their interiors are painted. At one level, these

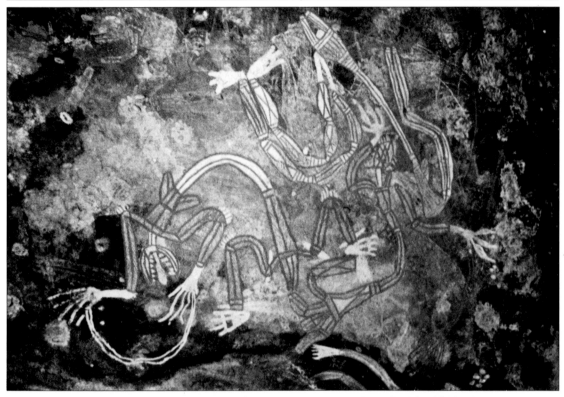

Figure 35. Cannon Hill, Australia. A group of Namarakain. From Mountford (1964:Pl.10). Reproduced by permission of UNESCO, Copyright UNESCO 1964.

paintings are creative exercises, the results of an excess of spare time. At another level, the designs inculcate and reaffirm the fundamental principles of the cultural system of which they are a part. The paintings are recreated each year because the houses are abandoned at the end of the rains. In addition to these "recreational" paintings, sheets of bark are also used to reveal the sacred designs, references to the mythical and actual history of the group, to young male initiates. This category of paintings is destroyed after use; if women or outsiders had access to them, they could make mischief by manipulating the information embodied in the paintings.

In addition to spirit-references and other representational forms, patterns (dots, lines, and planes of color) are also used to identify Arnhem Land groups. At crucial stages in the initiation, and other, procedures, these patterns (also rendered as bark paintings) are applied to the bodies of the initiates themselves; informa-tion about what they mean is also imparted (figures 29, 38). Even death does not terminate an individual's participation in the system. For example, in the western desert a dead body is exposed until decomposition leaves only the skeleton. When the group returns to the site, the skull is collected, painted with clan designs and "walked down"—carried by the family upon its annual circuit for several years—after which it is deposited in some sacred location (such as a rock shelter with important paintings) to go back to its Dreaming place.

This involvement of what seems to be a static and austere art with energetic movement and change is intrinsic to another design system described by Munn (1973). It is seen in the traces of Dreamings in the landscape from Central Australia, and in the designs which symbolize their movement as painted on hollow logs and into the earth for initiatory re-enactments—learning the Dreamings—and

Figure 36. Oenpelli, Western Arnhem Land, Australia. Bark Painting Depicting Nadulmi, the Mythic Being in his Kangaroo Manifestation. (Nadulmi has a feather attached to his head and holds a ritual dancing wand.) Courtesy Anthropology Research Museum, The University of Western Australia, #WU/P2421 (WU2628). Artist: Thompson Yuldidjiri, Gunwinggu tribe. Museum photograph.

Figure. 37. Bathurst and Melville Islands, Australia. Grave Posts. Made and painted in 1958; presented to New South Wales Art Gallery in 1959. From Berndt (1964:Pl. 5).

Figure 38. Arnhem Land, Australia. Bark Painting Representing a Giant Spirit who Steals Women and Eats Children. Artist: Yirawala, Gunwinggu tribe. Private collection, Germany.

which people follow during their own lives and even after.

Also as indicated in Munn (1973), beyond a certain rather low representational level, the meanings of the designs are not self-evident. The "real"—esoteric—meanings are privileged information, to be imparted only to the initiated. Compare the following ritual verse: "Shaking-there-drops it in a heap" seems

nonsensical to us. Actually it reports a memorable event in the history of the group: "Two men came to a cave. They lit a fire and asphyxiated the bats inside the cave. The men collected the dead bats and ate them." (It should not be surprising that many such verses are about food and/or progeny.) In short, the graphic design system presents layers of meaning which have counterparts in poetry and myth, which are extended from the minds of the Dreamings into the environment, onto people's bodies and into their minds.

"Bull-roarers" are sound-producing instruments used by Australians (and others) to imply the presence of supernatural phenomena. They are leaf-shaped tablets of wood, whirled around at the end of a cord to produce a pulsating, roaring sound. (Some are "elevated to uselessness.") The graphic designs ornamenting bull-roarers and the sacred tablets called *churingas* (figure 30) are the same sorts of maps used in other contexts to depict the movements of Dreamings. They are usually stored in conjunction with paintings and the owning group's skeletal materials. Similar patterns are applied to utilitarian objects such as the *woomera* (spear-thrower) and pearl-shell pubic ornaments. Thus Australian art can be described as full of information about important events, but it can also bear designs which are not totemic but rather seek to capture the energy embodied in flowing water.

The art of Australia is essentially two-dimensional, narrative, and highly abstract in character. Inherent to the system is the idea that the graphic symbols themselves can have power, and those who understand the meaning of the designs can actualize and utilize that power. There is little of the three-dimensional work—the sculpture—usually associated with "Primitive Art." What there is, is found in the north, such as the grave-posts of Melville Island, forms decorated with striking polychrome geometric patterns; as sculpture, the posts are primarily supports for graphic symbols (figure 37). Once again, what is important is the design rather than the surface to which it is applied. Aboriginal art is a manifestly portable, highly mental complex, for expression where and when needed in the accomplishment of social and cultural tasks. In sum, it embodies sensitive, elegant observations about the order of the universe—observations which are rendered as designs and patterns intimately bound up with the lives of their makers, and upon which they depend for the transmission of much of their culture from one generation to the next.

Herders

Fulani*

In Africa, herding is one of several viable modes of subsistence in and on the margins of the difficult environment represented by the Sahara— conditions broadly similar to the central area of Australia. A fundamental difference between herding and hunting/gathering is that with herding wealth can be stored. Both of these ways of life are itinerant and represent an "inconvenience" to modern nation-states, who seek to settle the people down, the better to control them.

Fulani subsistence and society is based on their herds of long-horned cattle which are well adapted to the comparatively arid conditions of the Sudanic margins of the Sahara (see map, page 68). Cattle represent the basis of clan continuity, including being used as the primary basis of bride-wealth (like a dowry in reverse). The life of the Fulani is dominated by the search for pasture above the fluctuating perimeter of tsetse-fly

*The film *Deep Hearts* (1980) was shown in conjunction with this section. Distributed by Phoenix Films.

infestation (and the trypanosomiasis—sleeping sickness—it carries), which moves north and south with the rains (figure 39). In the southern portions of their range, they and their cattle move through terrain occupied by farmers, who view them as a mixed blessing; milk and butter (and sometimes meat) become available, and manure for the fields, but sometimes the herds destroy crops.

Life for the young (seven- to fourteen-year-old) Fulani men is particularly difficult. Approximately six to eight months of the year are spent in semi-isolation, caring for sub-herds which are dispersed to exploit limited pasturage and protect a breeding nucleus in case of disease or other loss. During the rains, when pasturage is abundant, the clans come together for social ceremonies of various types. Young men of fourteen to sixteen years of age go through a test of courage. The initiate strikes a pose with both hands above eye-level, whereupon he is beaten about the ribs with a rawhide whip by his best friend; the victim must show himself indifferent to pain. This test represents a rite of passage, entry into adulthood, after which the youth can

West Africa

Senufo

◆ Fulani

● Asante

Miles

0 ⸻ 1000

marry and develop his own herd. The toughness and fortitude involved are requirements of the herding life.

Shelters may be made from materials at hand, such as cornstalks or brushwood where available, and abandoned when the herd moves on; in less endowed environments, women carry their shelters with them. (Younger men and women sleep in the open.) Fulani women are intimately involved with other forms of containers as well, particularly gourds for milk and butter. Although men own the cattle and the wealth they represent, women are entitled to the milk and butter, which they trade to farmers for agricultural produce and to craftsmen for articles of personal adornment. (It should be noted that Fulani wealth is stored "on the hoof," requiring constant care and realignment with changing conditions. There is no evidence that they invest any places in the environment with special significance as do, for example, the Aborigines of Australia.) In each new camp, Fulani women set up domestic altars, consisting of gourd containers, whose purpose is to increase the yield of the cattle (figure 40). The gourds are usually richly decorated, an important and apparently old tradition, intended to complement the animals and encourage them to produce more milk. Central to Fulani aesthetic ideology is the premise that something which looks nice will be more effective than something which does not. For example, a Fulani girl will dress very elaborately to go to the market where she intends to sell her dairy produce; she believes that looking her best will encourage people to buy from her.

In addition to acquired ornaments such as bangles, necklaces, and hair decorations, tattoo is widely practiced (figure 41). (In tattooing, pigment is inserted into the skin, usually with

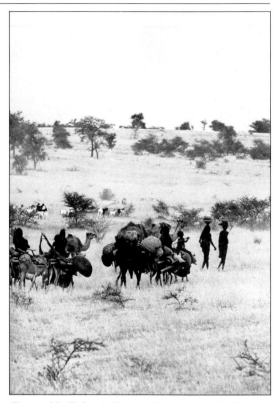

Figure 39. Fulani. Niger. "On the Move" (Detail). From Nomads of Niger, *published by Harry N. Abrams, Inc., 1983. Copyright Carol Beckwith.*

needles. More typical of the darker peoples with whom the Fulani interact are the cutting procedures called cicatrization, in which raised keloids, or scars, are the objective, and scarification, which produces marks below the level of the skin.) In general, the Fulani aesthetic system is primarily oriented toward the body. At the annual *yaake* and *gerewol* ceremonies, young men participate in what is essentially a male beauty contest (figure 42), here described by Delange (1974:148-9):

The importance accorded to beauty in itself is constant in Bororo [a Fulani group in Nigeria] society. But it bursts in all its vital significance in the [rainy] season, during the festivals that unite groups habitually dispersed by the sun in the arid grass, for seven magnificent days of *gerewol*, a beauty contest at which the handsomest men of the tribe compete. All the resources of the arts, which see

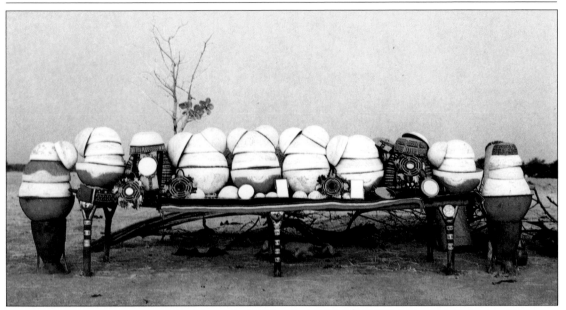

Figure 40. Fulani. Niger. "Calabash Altar." From Nomads of Niger, *published by Harry N. Abrams, Inc., 1983. Copyright Carol Beckwith.*

Figure 41. Fulani. Niger. "Women." From Nomads of Niger, *published by Harry N. Abrams, Inc., 1983. Copyright Carol Beckwith.*

Figure 42. Fulani. Niger. "Yaake." From Nomads of Niger, *published by Harry N. Abrams, Inc., 1983. Copyright Carol Beckwith.*

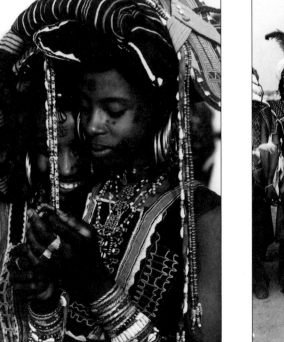

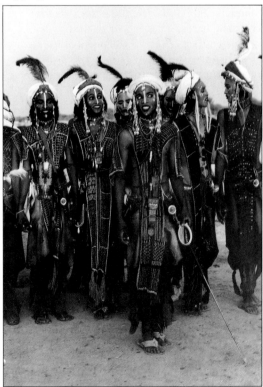

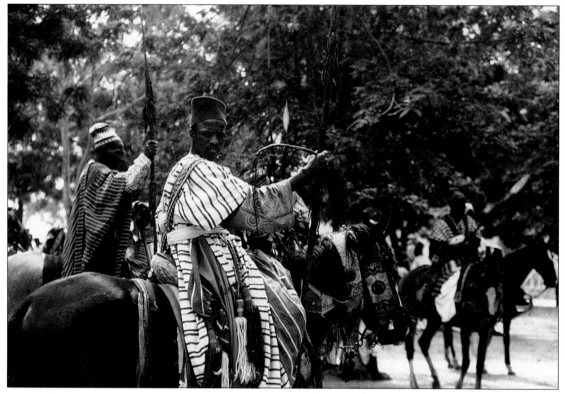

Figure 43. Gombe, Nigeria. Muslim Holy Day, Sallah Festival. Photograph, Arnold Rubin, 1982.

that harmonious, seductive, quasi-supernatural appearances are created, are put into play. The body is given over to the pursuit of painting and adornment to which each adds his own sensitivity. The afternoon of the festival the young men are lined up like splendid and mobile images of deities. The face is painted red, glistening with butter with outlined motifs, triangles embellished with points at the corners of the blackened lips; the head is coiffed with a cowrie headband surmounted with a long and plumy ostrich feather; from each side of the face fall strings of ram's beard, chains, beads, rings; the neck and torso, polished like precious wood, are adorned with multiple rows of white beads, leather and cowrie pendants, and metal discs which are also found on the dyed and embroidered loincloths. A solemn song is sung on a single note (the melody having been deliberately omitted) by the young men, who are balanced on their feet placed close together. The eyes are obligatorily open wide and the grin, a wide smile blocking out the impassive face, is likewise obligatory. . . .

The itinerant life, from water hole to water hole, frustrates and diverts the working of material and the creating of more or less permanent forms. The Bororo's passionate love of the beautiful, in addition to dance and song, could only be expressed in the application of exceptional ornamentation for the perfecting of the appearance by the daily adornment of the body and to the most elementary domestic objects.

One may conclude that these young men are secure in their sexuality and confident in their masculinity to the point that a blurring of boundaries between male and female systems of dress and adornment is considered to enhance their attractiveness rather than diminish it.

The sensitivity to wealth and the storage thereof, efficient organizational structure, toughness, decisiveness, and "geopolitical awareness" inherent to the Fulani way of life provided the basis for a dramatic transformation of their society during the nineteenth century. All across the West African savanna, from northern Nigeria to

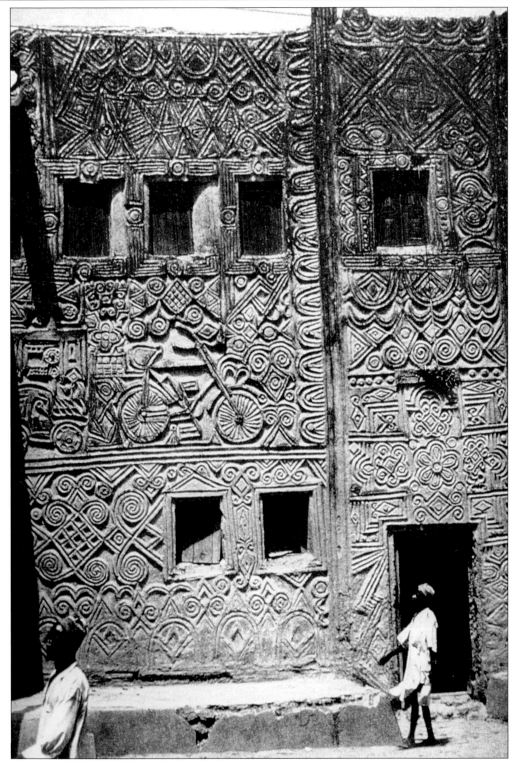

Figure 44. Zaria, Nigeria. House Facade. Photograph, Arnold Rubin.

the Guinea Highlands—the stronghold of Fulani herding activities—the Fulani led a series of Islamic *jihads*, or holy wars (figure 43). Previously Muslim, but not devout, they were led by a series of charismatic holy men who stimulated religious fervor and fostered centralization, unifying previously independent ethnic groups and political units. Primarily dependent on force of arms, and capitalizing on the martial skills and organizational abilities required for managing the herds, the Fulani found themselves forced to settle down in order to govern their newly won territories. Considerable changes were manifested in the display of wealth, such as a shift to an abundance of expensive cloth as the basis for clothing. Architecture also changed. As the Fulani began to intermarry with the sedentary farmers, their buildings became larger and more permanent, although reflecting numerous aspects of previous styles in terms of shapes and materials. In urban situations, circular, dome-shaped structures which were efficient for low-density, dispersed patterns of housing, wasted space; as a result, more compact rectangular forms using clay rather than vegetable materials were adopted. In some cases, however, the earlier system of ornamentation persisted on the exterior facades of these rectangular mud dwellings. Geometric design systems have traditionally been associated with Islam, but the predominance of such patterns among the Fulani seems not so much Islamic influence as reflecting a formal vocabulary deriving from women's arts, such as calabash decoration (figure 44). New motifs, deriving from the forms of modern life, were resolved in terms of this formal vocabulary, including extreme forms of coiffure, massive jewelry, and sumptuous (imported) textiles, all reflecting their origins in the highly developed aesthetic of personal adornment which carried over from the herding way of life as transplanted to a new social and economic setting. The calabash complex of Fulani women continued and expanded (in some cases shifting to enamel vessels) as symbolic testimony to a woman's domesticity. Production shifted, however, from work for oneself, relatives and friends to part-time/full-time production for the market, often with men rather than women doing the work, another fundamental change brought about by the shift from an itinerant to a sedentary way of life.

Sedentary Hunters and Food Gatherers

Asmat

Having confronted the primacy of beauty in the lives of the Fulani, involving beliefs and behavior so strikingly in contrast with our own norms as well as with the harshness of the life they are called upon to lead for most of the year, we may now be able to consider the arts of the Asmat of Irian Jaya (New Guinea). In contrast to the arid environments occupied by the peoples considered so far, the Asmat inhabit a swampy tropical forest on the southwestern coast of New Guinea (see map, page 74). The dense vegetation which surrounds them, and from which they extract their subsistence, occupies a central position in their economic, spiritual, and artistic life. While the Asmat are not cultivators, their sedentary way of life and comparatively extensive material culture are not typical of itinerant food gatherers. (In this respect they resemble, for example, the similarly sedentary foodgathering peoples of the Northwest Coast of North America whose traditional culture was even more elaborate and complex; see page 49.)

The life of the Asmat is characterized by 1. preoccupation with maintenance of energy-balance through capture and transfer; 2. the use in art of signature elements clustering around a developed iconography of POWER associated with cannibalism and headhunting; and 3. a finely-tuned sense of the relationship between people and the environment, with human beings conceptualized as analogous to trees. Gerbrands (1967:11, 14-5, 21-3) provides the following information:

In a small area on the southern coast of New Guinea, west of the Papuan Gulf and the Torres Strait, and north across the Arafura Sea from Australia, live the Asmat people. . . . It is important to realize that the Asmat live in an area that is virtually without stone. Stone is used only in the form of stone axes, and these are not indigenous but are obtained from high-land tribes by way of a long and still mysterious trade route. Pottery is unknown, probably because the muddy soil is unsuitable for the fashioning of earthenware. . . . The symbolism of Asmat culture seems to be dominated by two fundamental themes: the parallel of man and tree, especially the sago tree, on the one hand and images related to headhunting on

the other. These are closely related, and it is often difficult to distinguish between the two. . . .

For the Asmat, man and tree are metaphorically identified and interchangeable: man is a tree, and a tree is a man. Man's feet are the roots of the tree, the trunk of the tree is the human trunk, its branches are his arms, its fruits the human head. . [Blood and tree sap also are connected; see page 81.] The equation of fruit with the human head has particularly important consequences for the whole of Asmat art. Any dark-colored animal which is a fruit eater becomes the symbol of a headhunter, or even of headhunting in general, especially when the animal is a flying one. Therefore the black king cockatoo, the hornbill, and the flying fox are widely used symbols for the headhunter, encountered everywhere in the sculptural arts, usually in an abbreviated form. The sign of the black king cockatoo or *ufir* is the beak with the thick tongue, which characterizes the cockatoo. The hornbill is represented by a beak with a series of notches near its base. The flying fox is usually found only on shields and in a form which can easily be recognized as representing the outstretched wings of this animal [figure 45]. As a result of associative symbolism, other birds, usually black [the color of the Asmat themselves], also become emblems for the headhunter—for example, a special kind of heron and the sea pelican.

Animals in Asmat carving are always represented by a design which represents one of their particular characteristics. With a little training one can learn to recognize and identify these forms. The Asmat themselves have little or no trouble in interpreting the symbols,

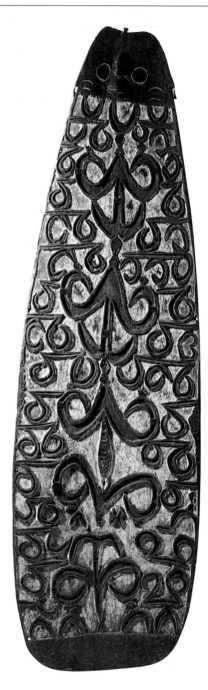

Figure 45. Asmat. Upper Undir River, Tjemor Village, Western New Guinea (Irian Jaya). Shield. The Metropolitan Museum of Art, New York, #1978.412.936. The Michael C. Rockefeller Memorial Collection, Gift of Nelson A. Rockefeller and Mrs. Mary C. Rockefeller, 1965. Museum photograph.

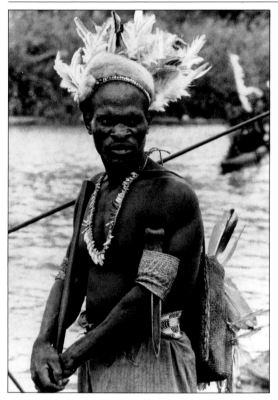

Figure 46. Asmat. Western New Guinea (Irian Jaya). Kerembit, from Yeu Nemengai in Full Festive Dress (cuscus headband with white feathers, necklace of dog's teeth, cassowary bone dagger). From Gerbrands (1967:82). Photograph, Michael C. Rockefeller, 1961.

because they all have become signs with fixed meanings, and one has only to learn how to read them. The forms are certainly more than just meaningless and ornamental decorations. We might very well call them ideograms, and one gets the impression that they are, so to speak, on the verge of becoming written language. In fact, they are limited in number, as ideograms are, and their meaning is generally the same all over the Asmat territory.

On festive occasions, and in former days as preparation to a headhunting raid, the Asmat transforms himself into one of the black, fruit-eating birds or flying animals [figure 46]. He sticks white feathers in his hair to imitate the hornbill, which has white tail feathers. He paints red around his eyes, for a black king cockatoo suddenly shows a red color on a bare spot around its eyes when angry, upset or afraid. On his forehead he wears a fur band made from the skin of the cuscus, which has

the same yellow color as the head feathers of a full-grown male hornbill. The cuscus, incidentally, is also used as a symbol for the headhunter, as it is a fruit eater, though not a flying one. Nor is it black, but rather, the color of the sun. It is, however, a night animal, and this probably makes up for the fact that the cuscus does not fly. The cuscus is also a frequent symbol in Asmat woodcarving, but as is so often the case only part of the animal is represented—the characteristic tail, curled like a spiral [see figure 47].

A spiral design may also represent the tusk of a boar. The boar is another animal with symbolic meaning, though its exact significance is not clear. It may, however, be presumed that a pig more or less symbolizes a human being. Pig hunting can be as dangerous as headhunting, especially if one takes into consideration the simple hunting weapons: bow and arrows tipped with pieces of bamboo, and a hard palm wood spear with the heavy claw of a cassowary as a point. Though hunting dogs are used to chase the pig, the killing has to be done by the hunter himself. A killed pig is carried into the *yeu* house where the successful hunter is welcomed with the same greeting formula used in former days when the body of a headhunted enemy was brought in. The pig is cut up in the same way as the human body was. And the pig is dark skinned as is the Asmat himself. Since color symbolism and a system of identities based on color similarity are very important in Asmat culture, so it may be that it is primarily the wild pig's dark, almost black color that makes it identifiable with the human being. In this connection it is interesting to note that a pair of boar's tusks, bound base to base and tip to tip, and large enough to encircle a man's arm, are a favorite ornament of big hunters and important men. Their status value is about equal to that of a headhunted human skull. . . .

Vital as fertility is to the Asmat, wood is scarcely less significant. A creation myth . . . suggests the dominant role of wood, and the relationship between wood, carving and creativity:

Fumeripits, a mythological culture hero, was the first to build a *yeu* house, as he was the first to make or to do many other things [figures 47, 48]. He created it simply by drawing an outline of it on one of the rare sandy spots along the coast. Suddenly, there it stood, made of wood, with palm leaf walls, and covered with a thatch of palm leaves; on one side a row of fireplaces, on the other a series

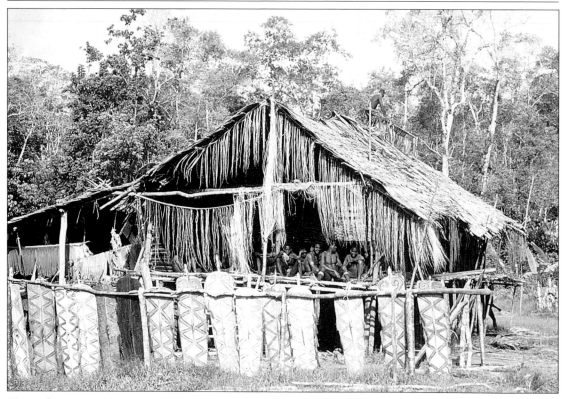

Figure 47. Asmat. Western New Guinea (Irian Jaya). Yeu at Japtambor Village on the South Casurina Coast. (The shields in this area, are all painted with a zigzag design that represents a wiggling snake; the upper end spiral is the curled tail of the cuscus). Photograph, Tobias Schneebaum, 1978.

of entrances facing the river—in short, the very prototype of the *yeu* house.

But it was an empty house. So Fumeripits began to carve statues of people from trees he found nearby. He carved men and women in abundance until the *yeu* house was completely occupied with the wooden figures. But there was no life in them; they were nothing but lifeless pieces of wood. So Fumeripits decided to make a drum. Inventing the method still used by the Asmat today, he hollowed out a piece of wood, made the inside larger by burning it with fire, carved the handle out of the outside, and fixed the skin of a big lizard over one of the ends of the hourglass-shaped body of the drum to serve as the drumhead [figure 49]. To secure the skin, he applied a mixture of blood and lime around the opening of the drum. Then the lizard skin was pulled tightly over it and a string of rattan was wound around the skin to keep the drumhead firmly in its place. After he had finished the drum Fumeripits began to play it,

and lo and behold! the wooden statues filling the *yeu* gradually came to life and began to dance in the characteristic Asmat way. With feet slightly apart, and knees wavering in and out to the rhythm of the drums, the dancers advanced slowly with small steps. Thus Fumeripits was not only the Creator of man, he was also the First Woodcarver and the First Drummer. As another myth . . . clearly indicates, Fumeripits was also the Great Headhunter.

Fumeripits had created six *yeu* houses by drawing their outlines in the sand, as described before. He was attacked by a monstrous crocodile which tried to destroy the newly-created houses. For five days a fierce battle raged, and every day the crocodile destroyed another of the houses. But every day Fumeripits wounded him more and more severely, until finally on the sixth and last day, he succeeded in killing the primordial crocodile before it destroyed the last of the *yeu* houses. He then cut the crocodile in pieces,

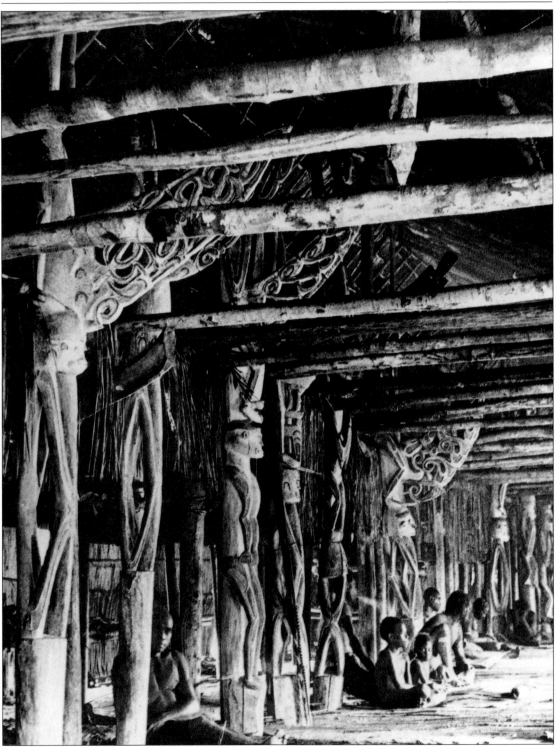

Figure 48. Asmat. Western New Guinea (Irian Jaya). The Yeu Amman, Interior (Rebuilt 1961 with an ancestor pole at each hearth). From Gerbrands (1967:55). Photograph, Michael C. Rockefeller, 1961.

cast the pieces in different directions. From these pieces sprang the different kinds of men, the black, the brown, the white. This myth expresses a fundamental Asmat conception: to create life one has to kill, or the destruction of life is a prerequisite of life itself. This is another corroboration of the fertility element in headhunting and its natural component, cannibalism.

Another important aspect of this myth is its explicit statement of the identity of man and tree. Man was actually created out of wood. To paraphrase the biblical saying in Asmat terms: "Wood thou art and to wood thou shalt return." The *yeu* community regularly re-enacts the story of Fumeripits the Creator, as told in the first myth. A great number of wooden statuettes are carved for the occasion and placed in the *yeu* house. During long drumming sessions the story of Fumeripits is narrated. . . .

It is probable that every Asmat woodcarver partakes of some of the sacredness of Fumeripits, the Great Woodcarver. Yet the Asmat *wow ipits* or woodcarver (*wow* means woodcarving and *ipits* is the Asmat word for man), is first of all a villager like anybody else. He has to do his own sago pounding, he goes hunting and fishing like the others, he has a wife and occasionally one or two secondary wives, and he has children. He lives in a house which is only rarely better than other houses in the village. As a young man he was initiated like all the other boys of his generation, and, in earlier times, he went headhunting to prove his courage and manliness. But then he has something which sets him apart from the ordinary people, for he is a woodcarver.

A society like the Asmat accepts more expression of individualism than the white outsider is likely to suppose. The artist in Asmat society is not the anonymous craftsman he was thought to be. The idea that the artist in Africa, Oceania, and other parts of the world which produce 'primitive art' is an 'anonymous' craftsman now appears to be a mistake due to western ignorance of the role of art in primitive societies. For a long time we were told that the artist did not count as an individual, and that it was only his work that was of value to his society. But this conception of the 'anonymous' primitive artist was based largely on collections in ethnographic museums—collections, that is, without any data about the men or women who had made the objects whose esthetic qualities compelled

us to call them works of art. We now know that the artist is not a nameless nobody but an individual well known for his work. Occasionally the distinction is even made between a good and a poor artist. . . .

The amount of freedom a given society allows an artist is something for which no hard and fast rules can be given. Artistic freedom is always conditioned by the society in which the artist functions. Among the Asmat one will find extremely clever craftsmen along with true artists. These latter we may characterize as the *wow ipits* who, while they work within a limited range of socially accepted forms and designs, have a personal range of esthetic expression larger than that of the ordinary *wow ipits*, and also more daring and imagination. Naturally, they experiment only hesitantly and on a small scale, for they have not much reason to go outside familiar themes and designs. Nevertheless, one will find in Asmat society, just as in the western world, excellent craftsmen who have that hard-to-describe extra something which makes the artist: that feeling for rhythm and harmony in design, that careful balancing of forms and shapes and shadows combined with a daring mind prepared to explore.

The Asmat artist uses only three colors: white, red and black. White is the basic color, and nearly all carvings are painted with a layer of white chalk mixed with water. Red earth mixed with water is used to represent details such as scarification tattoo marks or the bones of arms and legs. Black, obtained by mixing charcoal with water, is used only for hair—hair on the head as well as pubic hair.

Though Asmat art includes a considerable number of figures in the round, for example, ancestor poles and ancestor figures, it is basically a two-dimensional art. This is most evident in the shields, but many other woodcarvings which seem at first to be carvings in the round turn out on careful analysis to be very deep relief or even openwork carvings. This is the case with the large, pennant-shaped protrusions on top of the ancestor poles, and with many canoe prows. Even statues are often strongly two-dimensional.

The Asmat artist does not usually receive specialized training. Every Asmat learns how to handle wood, that is, how to cut a tree and make the objects he needs for his daily use. He has to be able to build a house, to make a paddle, bow and arrows, a sago pounder and a canoe, because without this knowledge he

could not survive. The youngsters learn these tasks by watching their elders and imitating them, a very loose and haphazard way of learning. (Formal education can only be found in the schools run by the missions and sponsored by foreign administrators.) Thus, although every Asmat can take care of his ordinary requirements for wooden objects, he turns to the *wow ipits* for anything special such as a decorated shield, a carved prow for his canoe, a paddle with decorated blade (perhaps with a small ancestor figure to decorate its long shaft), a vessel to mix red paint in, or a large ancestor pole. If there is a *wow ipits* in the family, that is, in the family group which belongs to a hearth in the *yeu* house, he is likely to receive any commissions that arise within the group, but this is not necessarily so. For various reasons another artist might be preferred. Perhaps another carver has a reputation for a special kind of work, say the making of shields, the carving of ancestor poles or figures.

"Culture heroes" like Fumeripits appear to be phenomena of sedentary societies, serving as models for the achievement of status through one's own contributions to society at large. Fumeripits was not a deity; he acted in the world of mankind, and every woodcarver partakes of his energies through re-enactment (in a small way) of his superhuman deeds.

Women are likened to the sago palm, a source of vegetable protein and an Asmat staple, and men to the mangrove, used for shields, canoes, and the main posts of the *yeu*. The *yeu*, or men's house, is constructed parallel to the main waterway and serves a defensive function, since most attacks would come from that direction. These structures are between 120 and 150 feet long, divided into a series of hearths where men of the same family gather and where important objects are stored (figures 47, 48). (Dwelling-houses for individual families are built behind the *yeu*.)

Among the Asmat, status is not inherited; rather, it must be achieved. For men, this traditionally meant headhunting, and (as Gerbrands points out), most Asmat art involved references to creatures regarded as symbols of this activity. Exponential curves, or spirals, are particularly frequent, suggesting stored energy—the tusks of the boar, the curled tail of the cuscus, the arc of

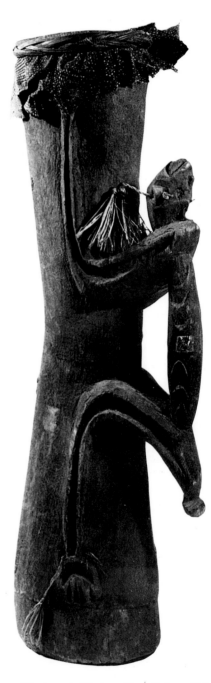

Figure 49. Asmat. Western New Guinea (Irian Jaya). Drum with praying mantis (wood with lizard skin). The Metropolitan Museum of Art, New York, #1978.412.981. The Michael C. Rockefeller Memorial Collection, Gift of Nelson A. Rockefeller and Mrs. Mary C. Rockefeller, 1965. Museum photograph.

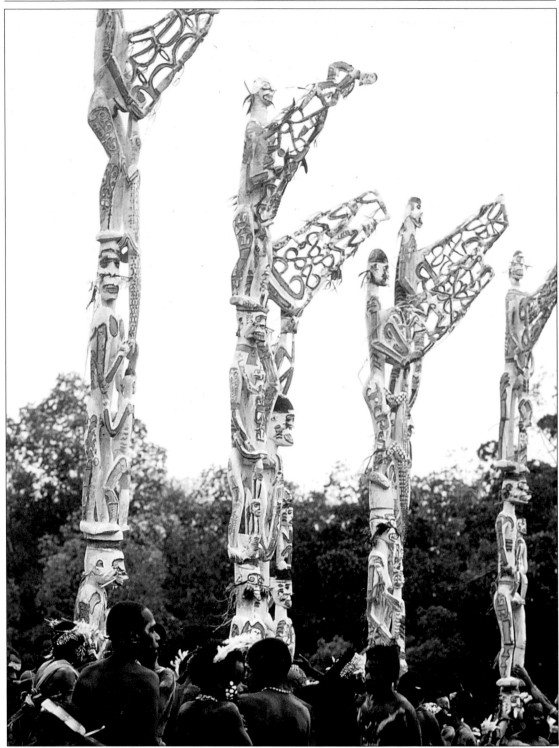

Figure 50. Asmat. Western New Guinea (Irian Jaya). Bis Poles at Buepis on the Fajit River. Photograph, Tobias Schneebaum, 1978.

the crescent moon. A central motif in Asmat belief and art is the praying mantis, a very direct counterpart in nature to the human headhunter: during mating, the female bites off the head of the male, which entomologists believe is essential for successful fertilization (figure 49).

Central to an understanding of Asmat belief and behavior is the idea that all resources are finite, and all these finite resources are entailed—owned by somebody or something. In order for an individual or group to increase its share of these resources, they must be taken away from others. These premises help to explain why the Asmat believe, for all practical purposes, that there is no such thing as death by "natural causes'; death occurs only as a result of a direct assault or through magic or witchcraft. In any Asmat village there is always a congregation of unavenged souls who take retribution on their living relatives (through sickness, bad dreams, "bad luck," etc.) until such time that the survivors even the score by taking a head from their enemies.

Initiation for young men reveals further dimensions of this competition for energy resources as embodied in headhunting. At one stage, each of the youths remains in isolation for three days contemplating a freshly-taken human head placed between his legs. They are then put into canoes—still seated with the heads between their legs—and taken downstream toward the open sea, which is the realm of the ancestral spirits. As the canoes approach the sea, the initiates simulate increasing age and, by the time the canoes enter the open sea, they have reached the point of symbolic death—they, and the heads, are immersed in the water. Reborn into adulthood, the youths are taken back to the village. The head, its power exhausted in bringing about this transition, is no longer of any consequence and may be given away or discarded.

About every ten or twelve years a new *yeu* must be constructed, requiring a number of central posts cut from mangrove trunks. Trees are felled by a "headhunting" expedition and brought into the village with the same ceremony as for a human victim. (The tree cooperates by exuding a red sap, as if bleeding.) The tree is stripped of its bark and carved with superimposed figures. One of the tree's buttress roots is left to represent the generative powers of the topmost figure, which usually stands on a "hocker" figure, with knees drawn up and elbows on knees—the fetal position, also used for burials, and another reference to energy-storage through compression. The hocker motif also closely resembles the form of the praying mantis and occurs frequently in Asmat art.

Each hearth within the *yeu* will have one or more ancestral posts, similar in form to the *bis* (or "pledge") poles (figure 48). *Bis* poles are actually conceived as canoes with enormous prow-ornaments, and represent a vow, in sculptural form, that an individual intends to undertake a headhunting raid on behalf of an ancestor (figure 50). They are carved when a man feels he can command the loyalty and support of the men of the community who will accompany him on the raid. The completed poles are laid out on racks on the water-side of the *yeu* so that they can be seen by passers-by. After a successful expedition, the *bis* pole, having served its purpose, is thrown into the sago grove to recycle the energy which had been concentrated within it. (Figures made for the re-enactment of Fumeripits' creation of humanity are similarly discarded following the completion of the ceremony.) *Bis* poles, like the ancestral posts they resemble and the canoe-prow ornaments on which they are based, are associated with virility; the Asmat name for canoe-prow can be translated as penis.

Asmat shields are also integral to the headhunting complex (figure 45). They are carved out of the buttress roots of the mangrove, and thus relate to the phallic energies of *bis* poles, *yeu* posts, and canoe-prow ornaments. They are not pierced, because of their protective function, but their low-relief designs closely correspond to forms and conceptions seen in other modes of Asmat art. A small, three-dimensional representation of an ancestor is usually carved at the top, with superimposed hocker-figures or headhunting motifs on the body of the shield. The shields also reflect a counterpart to the dumping of *bis* poles in the sago groves: immediately before a

raid, tassels made of fiber from the fronds of the sago palm are tied through piercings along the edges of the shields. This integration of the male and female principles creates a potent aura for the carrier of the shield.

During funerary observances, masqueraders symbolize a last visit by the spirit of the deceased. This complex raises the question of how a supernatural being can be plausibly represented (compare Senufo *kponyugu* mask). Masks are extremely important for non-centralized sedentary communities, where a single individual must often discharge multiple roles with reference to the same group of people. (Centralized societies tend to invest social control in offices, so that transformation of the body through costumes and masks is not stressed.)

Finally, it is worth noting that the two-dimensional graphic system employed by the Asmat broadly resembles the similar system of the Australian Aborigines. But, whereas the Australians use their designs to create a narrative history, a space-time map of their environment, the Asmat system reinforces the ideology of headhunting as the central act in and symbol of maintaining the energy resources of the community. This ideology raises fundamental questions about life and how it ought to be lived which go beyond the appearance or function of art, objectively considered. What has been presented here is not intended as an apologia for headhunting. Rather, it is intended as an examination of the premises which underlie a rich, distinctive, and highly integrated culture and the arts it produces. The relationship between art and headhunting must be viewed as a rational structure which challenges late twentieth-century Euro-American conceptions of life as a good in itself—increasingly called into question, for example by "acceptable" levels of mortality associated with nuclear war, for example, or pressures for capital punishment, "death with dignity," and abortion on demand. Asmat society offered no latitude for debate in these areas. Given the fine-tuned, inexorable, and multiple reinforced nature of their system, questions about headhunting as a way of life simply do not originate from within, as they do in our society. Everything is clear-cut. Everyone knows what is expected of him.

Non-Centralized Sedentary Cultivators

Pueblos

Hunting and food gathering represent the earliest forms of subsistence activity in the North American Southwest, continuing (in much of the Great Basin) until recent times (see map, page 84). Around A.D. 1, however, there was, in many places, a shift to agriculture based on irrigation and a sedentary way' of life.

The open, free-flowing designs of Australian art, full of narrative content, has little to do with either the characteristics of the media in which they were executed, or with the surface to which they were applied, whether rock-engraving or bark painting, *churinga* or human body. The origins and parameters of art-production were quite different in the Southwest, where basketry produced by women (and perhaps textiles woven by men) may have established much of the formal and conceptual vocabulary of Southwestern art (figure 51). Even those men's arts which are narrative and descriptive of events and phenomena in nature and culture, were often based upon the highly stylized forms and carefully balanced relationships which characterize basketry and textiles.

The relationships of motifs in basketry are substantially determined by the nature of the medium, requiring right-angle intersections of elements and a multiplicity of discrete gestures. Curvilinear motifs are difficult, if not impossible, to achieve. Yet, at about the time the shift to a sedentary way of life was taking place, these geometric motifs came to be increasingly executed in media which did not impose these requirements—such as *painting* on basketry or pottery (figure 56) or rock-engraving, where *curvilinear* motifs are more easily executed. Thus, the carryover of geometric design elements into these new media can be seen as a matter of conscious choice. While geometric decoration may appear to be "purely ornamental," there is an abundance of evidence that the designs were charged with cultural content and philosophical meaning, such as the primacy of centering, dynamic balancing of complicated elements within the design field, and striving to harmonize all things in nature. Particularly interesting is the extension of this formal

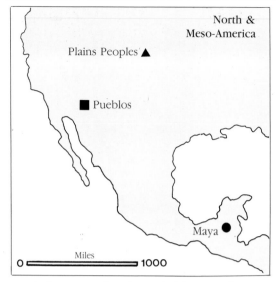

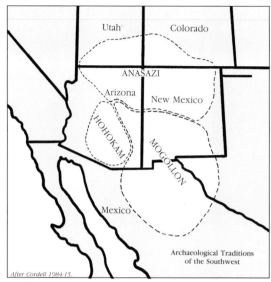

vocabulary to what is probably actualization through representation of spirit-principles— probably the spirit-helpers of shamans—in rock engravings, various categories of painting, and masquerades. The use of such geometric equivalences can thus be seen as one way of solving the general problem of how spiritual entities can be depicted or evoked through art.

Many of these extensions of textile motifs and techniques to works in other media can be traced to the shift from an itinerant to a sedentary way of life. When vessels did not have to be carried regularly over long distances, the disadvantages of fragility and weight were minor and there was a shift from baskets to pottery. Ceramic containers have several advantages; they can be made more quickly, minimize leakage of liquids and protect stored food against insects, rodents and moisture damage. Thus, the shift from basketry to ceramics as primary container mode is one aspect of the shift from itinerant hunting and gathering to sedentary cultivation (emphasizing maize), as also seen in the emergence of permanent, essentially collectivized "public works"—architecture, irrigation works, roads—and generally expanded material culture. By virtue of the requirement of increased cooperation in subsistence-related activities, the hunting-gathering band, whose ties were primarily based on kinship, was replaced by the village as the predominant social unit.

This evolutionary sequence can be seen with special clarity in the Four Corners area of the Southwest, where Arizona, New Mexico, Colorado, and Utah come together. In broad terms, the foundation stratum ("Old Desert Culture") was characterized by a hunting/gathering base, exploitation of brush-wood shelters (or caves) as habitations, and highly developed basketry.

Three major cultural groups are recognized in the prehistoric Southwest (see map above). The Anasazi (Navajo for "Old Ones") were centered in the Four Corners region and will be the major focus of our attention. Around 1,300 the Anasazi abandoned their northern homeland and settled in the areas presently occupied by their Pueblo descendants in Arizona and New Mexico (figure 53).

The Mogollon occupied the area to the south of the Anasazi and are best known for the distinctive Mimbres black-on-white pottery, produced from about A.D. 1,000 to 1,150 by the residents of the Mimbres Valley (figure 54). The Mogollon groups disappeared as a cultural entity by about 1,300-1,450 and their descendants have not been identified.

The third group, the Hohokam, farmed the desert lands of south-central Arizona through a highly developed canal system for irrigation. Ceramic arts produced at about the same time as Mimbres pottery include a distinctive red-on-buff ware (figure 55) as well as other idiosyncratic

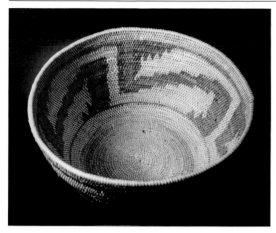

Figure 51 Southwestern United States. Pueblo II Basket. Courtesy Southwest Museum, Los Angeles. Museum photograph.

Figure 52. Mesa Verde. Colorado. Interior of Kiva with Sipapu at Cliff Palace. Photograph, Zena Pearlstone, 1974.

Figure 53. New Mexico. Zuni Pueblo. Courtesy Southwest Museum, Los Angeles, #33960.

Figure 54. Mogollon. Southwestern United States. Mimbres Bowl. Courtesy Southwest Museum, Los Angeles, #34414.

Figure 55. Hohokam. Southwestern United States. Jar with "Dancing" Figures. From Tanner (1976:135). Courtesy Arizona State Museum.

forms. Their descendants are believed to be the modern Pima and Papago peoples.

The initial Anasazi phase, which evolved from the "Old Desert Culture," is the so-called Basketmaker period that began some time before 100 B.C. and lasted until A.D. 700.* Villages consisted of clusters of pit-houses; marine shells from the Pacific attest to the beginnings of long-distance trade. Late in this period, pottery became widespread and the sipapu, a feature of later ceremonial architecture, made its appearance (figure 52, see page 90).

The later Anasazi phases, called "Pueblo" ("town" in Spanish) saw the emergence of large villages with a wide range of utilitarian and ceremonial structures, and ceramics in a dazzling range of sub-styles. An "Early" Pueblo period (encompassing Pueblo I and II) lasted from about A.D. 700 until 1,100, characterized by a

*The Pecos classification is used here: Basketmaker II 100 B.C.–A.D. 500, Basketmaker III A.D. 500–700, Pueblo I A.D. 700–900, Pueblo II A.D. 900–1,100, Pueblo III A.D. 1,100–1,300, Pueblo IV A.D. 1,300–1,600.

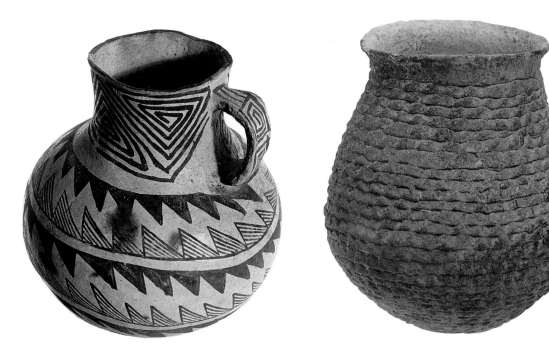

Figure 56. Anasazi. Forestdale, Arizona. Pueblo III Ceramic Vessel. Courtesy UCLA Museum of Cultural History #X72-1098. Photograph, Richard Todd.

Figure 57. Anasazi. Allentown, Arizona. Corrugated pot. Courtesy UCLA Museum of Cultural History #X72-1073. Photograph, Richard Todd.

typological separation of buildings into rectangular dwellings above-ground and circular structures, which may be ceremonial chambers, known by the Hopi term, kiva, below-ground.* Basketry diminishes in importance, offset by a dramatic expansion and elaboration of ceramic technology and loomed textiles.

As noted, early forms of basketry emphasized geometric designs rather than imitation of "lifeforms" (figure 51). As pottery came into general use, the design system was separated from the technology of its production and became a matter of conscious preference. The forms of basketry persisted into contexts and media where its use required astonishing virtuosity in

*It is now known that pit-houses persisted through the Pueblo III period (A.D. 1,100–1,300). Not every subterranean structure can therefore be called a kiva or assumed to have been used for ceremonial purposes. Subterranean structures, including kivas, may make reference to symbolic caves.

planning and execution. Pueblo II corrugated pottery was made by coiling and pinching a single narrow fillet of clay in a spiral, like coiled basketry except that successive layers overlap (figure 57). This heavily textured surface may have been more efficient for cooling and cooking, but it was relatively short-lived among the Anasazi. It may instead have been a vehicle to display the potter's mastery of a demanding technique. By the late 600s, Anasazi potters were applying a white slip to their vessels, a procedure which permitted greater smoothing and polishing as well as a brighter background for the black-painted design (figure 56).

Localized ceramic sub-styles were dramatically expanded and elaborated during the Pueblo III Period (A.D. 1,100-1,300). In the Anasazi area, refined shapes covered with a bone-white slip were decorated with carefully adjusted geometric patterns. Figurative vessels are also known,

Figure 58. Hohokam. Arizona. Stone Palette (horned toad with basin in back). From Willey (1966:Pl.4-49d). Courtesy Arizona State Museum.

Figure 59. Anasazi. New Mexico. Pueblo Bonito, Chaco Canyon. Courtesy Southwest Museum, Los Angeles, #34774.

reducing life-forms to their geometric equivalents. While this tradition of geometric patterns typical of basketry predominated in Anasazi pottery until 1,300, a second tradition emphasizing "life-forms" and (apparently) symbolic content was concentrated in the Hohokam and Mogollon areas. As techniques of forming and decorating were dispersed and refined, both geometric and representational design-systems and the shapes to which they were applied went from hesitant and tentative to reflect an attitude of consummate control.

Hohokam ceramics utilized a much narrower range of motifs than those of the Anasazi and Mimbres. Notable among these are processional (possibly dance) scenes (figure 55), stylized birds, and a figure who may represent a flute-player. The flute-player usually has a hump back, is sometimes ithyphallic and is associated with fertility; the hump is sometimes said to carry seeds. The humped back and the flute may refer to ancient beliefs associated with shamanism.

Also typical of the Hohokam area are large-scale architectural projects, such as the ballcourt

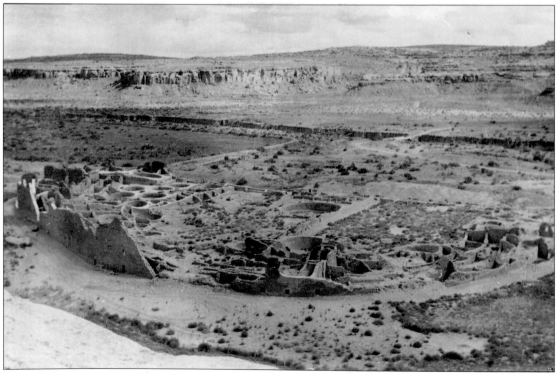

at Snaketown (ca. A.D.1–1,100) which archaeologists have compared to similar but better known Meso-American configurations. Flat carved stone plaques, reducing organic forms to their geometric equivalents, may have been used for the preparation of body paints (figure 58). Seashells, imported from the California coast, were etched (using vegetable acids) with geometric motifs and stained with color.

In the Mogollon area, motifs descriptive of forms in nature predominate (figure 54). The majority of such Mimbres vessels—shallow bowls, for the most part—appear to have functioned as "grave-goods." They were apparently "killed" before being placed with the deceased by being punctured (carefully, in most cases, so as not to interfere with the design), then inverted over the head of the corpse. This practice may have been intended to "send" the (essence of the) vessel to the other world for use by the soul of the deceased, or to consecrate it by rendering it unusable for any mundane purpose, or the vessel may have represented an analogue for the skull, with the perforation opening up to the vertical coordinate (the fontanel?) to liberate the soul, allowing it to return to the world of the spirits.

The highly abstract, austere, and difficult character of much of the art of the Southwest has tended to pale next to the more conventionally expressive and appealing forms of, for example, the Northwest Coast. Nevertheless, the art of the Southwest reflects an extraordinary coherence of design and aesthetic rigor which repays the effort required to understand its' rules and objectives.

Architecture was more highly developed among the Anasazi than it was among the Mogollon or Hohokam. Chaco Canyon (1,000–1,150) and Mesa Verde (1,200–1,300) house Anasazi architectural projects of unprecedented scale and coherence (figures 59, 60). The buildings of Chaco Canyon impose a geometric scheme upon the physical shape of the community. Chacoan pueblos may take the form of a "D," "L," "E" or rectangle. Pueblo Bonito, constructed

Figure 60. Anasazi. Colorado. Cliff Palace, Mesa Verde. Photograph, Zena Pearlstone, 1974.

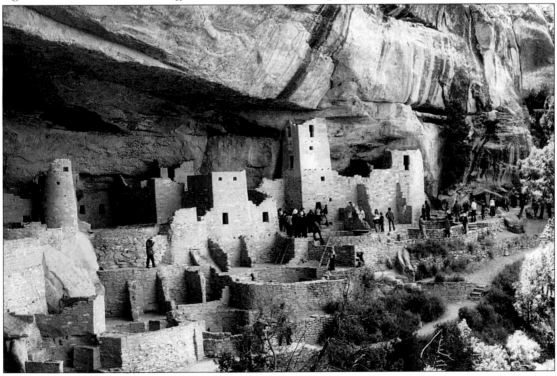

between A.D. 900 and 1,100, was a single D-shaped structure, four or five stories high in places, with as many as 650 rooms (figure 59). Apartment suites were located along its curved perimeter, and within its walls were at least thirty-two circular kivas, referred to as such because of their analogy to modern Pueblo structures that house ceremonial societies.* At least two "Great Kivas" (52 and 44 feet in diameter) were excavated into the plaza floor.

The smaller kivas were usually entered from above via ladders through a central opening (figure 61). A vertical ventilator shaft ran down from the terrace above to an opening in the kiva wall. A fire-pit was located in the floor near the center of the chamber with a deflector stone (controlling the flow of air to the fire) placed between it and the ventilator. Also in the floor of most kivas was the "speaking hole" or sipapu; among the Hopi, from whom the term is borrowed, the sipapu represents a symbolic point of access to the underworld, evoking the aperture through which the ancestors emerged from the world of the spirits to the mundane world (figure 52).** All Pueblo peoples refer to their villages as "the centerplace." The Zuni of the present call their Pueblo *Itiwana*, "the center; place where the directions converge," referring not just to north-south and east-west but the vertical coordinates as well (figure 53).

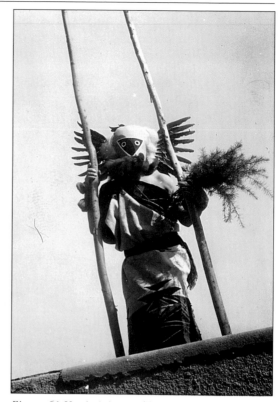

Figure 61 Hopi. Arizona. Tumas or Angwusnasomtaqa (Crow mother) Kachina emerging from Kiva. (Her case mask has crow wings.) Courtesy Southwest Museum, Los Angeles, #33963.

*In 1933, Ann Axtell Morris (39) noted that for two days the most prominent archaeologists of the Southwest at that time argued on "When is a kiva not a kiva?" "They not only failed to agree on that negative proposition," she tells us, "but, what was an infinitely greater loss, they never decided positively what a kiva is. And this, be it to their shame and discomfiture, when every man, woman, and child of them can instantly recognize a kiva as far away as it can be seen." The situation has become more complex with increasing information and the debate still goes on. While most kivas are subterranean, circular, ceremonial and limited to use by men, they can be found above ground, rectangular, oversize and sometimes allowing women. For the purposes of this book it is sufficient to be aware that these variations exist. For a discussion of the present status of the issue, see Lekson (1988).

**According to Smith (1972:120) a sipapu is a small hole found in the central plaza of every Hopi village as well as in most kivas. Like the kiva sipapu, the village sipapu "provides a ritual connection with the netherworld" and "the kachinas also come and return through it. It is thus the most sacrosanct of all places in the village." A counterpart in the eastern Pueblos is mentioned by Ortiz (1969:21).

Troughs or depressions in the floor of some kivas may have been covered with planks, on which the men danced, producing a rumbling noise which (amplified by the shape of the kiva) may have been intended to simulate thunder. By virtue of their agricultural way of life, the Pueblo peoples may be presumed to have been deeply concerned with rainfall and with such "manipulation" as was possible to increase it. Again arguing from "ethnographic analogy': in Pueblos of the present day, the Kachina dancers impersonating spirits associated with rain and fertility emerge from kivas to dance in the plaza during the winter ceremonial season, which encompasses the low point in the availability of environmental energy (figure 62). Some kivas have pairs of holes in the floor, apparently for loom anchors, indicating that men engaged in (possibly sacramental) weaving in the kiva. Men were

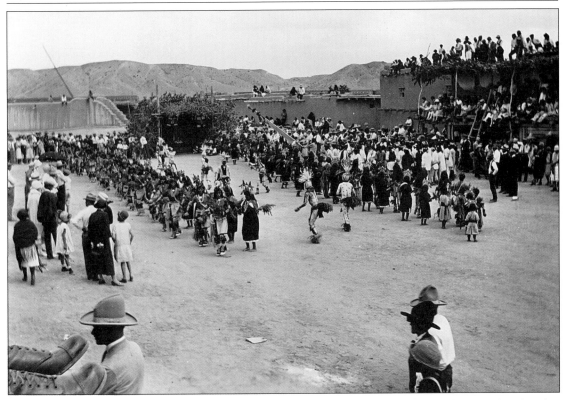

Figure 62. Santo Domingo Pueblo, New Mexico. Corn Dance. Courtesy Southwest Museum, Los Angeles, #34954.

traditionally the weavers among all Pueblo peoples except Zuni.

At Mesa Verde, up to three and four living levels could be inserted into rock shelters, presumably for the protection of the structures but also perhaps reflecting the persistence of earlier uses of such natural habitation sites. The cliff dwellings of Mesa Verde, unlike the structures of Chaco Canyon, must conform to space available within the rock shelter. Many kivas may be seen within the constricted space of the plazas, but there are few great kivas in Mesa Verde. The largest and most impressive of the Mesa Verde habitation sites is Cliff Palace with twenty-three kivas and about 220 rooms (figure 60).

By about 1,300, for reasons not yet completely understood, the great Pueblo communities were in trouble. The Anasazi moved southward to settle eventually in the Hopi mesas and the valleys of the Rio Grande and its tributaries in New Mexico, where their

Pueblo descendants live.

The forms of Anasazi art and architecture changed after 1,300 (Pueblo IV A.D. 1,300–1,600). The houses, especially in the Rio Grande area, were often built of adobe (sun dried mud). The room blocks were usually constructed in a rectangular form around one or more central plazas, some with well over 1,000 rooms. Kiva shapes and sizes varied, with rectangular forms gaining popularity. The representation of "life-forms" increased in ceramic and rock art and were a part of the fluorescence of mural-painting on kiva interior walls. At Awotovi archaeologists found walls that had been replastered as many as one hundred times, with as many as eighteen of the superimposed layers exhibiting traces of painted decoration. The designs, executed in earth-colors, use flat painted geometric units to portray narrative scenes depicting masked beings and ceremonial activities (figure 63).

A major objective of our discussion of Pueblo

Figure 63. Awatovi. Antelope Mesa, Arizona. Mural, Test 14, Room 2, Right Wall #6. Courtesy Peabody Museum, Harvard University, 1942, # 39-97-10/23046d. Museum photograph.

culture is to attempt to bridge the gap between archaeological and more recent phenomena (known through ethnography). Problems arise insofar as European missions and political entities had an early and considerable impact upon the peoples of the region. A fundamental premise of this book is that cultural forms (including art) and their associated beliefs and practices generally exhibit remarkable resilience and, though transformed, rarely disappear. Thus, carefully used, the arts of more recent times can elucidate archaeological materials. Among the Pueblos we fortunately retain, in addition, some of the intervening materials. The presence of kivas in prehistoric as well as modern villages and the naturalistic representations of ceremonial activities depicted in fifteenth- to seventeenth-century kiva murals provide the best evidence we have of continuity in religious practices between the Anasazi and their Pueblo descendants. Ceremonial attire and accessories worn or car-

ried by masked beings and human figures in the murals are much like those still in use today.

Local variations among modern Pueblo peoples are clear and echo the considerable and regional differences seen in art throughout the Anasazi period. (At least seven languages belonging to four major linguistic groups are spoken today by Pueblo peoples. Western Pueblo villages are organized according to a matrilineal clan system, while the Eastern Pueblo villages are organized into two moieties.) Nevertheless, certain broad generalizations in the area of culture seem valid, and (for present purposes) it is convenient to focus on elements of the symbolic system which seem to pervade Pueblo culture, ancient and modern—such as, for example, the primacy of the village as "the center of the world" and the concern for rain and fertility.

Today, in many Pueblo villages, kachina impersonators may emerge from kivas to dance in the plaza during the winter ceremonial season.

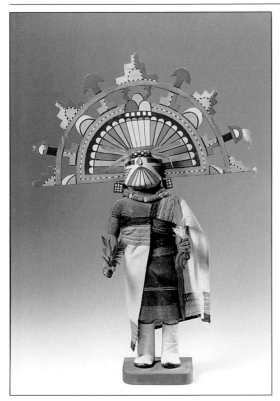

Figure 64. Hopi. Arizona. Polik (or Pahlik) Mana (Butterfly Maiden).(The Kachina figure wears an elaborate tableta with fertility symbols.) Courtesy UCLA Museum of Cultural History #X82-922. Photograph, Richard Todd.

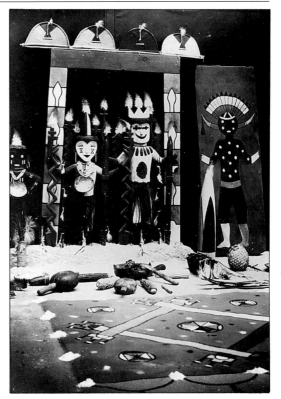

Figure 65. Hopi. Arizona. Prayer Altar with Dry-painting in foreground. Courtesy Southwest Museum, Los Angeles, #33961.

People sit on their terraces (which are their neighbor's roofs) to watch these ceremonies in the plaza at ground level below (figure 62). The masked dancers are believed to assume the identity of the spirit they represent when they don the mask. Because of their close association with the powerful kachina spirits, they are considered sacred and must be ritually fed and reverently treated. Although the same mask design and costume may be shared among several villagers, they tend to be interpreted differently, and ceremonial practices vary widely. In most villages, women do not wear masks although they may participate in kachina dances. Masked female spirits are impersonated by men.

The masks are usually rawhide cylinder helmets decorated with clearly demarcated areas of flat color (figure 61). Facial features are normally simply abstractions—circles or triangles for eyes and mouth. Wood or gourd attachments are used to indicate ears, horns or animal snouts. Women taking part in the dances may wear an elaborate wooden headdress called a tableta which often takes the form of a stepped triangle, or "cloud terrace," and may incorporate painted representations of the kachina's gifts: rain, clouds, lightning, insects and maize (see figure 64). The tableta may also be incorporated into Hopi masks representing females.

Small carved wooden images of particular kachinas and other spiritual entities are given by dancers to girls, and to women desiring children (figure 64). Children become familiar with the appearance of specific kachinas in this way. These images generally are not treated as "dolls" but are hung on the walls of the home.

The kachinas are part of a complex of associations and cults which cut across family lines and

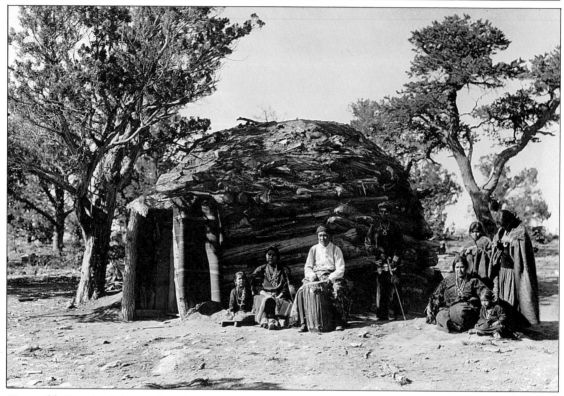

Figure 66. Navajo. Arizona. Family and Hogan. Courtesy Southwest Museum, Los Angeles, #33959.

organize the religious, political, social and economic life of the community. The responsibilities of these associations include rainmaking, hunting, medicine and curing and, in the past, warfare, among others. Where people live in such close and constant proximity, these associations provide a structure for orderly interaction and defuse the potential for disharmony and strife. An interesting aspect of the function of the kachinas is revealed in their relationship to children. Pueblo parents are indulgent, but the children are regularly threatened with discipline by the kachinas, and the tears of the children when switched by the kachinas are viewed as auspicious signs of bountiful rainfall.

Shrines, much like those depicted in precontact kiva murals, remain the foci of ceremonies. Such altars include plumed prayer sticks, painted wooden slats and a wide range of other elements, including ephemeral drypaintings (figure 65). ("Sandpainting" is a misnomer, since maize-meal in several colors, pollen, and other

Figure 67. Navajo. Arizona. Woman Wearing Blanket. Courtesy Southwest Museum, Los Angeles, #33958.

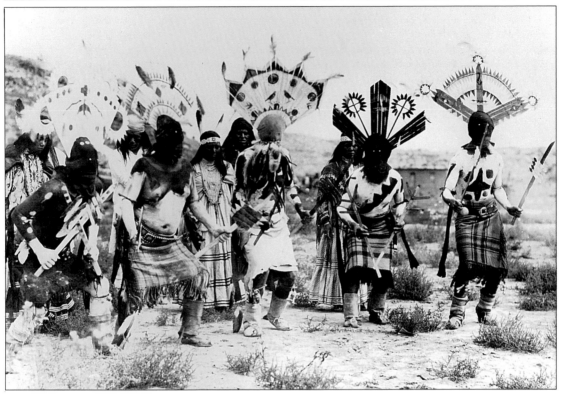

Figure 68. San Carlos Apache. Arizona. Gan Dancers. Courtesy Southwest Museum, Los Angeles, #33956.

pigments are used as well as colored sand.)

This drypainting tradition, along with Pueblo mythology and masked impersonators of the *yei*, "Holy People," were adopted and developed in a distinctive direction by the Navajo, one of the Athapascan-speaking peoples who moved into the Pueblo area sometime between 1,300 and 1,500.

The production of ephemeral compositions through dropping colored sands and other powdery materials over smoothed earth resembles Australian ground-drawings; chants and songs also accompany each stage in the creation of a sequence of designs. Most Navajo drypaintings are created in connection with curing procedures; when the sequence (or cycle) is completed, which may take up to nine days, the patient sits on the composition, soaking up the energy which has been organized and concentrated, and thereby "destroys" the work (figure 3).

In short, rather than for the collective rituals of socio-religious associations oriented toward influencing climatic or ecological phenomena as among the Pueblos, Navajo use drypaintings to meet individual needs. A person who feels ill will seek out and negotiate with a specialist, a member of his/her group who knows the appropriate chants and designs. Although the main vehicle of the cure is borrowed from people no longer organized as hunters and gatherers, its use among the Navajo represents an adaptation of agriculturalists' ritual to shamanic beliefs and practices.

[*Editor's note: Rubin was impressed with the book* The Healing Arts, *to which he was introduced at the onset of his illness, and particularly with the chapter on ritual which compares Navajo curing with procedures in contemporary Western hospitals. He asked that this chapter be included in the book and it is reproduced in the Appendix.*]

Navajo drypainting represents the last—and in many ways, most challenging—translation to other media of forms which evolved in basketry

and textiles. It was difficult enough to produce these complex geometric forms with brush on ceramic; how much more so by trailing different colored powders between thumb and forefinger!

The Athapascan experience is extremely useful for studying cultural confluence, because these peoples have interacted with many different cultures and appear to have been selective in terms of what elements they adopted and adapted. In the Far North, Athapascan art is clearly based on that of their Inuit neighbors, but also shows significant points of divergence. This pattern is paralleled where Athapascan groups interacted with Northwest Coast peoples and with those of the Great Lakes area. The Athapascans of the Southwest (Navajo and Apache) show a similar selectivity. As hunters and food gatherers, they rejected the village- centered life and the angular Pueblo houses. The Navajo still retain their traditional circular hogan both as a dwelling and as the setting for healing ceremonies (figure 66). Weaving on the other hand was adopted, particularly after the shift to herding, which followed the introduction of European sheep. Weaving, like drypainting, is popularly associated with the Navajo but both arts were borrowed from the Pueblos. Among the Navajo these weavings are done by women rather than men (figure 67).

Both Navajo and Apache also seem to have adapted the Pueblo masquerading complex, creating rather rudimentary masks which often had tableta-like attachments. The Apache remained a predatory/hunting culture until late in the nineteenth century, with only limited involvement in herding. Their masqueraders are called *gan*, described by early observers as "devil-dancers" (figure 68). In fact, *gan* dancers exercise curative rites at annual ceremonies which enable assembly of community spiritual power in order to fend off disasters and epidemics. They also commemorate the coming-of-age of young women who had begun menstruating the previous year; this puberty rite, therefore, celebrates the ultimate creative power. Like Navajo drypaintings, the Apache *gan* dance is bound up with events in the lives of individual rather than collective concerns, and thus also seems to reflect forms of shamanic belief.

Senufo

The Senufo live in the savanna region of West Africa—open, rolling grasslands—on both sides of the Ivory Coast-Mali border (see map, page 97). The power-struggles which characterized relations between the great states which flourished in the bend of the Niger River seem to have had a major impact on the lives of the Senufo and other village-based farming peoples of the region. The need to escape from war zones and the search for richer farmlands encouraged migrations southward, displacing others in a southerly direction toward the coastal forest, where non-centralized societies could better defend themselves against the organized military campaigns of slave- raiders and other exploiters. As a result of these stresses and the intermingling of populations which resulted, many different groups were brought into contact with one another, producing a multiplicity of forms and styles in art. Nonetheless, Senufo sculpture exhibits a stylistic coherence which makes it (usually) immediately distinguishable. Among more northerly groups, a tendency toward geometric precision is apparent; to the south, emphasis is on soft, rounded forms—in both cases conforming to prevailing regional characteristics.

We have seen that the arts of the Australians, the Asmat, and the peoples of the Southwest were essentially two-dimensional graphic systems applied to two- (or three-) dimensional shapes. Senufo art, in contrast, emphasizes the three-dimensionality typical of West Africa, worked out in the orchestration of very complex curvilinear forms.

A consistent feature of art in non-centralized sedentary societies generally is its use in fostering cooperation between individuals and groups not related by family ties. Among the Asmat, such collaboration was associated with the construction and maintenance of the *yeu*, with initiation, with headhunting raids, and with mourning masquerades. Among the Pueblos of the Southwest, a series of socio-religious associations (including the kachinas) provide the framework for interaction and continuity.

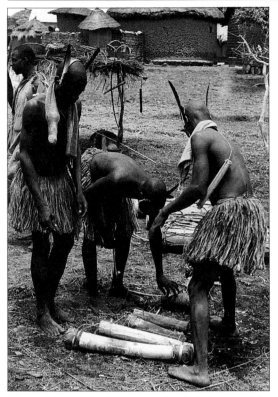

Figure 69. Senufo. Ivory Coast/Mali. Initiates of the Junior Grade (in ritual dress during graduation ceremonies, with mock drums, quivers, and sacks in imitation of the Senior Grade). Photograph, Anita J. Glaze, 1970.

Among the Senufo, two separate but interdependent "secret societies"—Poro, primarily the men's arena, and Sandogo, primarily the domain of women—organize the community. In reality, the Poro association is not secret, because everyone who meets the requirements of age, sex, citizenship and "good sense" will invariably belong to the appropriate branch at some level. At least one appointed female from each matrilineal family unit belongs to the sacred women's society of *Sando* diviners and guardians of lineage purity. Practically nothing was known of Sandogo until the work of Glaze (1975) because most investigators of Senufo art and culture have been male.

Poro involves three grades, with six and one-half years spent in each grade. The first stage, for boys in early adolescence, is oriented toward socialization and imparting fundamentals of communal responsibility. The second stage, entered in the late teens or early twenties, introduces young men to the social/political structure of the community and its historical/mythological traditions (figure 69). This grade also serves the community as militia. The third stage, at late twenties or early thirties—"young elderhood"—imparts the true meaning of initiatory formulae and other traditions of the group. Members of this grade become the custodians of culture and begin to participate in the process of making decisions about questions facing the community. In some areas there is also a formal fourth level of Poro, "true elderhood." Each level has its own distinct complex of sculptures.

Initiation and other Poro ceremonies take place in a reserved area of virgin bush which is maintained as an earth-shrine or sacred grove, symbolic of a past in which mankind had not yet intruded upon the natural landscape. There may be three or four or more of these groves, called *sinzinga*, in each community, sometimes with membership sorted out on a "caste" basis. Blacksmiths, in particular, were set apart and prohibited from marrying into farming families, the custodians of the land. Other Poro chapters may be limited to farmers, or the Mande-speaking immigrant traders from the North who have settled among the Senufo.

Removal of the young men to the *sinzinga*, often for several months, puts them in touch with the energizing forces of their tradition while forging bonds between "age-mates," the members of a "class" who go through initiation together. Formal transitions in status—"graduation"—are declared to the wider community through distinctive forms of dress and adornment, and by masquerades and other

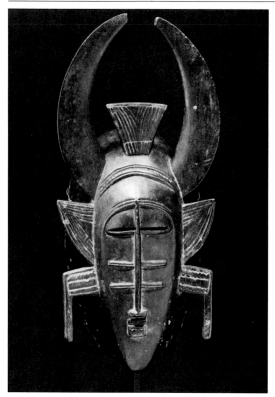

Figure 70. Senufo. Ivory Coast. Kpelie mask. Tishman Collection. From Vogel (1981:41).

Figure 71. Senufo. Ivory Coast/Mali. Kagba mask. Drawing, Carolyn Dean.

uses of the sculptural attributes of each grade. Poro initiations require the participation of women, just as certain essential functions of Sandogo, such as blood sacrifice, require the participation of men. At the highest levels of both, there is a kind of interlocking director-ate which makes decisions affecting the entire community.

Divination represents a major context for which figurative sculptures are commissioned; as we have seen, it is unusual for women to be involved with representational art. Sculpture used by men tends to be large-scale, dramatic in form, and manifestly public. That used by women is usually smaller, more private, and less emotionally intense, comprising small figures (and male-female pairs of figures) used as spirit-patrons of divination and images of mothers-with-children brought out for the funerals of important women.

Outside of explicitly ceremonial contexts, carved wooden doors for shrines and the houses of important people display several of the creatures important in Senufo mythology and power magic, with crocodile, snake, tor-toise, lizard, and hornbill being particularly frequent. Motifs relating to worldly power are also included, such as capture scenes and weapons, along with references to ceremonial life in the form of certain types of masks, espe-cially *kpelie* (figure 70; see pages 101–102). The *kponyugu* mask (the name of this mask varies from group to group), used in the control of witches, also combines motifs drawn from many sources in the natural environment (figure 7; see page 28). Protective bronze amulets worn by initiates include representations of leopard, buffalo, and hornbill. The protective power of the hornbill and its allusion to social secur-ity and prosperity is also evoked by weavers, in the form of carved wooden heddle-pulley frames. In addition giant representations of the hornbill are danced for Poro ceremonies. A dorsal view of the crocodile is also shown on the flat, openwork boards (*kwonro*) worn as vertical headdresses by young men leaving the first level of Poro (figure 72). Notwithstand-ing the frequency and variety of these animal

motifs, human figures are probably the largest category of Senufo sculptural expression.

The following selections from Glaze (1975), "Women Power and Art in a Senufo Village," explore the role of Senufo women. The iconological and metaphysical roles of female imagery in Senufo art are further explored and illustrated by Glaze (1986) in "Dialectics of Gender in Senufo Masquerades." This further research has confirmed and strengthened our appreciation of the Senufo concept of female spiritual power.

A telescopic vision that . . . focuses on the visual excitement of masquerades in a Senufo funeral ritual is apt to miss the elder women standing unobtrusively at the periphery of the ritual arena; yet it is the very presence of these Sandogo [women's divination society] leaders that both validates and adds power to the ritual itself. Poro [men's society] and Sandogo work together to meet problems and ensure the continuity of the group; however, in the Senufo system, women are ultimately more responsible than men for seeking the goodwill and blessings of the supernatural world—the Deity, the Ancestors, and the bush spirits. . . . [While males hold authority in the sociopolitical (i.e. temporal) sphere, all powers and positions among the Senufo, rest ultimately on supernatural authority (the area of women's involvement). A basic tenet of Senufo ideology is a balance of male and female components.]

. . . In its role as the principal center of male religious and social instruction and as the basic framework for the male political leadership . . . Poro can . . . be termed a men's society. . . . [However,] Poro is also a "society of the sacred grove," an epithet that at least has the advantage of not entirely excluding the integrated activities of girls and women and that draws attention to the *sinzinga* [that is, the actual sacred forest precinct of each Poro organization]. . . . So critical is the woman's part in Poro that her presence is absolutely necessary in the founding of a new *sinzinga* organization. The initial ritual act that creates and dedicates the *sinzinga* is performed by a man and a woman acting together. [It is the woman] who is considered the chief head of Poro [at this ritual, and who, having lost this power in the mythical past, passes it to [that is, legitimizes the authority of] her brothers or nephews [who then act as chief].

Poro is above all an organization designed to maintain the right relationships with the Deity and the Ancestors. The most important ancestor is the woman who was head of the founding matrilineage of each *sinzinga*, the greater ideological weight of Ancestress over Ancestor being neatly expressed in the larger proportions of the female in the vast majority of male and female couples, the primary category of figure sculpture used by Poro and Sandogo [societies].

. . . [The Ancestress,] Ancient Mother . . . is considered to have her . . . home and seat of authority in the *sinzinga*, the very nexus of divine and temporal authority . . . in the Senufo village. . . . Ancient Woman (or Mother) works at the level of village life primarily through the institution of the sacred grove and attendant Poro members. The secret names of certain of the Poro's most sacred equipment (such as the most important drum and mask types) refer directly or indirectly to Ancient Woman. Although justice and punishment are concerns of both facets of the deity, it is primarily Ancient Woman who deals with crimes that threaten the well-being of the community. . . . More importantly, the members of Poro are entrusted under the authority and validation of Ancient Woman to maintain community order by means of a complex system of education, designed to help shape the intellect, moral character, and skills of each succeeding generation and age set . . . young girls are intimately involved at every major stage of [Poro] training . . . and women past menopause undergo a special initiation into full Poro membership.

. . . [Sandogo women's society, complements, and is integrated with, the functions of the Poro society among the Senufo.] Sandogo, the association of *Sandobele* [plural for *Sando*; that is, a diviner of a certain category] is a dual level institution which includes a branch of divination specialists but whose primary concern is with family relationships. The Sandogo members' greatest responsibility is safeguarding the purity of the matrilineage; their activities include, for example, administering penalties in cases of adultery. . . . Sandogo . . . membership is composed of representatives from every matrilineal segment . . . most of whom are designated by ancestral diviners who communicate with the living diviners by means of the *Sando* technique. [The] involvement of women [as diviners is crucial among the Senufo.] Neither male nor female leadership would make a single important decision or

ritual act of importance without consulting one *Sando* . . . or even a dozen *Sandobele* . . . whose assistance as intermediaries with the supernatural world is considered indispensable. . . . Under certain circumstances, men can be trained as diviners; however . . . this skill is always considered an inheritance through the maternal line. . . . Unlike the *Tyekpa* society, which parallels the Poro society in its emphasis on prestigious visual display for large audiences in funeral and initiation rituals, the sphere of Sandogo is more an inner, closed arena where the individual grapples with daily problems and his relationship with the unknown. . . . The contrast of a public [that is, Poro] versus a private [that is, Sandogo] world is . . . reflected in the very dimensions of figure sculpture used by Poro . . . (two to three feet high) and that which forms part of the *Sando's* equipment (averaging six to eight inches).

Among the various spirits that communicate through the mediation powers of a *Sando* diviner are twins. . . . The Senufo explain the tremendous significance of twins as follows: "When *Kòlotyölöö* [the creator god] created the first man and woman (they became man and wife). When the woman conceived for the first time, she gave birth to a boy and a girl who were twins. So it was that twins were the first children born to man."

The Senufo believe that twins possess a supernatural power that can be a potential force for good or bad. . . . To be right . . . twinness must have the sexual balance indicated in the text [that is, a boy and a girl, indicating] the criterion of balance as an ideal quality.

[Among the Fodonon people, a Senufo group living in the Kufuru region of the Senufo area, there exists] *Tyekpa*, literally, "women's poro",.[which] appears to be in effect a declaration of ritual independence on the part of Fodonon women. . . . *Tyekpa* presents direct. . . . parallels with the Fodonon men's [Poro organization called] Pondo. . . .

The following narratives relate the origin of the Fodonon men's Poro (Pondo or Kpa-) and women's Poro (*Tyekpa*). "Poro" as used in the two narratives below refers not only to the secret society organization as a whole but especially to its sacred paraphernalia such as drums, figure sculpture, and masquerades, a usage that is common practice in Senufo conversational idiom.

The Origin of Pondo

"In the beginning, Pondo was with the women. If you hear *màlëëö* or *kàtyelëëö* (the Ancient Woman), this is to remind us that the first Poro belonged to the women and was not with the men.

The men prepared food and pounded yam. When the men finished preparing the meals of pounded yam, the women would come out of the sacred forest of Poro to take the food. But the men were forbidden to see (the secret things of) Poro. If the women came out (dressed in Poro), the men had to hide, leaving the dishes of food outside the house.

Then the Creator God (*Kòlotyölöö*) said, 'No, I cannot leave Poro with the women—they are too wicked and sinful.' So he seized the Poro and gave it to the men. The men were too tired and thin. They had to hide while the women ate."

The Origin of Tyekpa

"The first person to do Poro in (Senufo) country was an elder woman who went to the stream to look for *kobi* (used to make a strong soap). When the woman entered the woods by the stream, she saw some *madenÿudö* (chief of the *madebele*, a hairy-headed bush spirit). The bush spirits were drumming a *Tyekpa* dance. She stopped and looked: 'This thing is too beautiful!' So the bush spirits asked, 'What are you doing here? You must take Poro and go with it; that is what you want—we are tired of it.'

When they let the woman return to the village, the *madebele* told her, 'You must go have carved spirit figures in wood and you must also make Poro as you saw us do.'

When the old woman came to the village, she fell sick. Her family went to see a *Sande*. They consulted with the Sandogo. The diviners found that the kind of thing she had seen among the *madebele*, this same thing she should do. So then the women had made some 'little children of Poro' (i.e. figure carvings) and they had them carved of wood. So they did all that the old woman had seen among the *madebele*. That was the beginning of *Tyekpa*."

. . . The major theme that emerges clearly in the narrative is one of tension between male and female roles, a conflict requiring supernatural intervention. As expressed in the creation theme of the primordial couple and the

twins, issue of the first procreation, the Senufo philosophic ideal is a balance between male and female. This balance is a precarious one, however, and the text relating the origin of Pondo reveals that the real situation can become distorted through human weakness and abuses of power. So it came about that in ancient times Senufo women lost certain privileges and aesthetic pleasures of Poro because of their "wickedness" (*fûbehefölö*: "Owner" of breaking a sacred restriction; ugliness; blindness). The myth teaches that power may be used for good or evil. . . . Persons who break the laws of Ancient Mother and the Ancestors, and those who appropriate supernatural power for anti-social purposes, the witches, are an ever-present threat to the equilibrium of self, family, the village. The dynamic interaction of female and male leadership in both Poro and Sandogo engages the Senufo in what is ultimately the most important level of interaction, that of man and spirit.

Senufo Art

by Elisabeth L. Cameron

The Senufo of the Ivory Coast are comprised of many groups. Each group speaks one of about thirty dialects of the Central and Southern Senufo languages (all of the Gur family). Each group is further defined by occupation, which for many involves the production of art. The five major art-producing groups, who manufacture primarily masks, and wood and metal sculpture, are according to Richter (1979:67-9):

1. *Kulebele* (singular *Guleo*). The men carve wood and the women repair calabashes.
2. *Fonombele* (singular *Fonon*). The men are blacksmiths and wood carvers, the women, basketmakers.
3. *Kpeembele* (singular *Kpeo*). Men work with metal, primarily brass, and the women are potters.
4. *Djelebele* (singular *Tcheo*). Men work with leather and the women are farmers.
5. *Tchedumbele*. The men are primarily gunsmiths and blacksmiths. The women make pottery.

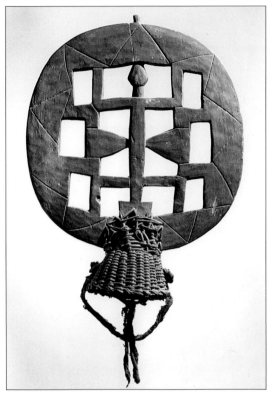

Figure 72. Senufo. Ivory Coast/Mali. Kwonro headdress. The Metropolitan Museum of Art, New York #1978.412.457. The Michael C. Rockefeller Memorial Collection, Gift of Allan Frumkin, 1962. Museum Photograph.

KPELIE *or* KPELI-YEHE *(FACE MASKS)*

These carved wooden masks (figure 70), used at initiations and funerals, may be owned by members of either Poro or Sandogo but are only danced by Poro initiates. They are, in addition, the only ones used for non-Poro entertainment. Face masks always represent females and appear in conjunction with male helmet masks (figure 7). Titles for this mask such as "Koto's girlfriend or lover," and "wife of Yasungo," reflect their female roles. Glaze (1981b:41) notes that "the face mask/helmet mask duo is but one of many formal pairs in Senufo visual and dramatic arts that express the complementary roles of male and female."

The horns represent either buffalo or rams horns; the buffalo motif symbolizing death and rebirth particularly as applied to Poro grade

*Figure 73. Senufo, Tyebara. Ivory Coast.
Figure Group. Tishman Collection.
From Vogel (1981:45).*

advancement. The hornbill, one of five primor-
dial animals (see page 28), is often represented
as the crest between the buffalo horns; in this
example (figure 70) the crest is a probable vari-
ant of the kapok-thorn motif (Glaze 1981b:41
and personal communication 1989).

Richter (1979:73) indicates that Senufo
masks must be identified with caution. She
stresses that "the key to classification . . . is
function, not form" and that the Senufo them-
selves "are often unable to identify masks out
of context."

KPONYUGU *(HELMET MASKS)*

Danced with *kpelie*, these masks (figure 7) are
always associated with men but they exist in a
variety of styles and the name of the mask
changes with the context. Worn with a partic-
ular costume, one manifestation is called *wam-
bele*, and these masqueraders may manipulate
cadavers so that they can be given tobacco. The
literature on these masks has, in the past, desig-
nated all helmet masks as "firespitters" but
manipulating fire is practiced by only a few
kponyugo and then is but one of various per-
formance devices.

NOSOLO

The *nosolo* mask is similar to the helmet
mask but is attached to a tent-like construction
manipulated by two men. Originally, the *nosolo*
may have represented bush cows but today
they represent antelopes. The masquerade,
which circles the village, comes out every six
years, at the end of the third year of the senior
grade, to celebrate the completion of this
rigorous and difficult three-year period. A simi-
lar construction, *kagba* (figure 71), will perform
for those high-status initiates who can afford to
pay for its appearance (Glaze 1989, personal
communication).

KWONRO *(HEADDRESS)*

These flat openwork boards are worn as ver-
tical headdresses over a wicker cap by initiates

completing the sacred rituals of the Junior Grade (figure 72). A dorsal view of the crocodile is portrayed.

MADEBELE *or* POMBIBELE
(RHYTHM POUNDERS)

These "bush spirits" or "children of Poro" (figure 5; see page 23) are used by Poro and Sandogo initiates at funerals. At the death of an important elder the initiates leave the *sinzinga* (sacred grove) to visit the body of the deceased. One initiate swings the sculpture slowly from side to side striking the ground in synchronized beats. The group circles the body three times for the three grades of the Poro cycle.

FIGURES

Despite the Western tendency to refer to these carvings (figure 73) as "mother and child," the sculpture in fact designates the deity *kàtyelëëö* (Ancient Mother) providing an initiate with the "milk of knowledge." After drinking of this liquid, the initiate is returned to the village as a human being. The small figure, which represents the initiate before acquiring knowledge, is seen as non-human, a symbol of the uninitiated. These sculptures are shown during initiation cycles and impart the intellectual process of moving from obvious to esoteric through levels of meaning.

TEFALIPITYA *(TROPHY STAFF,*
"The hoe-work-girl")

Trophy staffs are used to identify and reward the best hoer in the village. The staff, according to Glaze (1981b:48), honors not only the champion cultivator "but by extension, the residential and kinship unit . . . whose pride and prestige he upholds. The champion cultivator as culture hero is a theme celebrated by an entire complex of sculptures, praise poems, musical and dance arrangements, and funeral rituals." The process of selection makes backbreaking work more interesting and spurs the men on to greater production. The champion, once determined, is

Figure 74. Senufo. Ivory Coast. Tefalipitya (detail). Courtesy UCLA Museum of Cultural History, #X87-1416. Photograph, Richard Todd.

identified with the staff which is always carried behind him as he works. The trophy staffs are passed down through generations.

Champion cultivators are generally permitted to make the best marriages. The finial of the stick represents a proud, young woman at her peak, symbolizing beauty and fertility (figure 74). "In death as in life," Glaze (1981b:49) notes, "the staff is a sculptural honor guard . . . placed outside the house of a dead member of the kin group."

Centralized Sedentary Cultivators

Maya

Centralized societies reflect increased specialization at all levels, and increased subordination of individual interests to those of the social order and to those who embody it. In non-centralized societies, most mature individuals will control most of the available technology, with only limited specialization (such as in iron-working or weaving). Even those specializations were usually part-time, complemented by some measure of involvement with primary subsistence activities (such as farming). Non-centralized communities tend to have only a limited sense of belonging to a larger unit (such as a tribe). In contrast, such a sense of collective identity beyond the community is typical of centralized societies, often enforced through more or less direct administration in which the arts may play a major role. Large-scale projects are the rule, and glorification of the worldly rather than the transcendental predominates. Social control tends to involve coercion as well as consensus, and authority structures are remote rather than proximate. Actual or invented genealogy within a hierarchical framework largely determines an individual's life experiences, rather than his/her own efforts; in other words, status tends to be inherited rather than achieved. In art, true representational portraiture often makes its appearance. Record-keeping in some form—census rolls, tax-counts, astronomical observations—is often reflected in literacy among the elite. A sense of "real" history emerges, of real people doing real things—births and deaths, battles and alliances, marriages and construction projects. These characteristics of centralized societies are especially clear among the Maya of southern Mexico and adjacent parts of Guatemala.

Because of their great stone cities, lyrical sculpture, and highly developed painted pottery, the Maya have often been called "The Greeks of the New World." By now, we should be able to recognize this sort of ethnocentric characterization. The number and quality of real or fancied resemblances to the ancient Greeks are taken as the measure of another culture's state of civilization, and implicitly of their worthiness as the subject of study. One premise

North &
Meso-America

Plains Peoples ▲

■ Pueblos

Maya ●

Miles
0 ⬛⬛⬛⬛⬛ 1000

Figure 75. Teotihucan. Mexico. Pyramid of the Moon (from the Pyramid of the Sun). Photograph, Zena Pearlstone, 1985.

of this book is that all cultures are "worthy of study," and that their arts and architecture take specific forms and discharge specific functions within integrated cultural ecosystems.

The earliest centers of Maya cultural elaboration appear at present to have been located in the Guatemalan Highlands. Recent excavations have shown, however, that by the time of Christ the focus had shifted to the Lowlands, in Belize (formerly British Honduras) (see map, left).* The Classic Period, formerly dated from A.D. 300 to 600, is now seen as having been at least half a century earlier. It is divided into roughly equivalent Early and Late periods.

*Excavations at the lowland sites of Tikal and El Mirador in the Peten, as well as at Cuello and Cerros in Belize, have revealed extensive population density, monumental construction (including the largest manmade structures in Meso-America) and architectural sculpture dating to the centuries just prior to the beginning of the Christian era (note: Cecelia Klein).

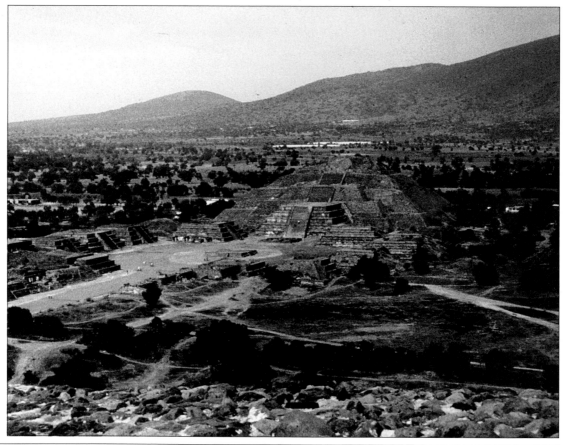

Material from Tikal (located in present-day Guatemala) will here serve as examples of the Early Classic Period, and material from Palenque and Yaxchilan along with the murals of Bonampak (all in the Mexican state of Chiapas) will be taken as representative of Late Classic Maya art. Coeval with, and related to, the emergence of Early Classic Maya centers was the Empire of Teotihuacan of Central Mexico—proposed to have been the world's greatest city of its time, a massive metropolis with trading networks which extended into (and possibly beyond) the Lowland Maya area (figure 75). Jade and other hard stones, exotic feathers, prestige ceramics and other materials of great cultural value (though not fundamentally associated with subsistence concerns) appear to have been staples of this trade.

Teotihuacan is thought by many scholars to have influenced some Maya art and architecture during the Early Classic Period, particularly at Tikal. The ceremonial structures at Teotihuacan were deliberately destroyed by fire, however, around A.D. 750 (probably by the city's own inhabitants) and the population diminished notably. The city ceased to be a power from that time on. In the ninth century, for reasons not fully understood, the Lowland Maya centers were abandoned, one after the other, echoing events at Teotihuacan 100 years earlier and in southwestern North America 300 years later.

Although characterized by tropical forest vegetation, the Lowland environment was actually very precarious as regards water resources; a thin layer of soil over permeable limestone made for rapid percolation, with few year-round streams or wells. This same fine-grained limestone was exploited for building construction and sculpture, and burnt to make lime for modelled stucco ornamentation and for plaster surfaces for murals. Environmental/ecological crises may thus have contributed to the "collapse" of Lowland sites. In any case, by A.D. 900 major "Post-Classic" centers had emerged north of the Lowlands on the Yucatan Peninsula, and there is evidence that Central Mexico again became influential with the arrival of Mexican raiders and traders.

The Maya utilized two systems for recording time. The widespread use of the system known as the Long Count is taken as a hallmark of the Classical Period. The Long Count system uses units of days ranging from one to 144,000, indicated by a system of bars (= five) and dots (= one) up to twenty, measured forward from an arbitrarily determined starting point around 3,000 B.C. According to this system, each day has a unique value, and chronology is absolute rather than relative. For keeping track of time on a day-to-day basis, however, a second system called the "Calendar Round" was used, based upon the meshing of a 260-day ritual "year" and a 360-day solar "year" (with five days of "ill omen" left over). The two systems meshed, through a combination of numbers and symbols, with a specific day-name only repeating itself after fifty-two years had elapsed. The end of one cycle and the beginning of another was regarded as a time of great vulnerability—possibly the end of the world. These periods were often marked by major architectural projects—as if such works were intended to charge up the universe in order to start a new cycle.

One reason for this preoccupation with calendrics (firmly based, incidentally, in very advanced astronomical observations) was its origins in determining optimum times for planting and harvest. In the Maya area, variations in time of planting or harvest by as little as a week have been shown to result in substantial increases or decreases in yield. These rationalized forecasts were apparently in the hands of an hereditary priesthood (whose vocation had its roots in shamanism). This increasingly refined specialization and the economic leverage it exerted was reflected in the consolidation and expansion—and marked centralization—of political power.

Scientists were certain that the symbols (in addition to dates) which covered most Classic Period monuments were a written language, but it took some time to be able to read many of them. Due perhaps to the Grecophilia mentioned earlier, it was long assumed that these inscriptions, and Maya art generally, were about

Figure 76. Maya. Guatemala. The Leiden Plaque. Drawing by Linda Schele from Schele and Miller, The Blood of Kings, *Kimbell Art Museum, Fort Worth (1986:126). (Glyphic information is unclear as to whether the Leiden Plaque refers to a Tikal ruler, or one from some other city.)*

Figure 77. Maya. Guatemala. The Leiden Plaque, reverse. Drawing by Linda Schele from Schele and Miller, The Blood of Kings, *Kimbell Art Museum, Fort Worth (1986:320).*

gods and myths. It turns out that the vast majority of Mayan art is about *this* world, dedicated to the glorification of the ruling class through chronicling their heroic exploits: battles won or lost, marriages and other alliances established, tributary relationships, and "public works" projects undertaken—in other words, as propaganda tending to reinforce the superior status of the elite. Given the large numbers of people involved, regular face-to-face contact between leaders and led could no longer be the basis of social control. People and taxes and the movements of the heavenly bodies had to be counted, territorial and other claims to privilege had to be forcefully proclaimed, and these and other sorts of information had to be stored and retrieved. Given this archival function, it is easy to see why dates and dating were so important

in Maya dynastic art, allowing for the revalidation of relationships through the marking of anniversaries.

The Leiden Plaque (found in Honduras, later taken to Holland; figures 76, 77), while a comparatively modest work, effectively portrays the man-centered character of Maya art; the profuse ornamentation of the central figure, King Balam-Ahau-Chaan, does not overwhelm him or detract from the regal attitude. The piece, which dates to A.D. 320, is a celt with incised decoration on both sides. On one side, the King, embedded in a matrix of royal regalia (including a double-headed serpent bar as a sign of his rank), stands in front of a bound victim soon to be sacrificed at the King's accession ceremony (see Schele and Miller 1986:121). The main figure is naturalistic in proportion (approximately one: eight) and

indicates close observation of the forms of the body. The glyphs on the second side give us the date, names of individuals and circumstances.

The vast site of Tikal, which may be the home of the Leiden Plaque, is discussed by Weaver (1972:154-165):

Let us consider Tikal as an example of a Classic Maya city [figures 8, 9]. The most extensive of all Maya sites, Tikal has been the object of a sixteen-year program of excavations sponsored by the government of Guatemala in conjunction with the University of Pennsylvania (W.R. Coe 1962, 1965, 1967). We do not know how many of the Peten centers were of equal importance, but Tikal probably was not unique. Its setting is a rain forest in northeastern Peten. Rivers are rare in this area and the most reliable sources of water were water holes called *aguadas*. These were favorite habitation sites, as were the level ridges of natural or artificial elevations, the edges of lakes, and *bajos*, low areas that become swampy in the rainy season. The rains fall mostly between June and December, contributing an average of 135 centimeters annually. Tikal was settled in this hilly, tropical terrain, which was obviously unsuited for a grid plan of settlement. The choice of location was apparently dictated by the local topography, and such requirements as water resources and drainage. The large natural supply of flint, valuable for tools, is another advantage which may have played a part in the selection of the site.

At the peak of its development, following A.D. 550, Tikal was occupied by [between 10,000 to 40,000] people and covered an area of [twenty-five square miles]. Central Tikal alone can boast of five great pyramid-temples as well as "palaces," shrines, terraces, ball courts, ceremonial platforms, sweat baths, and thousands of structures considered to be housing units [see map, page 112]. Individual houses were constructed of wood, mud, and thatch, of which nothing remains. A large number of walls, temples, and "palaces" still stand because they were built of limestone and mortar and faced with stucco. The walls of these structures typically were very thick and solid, and the windowless rooms, which today are usually damp and clammy, very small in proportion to the walls. We would not consider such quarters to be habitable, but the ancient Maya might have used some "palaces" as prestigious residences for the elite. Imagine the city at its prime, with the vegetation cut back and the plaster pavements kept in repair—measures which alone would go far toward preventing humid, moldy conditions. Adams (1970) visualizes these rooms as dry and cool, furnished with benches, skins, mats, and textiles. Benches seem to be a particular feature of residential "palaces." Other such multiroomed structures were probably used for storage or administrative functions. A "palace" may often be identified as residential by its general arrangement and appearance, which is but a larger all-masonry version of the smaller perishable house. Other evidence of habitation would be the presence of household rubbish, ordinary burials, and the absence of traces of ceremonial activity (Haviland 1970).

House mounds and residential units have been studied in the same way to determine their function. The presence of utilitarian artifacts denotes living quarters as opposed to workshops or rooms designated for ceremony or ritual. With this in mind, the structures on strips of land five hundred meters wide by twelve kilometers long that radiate in the four cardinal directions from the Great Plaza have been carefully mapped and studied. In contrast to the typical ceremonial center with a small resident population, Tikal reveals a concentration of ruin mounds close to the core that falls off in density distributed around plazas, but these groupings in turn are scattered at random. Nevertheless, the general pattern is a dense central core which is surrounded by a less densely populated periphery. . . .

[Haviland 1970] reconstructs the population of Tikal as attaining its peak by A.D. 550 and maintaining this level until roughly A.D. 770. A decline is noticeable by A.D. 870, and by A.D. 1,000 all the mapped structures had been abandoned. Both the dates and figures are tentative estimates and subject to change; but the large concentration of population is supported by archaeological evidence. Now we want to know how the population reached these proportions and how this extraordinary nucleation was maintained, that is, what was the economic base and social structure of these people, and how did they maintain order and authority?

ECONOMY. Although most of Tikal's population was probably engaged in agriculture, there must have been many who were dedicated to other economic pursuits. For example, the abundant supply of flint not only provided local material for tools, but could be exported either raw or as a finished product. Such exchange of goods and commodities is found

Figure 78. Maya. Tikal, Guatemala. The Great Plaza. Photograph, Zena Pearlstone, 1972.

over and over again to be an important process in the emergence of both Old and New World civilizations. Despite a relatively homogeneous environment which basically offered the same products and resources, the Classic Maya centers of the lowland Peten shared many features such as architecture, religious symbolism, a system of dating and inscriptions, and ceramic styles. But as we shall see, it may not have been local but long distance trading relationships that were the major integrating force [in these centralized sedentary cultivators]. Three essential household commodities have been singled out by Rathje (1971) for analysis, all of which were lacking in the Peten. Mineral salt had to be imported from the Guatemalan highlands or from northern Yucatan (Thompson 1970). The only sources of obsidian, so necessary for making sharp knives, are found in the highlands. The third Peten import is the *metate*, the standard grinding quern in every household. Although the Peten has ample limestone deposits, this is too soft a stone for a *metate* as it leaves particles of grit on the corn during the grinding process. Of the 2,000 *metates* found at Tikal, eighty-five percent are imported hard stone (Culbert 1970). In addition, hematite, jade, slate, pyrite, and marine materials were brought into Tikal (Haviland 1970). The presence of Peten polychrome ceramics in both the Guatemalan highlands and northern Yucatan is evidence that the long-distance trade was reciprocal. . . .

ARCHAEOLOGICAL REMAINS. In the following description of the ruins of Tikal and a few of the outstanding tombs and caches, the skills that were prerequisite must be kept in mind: knowledge of architecture and engineering, astronomy, and craftsmanship in all the arts. Full-time craft specialization has been amply documented; flint and obsidian workshops have been identified in central Tikal. After the description of the city itself, current ideas about the structure of Classic Maya society will be reviewed.

The very core of Tikal consisted of the East, West, and Great Plazas, and the huge complexes of the North and Central Acropolis [figures 9, 78]. Two temples of Late Classic

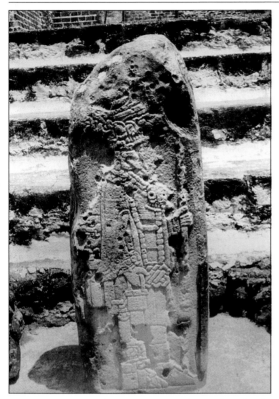

Figure 79. Maya. Tikal, Guatemala. Stela 13: the Ruler, Kan Boar. Photograph, Zena Pearlstone, 1972.

Figure 80. Maya. Tikal, Guatemala. Stela 20: Detail of Glyphs. Photograph, Zena Pearlstone, 1972.

date—Temple I, also known as the Temple of the Giant Jaguar, and Temple II (the Temple of the Masks) [figure 8]—are located on the Great Plaza. These giant temple-pyramids with their high roof combs soar to a height of 528 feet; together with lower buildings, courts, and plazas, they make up the central ceremonial cluster. From this nucleus, three causeways, in Late Classic times flanked by parapets and separated by two ravines, lead to other structures and groups of buildings, all of which have vaulted ceilings. The exteriors, which once had elegant flying facades, are very simple with relatively little stone carving while the combs were elaborately decorated with stucco masks. The Temple of the Inscriptions marks the end of the southeastern or Mendez Causeway, while the Maler Causeway originates behind Temple I and runs north to three twin-pyramid complexes. . . . The pyramids are accompanied by stelae and altars, some of which are magnificently carved and bear Initial Series dates. Continuing north, this causeway terminates at a large plaza bor-

dered by two temples, another twin-pyramid complex, and acres of other structures, many of which are still untouched by the archaeologists. This entire area is now called the North Zone. The third or Tozzer Causeway leads northwest from the central area to Temple IV . . . which is connected by the Maudslay Causeway to the North Zone and the Maler Causeway, thus completing a huge triangular thoroughfare [see map, page 112]. From the height of Temple IV, or from the base of the enormous roof comb, if one is bold enough for the climb, the view of all Tikal is superb. Imagine this magnificent jungle city in its Late Classic splendor, a bustling wealthy center where priests, merchants, artisans, and administrators circulated through the paved courts and causeways, temples, "palaces," and accessory buildings—all stuccoed and painted, roof combs and stelae erect—and the luxuriant jungle cropped back to the city limits.

The Great Plaza, dating from the Late Preclassic period and re-plastered four times, was the heart of ancient Tikal. Temples I and

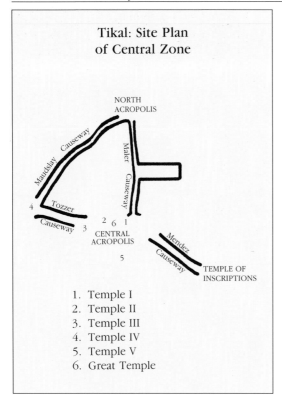

Tikal: Site Plan of Central Zone

NORTH
ACROPOLIS

Maudslay Causeway

Maler Causeway

Tozzer Causeway

CENTRAL
ACROPOLIS

Mendez Causeway

TEMPLE OF
INSCRIPTIONS

1. Temple I
2. Temple II
3. Temple III
4. Temple IV
5. Temple V
6. Great Temple

II, built about A.D. 700, face each other across the plaza, while between them on the north side is Tikal's single most complex structure, the Northern Acropolis [figure 9]. Occupying two and one-half acres, it alone supports sixteen temples and conceals nearly one hundred buildings underneath. . . . Much of the known Preclassic materials underlies the Northern Acropolis. . . .

Numerous stelae have been found at Tikal, many uncarved, others bearing [figures of the elite (figure 79) and/or dates and other glyphs (figure 80)]. Stelae are found most frequently in prominent positions in courts or plazas before stairways and buildings, and are usually paired with altars [figure 78]. It was once believed that stelae were erected to stand throughout eternity to commemorate important calendrical events but at Tikal the stelae often were deliberately broken and smashed, some were placed in tombs while others were reused and even reassembled upside down. Perhaps these stelae . . . were dedicated to a particular ruler or important dignitary and, after his death, were fragmented to accompany him to his grave. Thus, rather than being public monu-

ments designed to last an eternity, such stelae may have been personal tributes honored only during one individual's lifetime. . . .

A distinctive Late Classic feature is the twin-pyramid and stela room complex. These pyramids are relatively low and have stairways on all four sides. They are associated with a long, narrow room across a court to the north, which presumably was roofed over with thatch and contained a stela. In the Late Classic period, Tikal stelae were fashioned wider and taller than previously, with figures carved in high relief, and the appearance of women for the first time. A general change notable in Late Classic stelae is that of presenting the body in full front view with feet pointing outward. The altars of this phase, like the stelae, also were heavier and larger than earlier ones. Wall paintings and elaborate burials of important personages emphasized class distinctions and social rank.

A good example of this was the interment of a prestigious adult male (known to archaeologists as Burial 48) who was given a very special burial in a tomb tunneled into bedrock under a succession of temples in the Northern Acropolis. Prior to interment, both head and hands were removed. He was buried in a seated position but his bones eventually collapsed into a heap. There is no question that his rank was high; not only was he accompanied by the bodies of two teen-agers, but the walls of the tomb itself had been stuccoed and painted with an Initial Series date of 9.1.1.10.10 (A.D. 457). Among the rich offerings were elegantly decorated pots [see, for example, figure 81], a particularly fine Teotihuacan-type cylindrical tripod covered with painted stucco, and a fine alabaster bowl also stuccoed in pale green and decorated with a band of incised glyphs. Jade, a highly prized possession that had to be brought from the Motagua River where boulders and small stones of apple-green color are found, was represented here by hundreds of beads and two pairs of ear-plug flares. Marine products, food offerings, and greenish obsidian, a possible central Mexican import, gave the deceased ample supplies for any eventuality in afterlife. Such treatment was only given to very privileged people of the highest rank. The commoners were usually interred under the floors of their houses, so nothing resembling a cemetery has been found.

After A.D. 600 Late Classic additions and changes were made that altered the profile of the city. The Temple of the Giant Jaguar was

built at this time, undergoing many stages of construction to bring it to its present form. Prior to the initial construction, however, a large vaulted tomb was dug deep into the Great Plaza. Its main occupant was lavishly buried with the finest offerings available: 180 pieces of worked jade, pearls, pottery, alabaster, and shells. Quite remarkable is a pile of ninety bone slivers, located in one corner off the dais on which the deceased had been extended. Thirty-seven of these bones were delicately carved depicting deities in naturalistic scenes such as traveling by canoe, and some of these have hieroglyphic texts. The richly stocked tomb of Burial 116 is admittedly one of the finest, but apparently important interments were frequently made prior to starting construction of a temple-pyramid. Archaeologists conducting a dig can usually tell when they are approaching an underground tomb because quantities of chips of obsidian and flint appear in the fill (W.R. Coe 1967).

Above this tomb, the Temple of the Giant Jaguar rises to imposing heights, its nine sloping terraces supporting a temple of three rooms at the summit. These rooms, recessed one above the other, are small and dark—typical of the period, for not until later times were doorways wider and more plentiful, and walls thinner. Each vault was supported by *sapote* wood, the exceedingly hard wood of the sapodilla tree, which fortunately has resisted the decomposition characteristic of the tropical forest, preserving some magnificent carving. The exquisitely carved lintels of Tikal are well known, as some have found their way to foreign museums. Fortunately, others still perform their intended function. Not all the beams and lintels were carved, and as a rule, outer doorways have plain lintels. Over the wall of the last of the three temple rooms rises a tall, two-leveled roof comb, the face of which was decorated with stone blocks representing an individual seated between scrolls and serpents that are now badly weathered. The entire limestone temple once was painted red, with a roof comb of red, cream, and perhaps blue or green.

The Late Classic period at Tikal has also revealed sweat-houses consisting of a single room with a low doorway from which a channel leads to a firepit at the rear. Sweat baths, or *temescales*, which probably were of ritual significance and may have been associated with the ball game, are known from both lowland and highland regions.

Tikal was also not without its ball courts. A

Figure 81. Maya. Tikal, Guatemala. Vase from Burial 116, Temple I. Tikal Museum. Photograph, Cecelia Klein, 1988.

small one, with low sloping benches . . . was located in the Great Plaza. A second was found in the East Plaza, and another, in the Plaza of the Seven Temples, contained a triple court. None had markers, and all are open ended, as is typical of lowland Maya ball courts.

The architecture at Tikal during the Classic Period underwent an attenuation paralleling that evident in sculpture; ground plans were simplified, which had the effect of accentuating the verticality. Within the shrine-structure on top of the pyramids (and for special-purpose buildings at ground level), heavy stone walls and tie-beams were used to anchor corbelled arches. The white limestone which characterizes Tikal's appearance in the present day is deceptive; in use, the buildings were covered with polychrome stucco. Large numbers of free standing stone stelae and drum-shaped altars, all elaborately carved in low

relief with regal figures, names, dates, and descriptions of the events they commemorated, were a feature of the plazas (figures 78, 79, 80). Monumental architecture on this scale probably was a source of pride for participants in the state-structure which produced it, as well as of intimidation for their adversaries.

Olmec sculpture in hard stones (such as jade) emphasized the monolithic, and the work proceeded by reduction. Among the Maya, there appeared to be a more economical use of these rare and precious materials, paralleling the increased efficiency evident in the organization of society at large. Similarly, the very shallow carving typical of relief-sculpture at Tikal and other sites not only testifies to the virtuosity of the artists, but also means that less material had to be removed from the block in order to realize the design.

A number of important projects at Palenque which took place after the decline of Teotihuacan influence around A.D. 750 ushered in the Late Classic Period. Notable among these is the Temple of the Inscriptions, discovered in 1952 to contain the tomb chamber of Pacal, who ruled at Palenque from A.D. 615 to 683. His stone sarcophagus was covered with a carved slab weighing some twelve tons (figure 82). Low-relief inscriptions on this slab show the ruler at the instant of death, dropping into the jaws of the earth-monster. He is surmounted by a cross-shaped representation of the "world-tree" (analogous to the vertical coordinate discussed among the Pueblos), with a bird shown on top; its feathers functioned as *POWER* materials and were important in the regalia of Maya leaders. The human image exhibits the facial features typical of Maya nobility, particularly the aquiline nose. While studied in its elegance and idealization, the figure is also realistic: Pacal's six-foot, six-inch skeleton reveals that he suffered from a genetic abnormality resulting in the fusion of two toes. This individuating characteristic is carefully rendered in the relief which represents him.

Late Classic relief sculpture, at times, stood as high as fourteen feet and tended toward a much greater plasticity. This latter quality is demonstrated by the lintels of rulers at Yaxchilan which

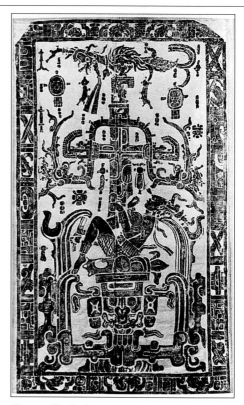

Figure 82. Palenque. Mexico. Sarcophagus Lid of Pacal. Rubbing, Courtesy Merle Greene Robertson.

often also embody the pervasive Maya concern with representing oppositions (superior/inferior, dominance/submission). Lintel twenty-four (figure 83) at Yaxchilan (A.D. 725) shows the King, Shield Jaguar, with his wife Lady Xoc, kneeling before him; she is in the act of pulling a cord studded with thorns through a hole in her tongue, allowing the blood to drip on paper in a basket before her. Such references to (and implements for) self-sacrifice are widely encountered in Maya art and this practice may have been the only offering an individual could make which was uniquely his/her own.* (A similar

*It is becoming increasingly clear that autosacrifice is alluded to either directly or indirectly in numerous Classic Maya artworks and that blood was seen as a source of life and regeneration. Maya deities were seen as "reborn" in the process of royal bloodletting rituals. Thus bloodletting by the royal family was thought to maintain the gods and the universe; as such it became the family's most important ritual responsibility (note: Cecelia Klein).

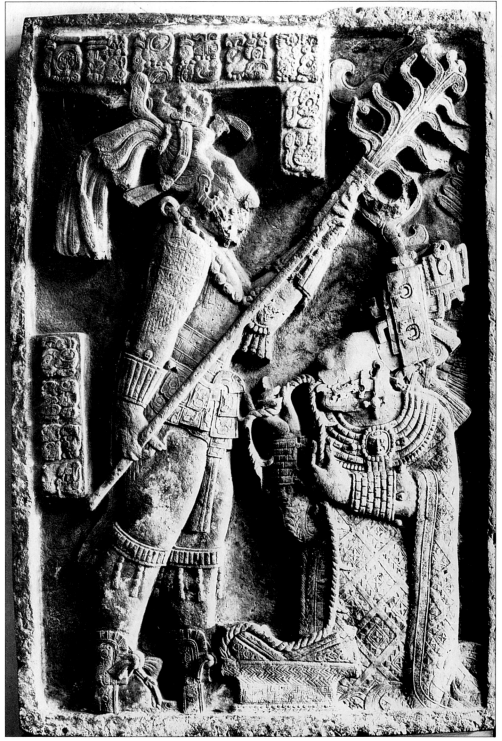

Figure 83. Yaxchilan. Guatemala. Lintel 24. Courtesy Trustees of the British Museum (Museum of Mankind). Museum photograph.

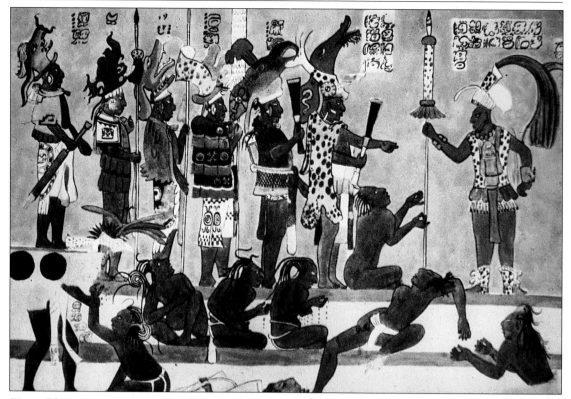

Figure 84. Bonampak. Mexico. Detail, Room Two. Painting, Giles Healey. From Morley et. al. (1983: Fig.13.25)

conception seems to underlie the Sun Dance of the North American Plains, to be discussed later.) Considered in isolation, such procedures might seem psychotic; in context, they can reasonably be seen as components of a coherent philosophical system which takes the body, not as an inviolable temple, but rather as an instrument for attaining a higher level of consciousness.

The site of Bonampak was discovered by a group of chicle prospectors in the early 1940s. Although its pyramids were modest, they sheltered one of the most important examples of Maya mural-painting extant: a suite of three main scenes including preparations for a battle, the battle itself, and the victory celebration. Miller (1986) has argued that the primary theme of the paintings is the presentation of a young male heir to the throne whose father went to battle to secure prisoners for the festivities. The survival of the paintings is due in large part to the use of "true fresco," with pigments applied

to wet plaster to produce an integral bonding, as opposed to "dry fresco," paint applied directly to dry plaster (which is prone to flake off). Further, the chamber housing the murals was sealed for a long period, and silicates leaching out of the limestone walls formed a protective skin over the paintings.

The aftermath scene is in many ways the most elaborate and revealing. For the victors, regalia is rich and postures are reduced to the highly stylized presentational formulae seen earlier in the Leiden Plaque, Tikal stelae, and other monuments. Within the Maya system, high-status identity appears to have been bound up with a prescribed rhetoric of posture and gesture, dress and adornment. In contrast, the prisoners are shown stripped and exhibiting a wide range of emotions, from pleading to despair and resignation; intriguingly, they (rather than the high-status figures) provided the artists with an opportunity to demonstrate their virtuosity in describing emotional states

through depictions of the human body in space (figure 84). At one level, the mural is reportage, but it transcends this function (where the iconographical program was least constraining) to create an extraordinary document of human pathos.

Associated glyphs date the Bonampak murals to about A.D. 800 and give dates and details of the events represented. One hundred years later, the site, and all other Classic Maya sites, were deserted. The reason for this downfall is not well understood; scholars have proposed epidemics, invasions, social revolutions and hurricanes. Despite the lack of consensus certain tentative conclusions can be reached. Maya cities, with their paintings, sculptures, and vast architectural projects became repositories of cultural information and ideology, part of the historical record and collective identity of their subject populations. As more and more people were incorporated into the state, the range and numbers of full-time specialists increased, including weavers, jewelers, potters, architects, mural painters, and sculptors. Without question, their accomplishments were prodigious, but they were bought at the price of self-determination on the part of the majority of interests to those of a small elite. It is possible that a top-heavy bureaucracy had reached the point of diminishing returns in taxation. (One scholar estimated that, by the time of the collapse, a farmer starting out from the frontier of a major state carrying as much corn as he was able, with the intention of bringing it to the center as tax, would consume it all in reaching his destination.) Scholars have also noted that beginning around A.D. 750 alliances began to deteriorate, long-distance trade declined, conflicts between city-states increased (the Bonampak murals illustrate one such confrontation), the population decreased and eventually construction came to a halt.

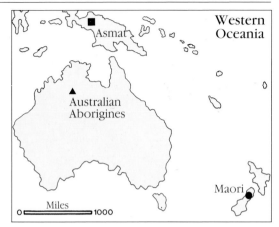

The Maori

Like the Maya, the Maori of New Zealand developed a highly stratified social system. The islands were settled by immigrants from Central Polynesia with a material culture inadequate to the temperate climate they found (see map above). For example, the paper mulberry used in producing Central Polynesian bark-cloth clothing did not do well in New Zealand, and houses with thatched roofs and loosely woven mat walls were inadequate for New Zealand's cold winters. Among other adaptations of tropical patterns to these new conditions, local flax was used to produce clothing, and the excellent timber which was available was used for the construction of substantial houses and other structures (figure 85). Tropical food-crops also did not do well in New Zealand. A Maori dietary staple was the sweet potato, a New World domesticate which had reached Central Polynesia from South America and was apparently carried by the ancestors of the Maori to the islands they now occupy.

The earliest migrations probably occurred around A.D. 700, possibly followed by a "Great Fleet" around A.D. 1,300. The Maori were organized into stratified chiefdoms of the sort typical of Polynesia, in which warfare was a cultural preoccupation. Subsistence was relatively easy, with the result that the Maori had a lot of spare time to make war and art. People lived in communal dwellings in fortress villages in a

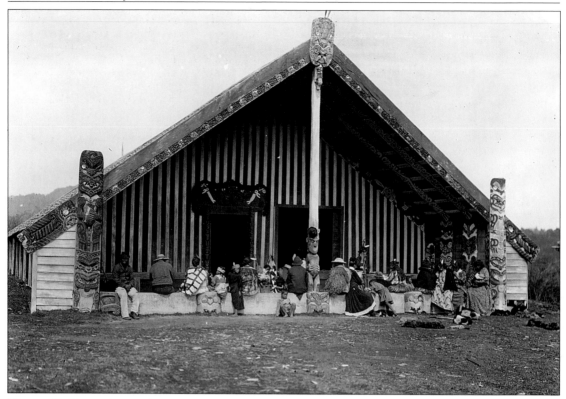

Figure 85. Maori. Ruataahuna, Urewera National Park Area, New Zealand. Meeting House called Te Whai-A-Te-Motu. (The name refers to and the house is in honor of Te Kootis, the great eighteenth century Maori prophet. The house took eighteen years to complete and was opened in 1888; reconstruction took place in 1932). Courtesy National Museum of New Zealand, Wellington. Museum photograph.

virtually constant state of armed conflict with their neighbors. As the products of a highly militaristic society, Maori art will pose for many of us problems similar to those encountered in dealing with the art of the Asmat. In battle, the Maori warrior sought to intimidate his opponent by violent gesticulations and distortions of face and body; these postures and gestures seem to be the source of the aggressive intensity and strikingly extroverted character of Maori art. Apotropaic faces, emphasizing open mouth with protruding tongue, flaring nostrils, and huge eyes (highlighted by discs of haliotis shell) occur in a wide range of contexts (figure 86).

Maori communal houses resemble those of the Northwest Coast of North America in that they receive a heavy investment of cultural energy in the form of embellishment, reflecting a sense of collective identity and a high level of creative energy (figure 85). Also resembling the Northwest Coast, the houses are occupied by groups of related families only during the winter; during the warmer growing season, the occupants move out into shelters more closely resembling their Central Polynesian prototypes. Specialization by elite members of society in such activities as woodcarving, warfare, politics, tattooing, jade-working and oratory tended not to be full-time, since they were expected to have skills in many of these areas. Such capabilities were bound up with the conception of *mana*, or impersonal vital force, discussed earlier (see page 42). (*Mana* was concentrated in the head, which probably explains the emphasis on this part of the body in sculpture.) *Mana* was transmitted primarily genealogically, but if displaced, a leader (or group) would suffer

mana depletion. His successor would then set about justifying the change in hierarchy through reinterpretation (or invention) of an appropriate genealogical mandate. The ability to control (and defend) such traditions is a major source of power within the group. Among the Maori, elite males attended academies to learn the traditions which supported their positions within the group; as with Harvard, Yale, and Princeton, they acquired not only knowledge but good contacts. Among the Maori, the chiefs were freed of subsistence responsibilities in order to pursue their roles as politicians, artists, and soldiers.

Contact with European industrial civilization following Captain Cook's visit late in the eighteenth century brought about major changes in Maori life and art. Firearms, in particular, established a new basis for warfare, previously highly stylized but with limited casualties. Because of the effects of disease to which the Maori had no immunity, together with massive social disruption, the Maori population went into drastic decline. On the other hand, the introduction of steel tools made carving easier (although changing its quality), and chiefs acquired sufficient wealth (through trade) to commission new projects on a large scale. In particular, late in the nineteenth century, there was a major revival of Maori art as part of a rediscovery of traditional values. But the rounded, volumetric approach to form and a restrained use of ornamental detail typical of older works gave way to an icy brilliance, a profusion of decorative details, and a kind of conventionalized perfection, although the basic system remained intact: massive heads, bowed limbs, and complex arrangements of forms and ornamentation which often make it difficult to "read" Maori art. Linton and Wingert (1946:53, 55) describe this carving and the process of its manufacture:

> In woodcarving, rafter painting and tatooing [sic], which were men's arts, only curvilinear designs were employed. Highly conventionalized human faces and figures were extensively used in wood carving for decorative effect but never appeared in painting or tatooing. A few . . . semi-naturalistic images were carved to

commemorate men and women of high rank. In these the poses are static, in sharp contrast to the vigorous action portrayed in many of the conventionalized figures. The Maori regarded such commemorative figures as portraits, but the portraiture consisted in an accurate reproduction of the individual's facial tatooing. . . .

The Maori master carver trained himself to visualize his design in its entirety before he began to carve, then worked without the aid of sketches or guide marks. This ability to visualize designs and carry them in the mind was reflected in certain forms of virtuosity. In some objects it is clear that the design was conceived in terms of a field larger than the object to be decorated and even different in shape. The object was super-imposed upon the imaginary design field and only those parts of the total design which fell within the area covered by the object were reproduced upon it. Other objects were decorated with two or more designs, each complete and coherent in itself, which have been superimposed upon each other. The artist's audience, who understood the skill required for compositions of this sort, were able to draw esthetic satisfaction from designs which seem, to the European, incomplete or confused.

The communal houses received special attention during the revival, and several major examples were constructed (or reconstructed). Consistent features include a large gable-mask, a frieze of monstrous faces, a decorated lintel above the main entry, other interior and exterior carving, painting and matting. The carved lintel often includes a displayed female figure: exposed genitalia were thought to counteract harmful magic, and, since the communal house concentrates energy, inhabitants would be "neutralized" by passing under the figure, enabling them to interact harmlessly with others. Carved wooden planks with representations of identified ancestors line the interior of the house, implicitly keeping their accomplishments as ideals before its inhabitants. [The Maori believed that their ancestors came from Central Polynesia in seven canoes. Each canoe bore the descendants of one of the seven groups of the Maori. The seven navigators, who are considered the most important ancestors,

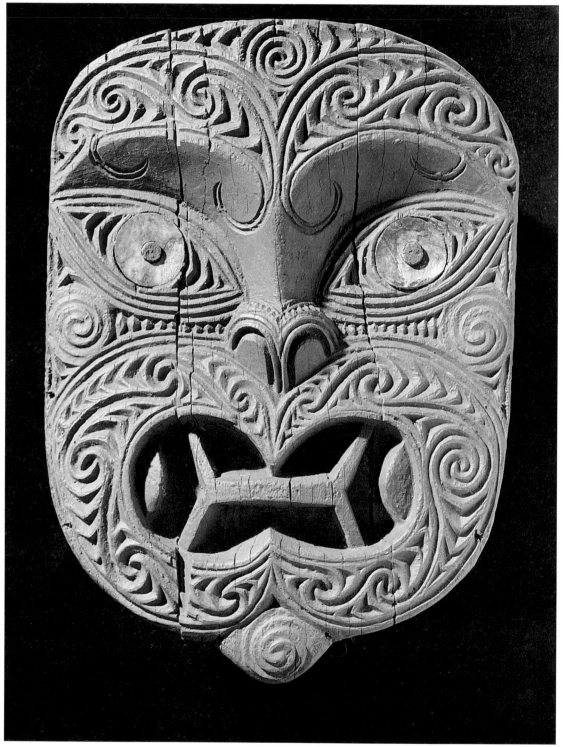

Figure 86. Maori. East Coast District, New Zealand. Koruru (finial mask). Courtesy National Museum of New Zealand, Wellington. Museum photograph.

are depicted on the gable-masks.] Mats woven (by women) with geometric patterns separate these panels. Curvilinear designs are painted on the rafters.

Moko, or skin carving, is usually described as tattoo (from the Central Polynesian *tatau*) (figure 12). Although color is used, the term scarification (as defined page 68) is more accurate than tattoo, since the marks which resulted were below the level of the skin. A sharp, bird- bone chisel is used to make incisions in the skin, which are filled with an oily, sooty pigment. Full *moko* were the prerogative of high-status Maori men, with designs applied to face, thighs and buttocks in a curvilinear, spiraling pattern similar to woodcarving. (High-status women might have their lips and chins done.) No two *moko* designs were identical, and (since the designs were symmetrical) half of a man's *moko* might function as his signature on a contract.

As noted earlier, the head is the seat of an individual's *mana*. When a chief was killed in warfare, his people would make every effort to retrieve his head, which was emptied, smoked, and maintained as a way of preserving his vital energies. Similarly, groups would seek to capture the heads of important enemies as a way of diminishing their vital energies. Since such heads were of little account (except as objects of contempt), they might be freely sold to Europeans, and trade in these grisly souvenirs fostered a lively industry. Since the number of such heads available was limited, slaves or war-captives temporarily reprieved from the pot would be given an elaborate set of *moko*, allowed to heal, then sacrificed so that the preserved heads could be sold to Europeans. The results of this process, due entirely to European demand, confirmed European judgements of the Maori as savage and bloodthirsty.

Jade ear- and necklace-pendants might also be worn by both sexes. The *hei-tiki*, worn predominantly by women, is derived from an axe-blade form (figure 87). Of nephrite, with eye-rings inlaid with haliotis-shell or filled with red paste, *hei-tiki* echo the contortions of Maori wood-sculpture. In form and material, they

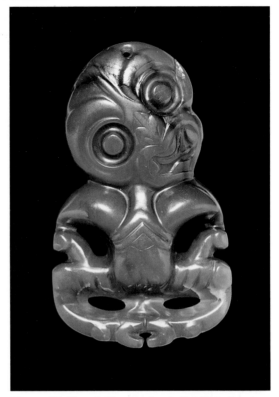

Figure 87. Maori. New Zealand. Hei Tiki. Courtesy National Museum of New Zealand, Wellington. Museum photograph.

also closely resemble figurative axes from the Olmec (figure 16) and other peoples of Native America—and eastern Asia. Thus, the conception might be proposed as part of the "mental baggage" carried by immigrants from Asia to the New World and into the Pacific Basin.

Objects of daily use—such as feather-boxes, adzes, weapons, musical instruments, canoe prows (and bailers!)—were often heavily decorated as a reflection of their association with individuals of high status, and reinforcement of the *mana* which can be said to have flowed in both directions.

In the area of religious art, a few Maori "God-sticks"—twelve- to fourteen-inch wooden pegs wrapped with cord, with head-shaped finials—are known; they were used as "perches" for deities invited by chants to come and receive sacrifices. Ancestral spirits were venerated (rather than worshipped) for their accomplishments

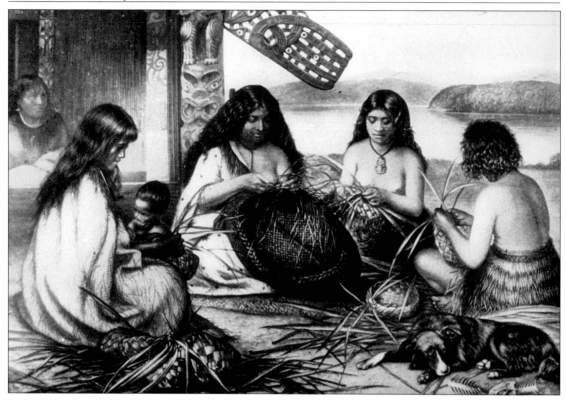

Figure 88. Maori. New Zealand. Women Weaving Baskets. Painting, 19th century.

and held up as exemplars. Underlying these beliefs is an emphasis on inherited *mana* as a starting point, complemented by one's own efforts. Self-reliance, resourcefulness, and a pragmatic emphasis on influencing events in *this* world are important values in centralized societies generally. Deities are joined in importance by living members of the elite in providing cultural coherence and continuity.

Maori art is described further in the following passages from Buhler, Barrow and Mountford (1962:194-7,200-1):

In New Zealand the decorative arts may be classified under plaiting, weaving, lattice-work, painting, tattoo, and carving in stone, bone, and wood. The spectacular development of wood-carving and the interesting nature of its symbolism calls for special attention. Carving in hard materials, the painting of house rafters, and tattooing is the work of men; the manipulation of soft materials is assigned to women. Women are considered the

destroyers of *tapu* and therefore should not be about when the sacred business of house-building, canoe-making or other ritualistic work is in progress. The women who do fine craftwork are esteemed and vie with one another in their work, but the man of rank who qualifies as a skilled carver or tattooer is given the high social status of a *tohunga*. The skilled craftsman is a priest whose art is a dangerous field where personal behavior is important, for any infringement of the laws of the craft could bring loss of knowledge or worse. Even inadvertent infringement such as an omission in a ritual chant or some unlucky act would have dangerous consequences. Chips from the carver's chisel are a potent cause of trouble if misused. For example, it would be disastrous to put them on a cooking fire or to blow them with one's breath from the surface of a carving.

Bark-cloth manufacture was attempted in New Zealand with little success. . . . A substitute for *tapa* was found in the indigenous flax . . . which provided long tough fibres for garment manufacture and plaiting of baskets and mats [figure 88]. Designs in weaving are

obtained by the use of dyed elements and by changing the number of wefts crossed. Cloaks are decorated with feathers, coloured cords, strips of dog-skin, or with more elaborate bands of rectilinear designs worked in dyed fibres (*taniko*). As loom weaving was unknown in Polynesia the Maori used . . . unfailing ingenuity by developing a form of 'fingerweaving' based on a technique used throughout the Polynesian islands in the manufacture of fish traps. The story of the evolution of Maori clothing is an example of the use of a . . . traditional technique as the basis for the evolution of a new artistic form.

Decorative painting on the rafters in Maori ceremonial houses consists of predominantly curvilinear patterns [as opposed to the angular, geometric designs characteristic of women's art] of great variety rendered in red, black and white. The red pigment is obtained from burned ochrous clay, black from soot, and white or bluish-white natural clays. All colours are first powdered, then mixed with oil obtained from shark liver. The designs on rafters . . . [sometimes suggest] . . . plant forms. . . . All designs are named. Scrolls, crescents, and occasionally rectilinear elements are combined in patterns running up the broad rafters.

We find associated with rafter patterns in the superior type Maori houses lattice-work, panels called *tukutuku*, set between ancestral panels. *Tukutuku* are composed of light horizontal laths lashed from behind to vertical reeds with a great variety of stitches. [Lashings were done from behind because the women who executed them were not allowed in the house.] As the laths are usually painted red with dyed flax or orange-coloured grass used in the lashing, the face of the panel is highly decorative. The resulting designs, although abstract, are assigned names suggested by the general pattern. Zigzag lines are termed *kaokao* (ribs), lozenges are referred to as *patiki* (flounder), and certain triangles as the teeth of monsters (*niho taniwha*). These *tukutuku* panels were developed locally in New Zealand but relate to the Polynesian practice of . . . lashings [used in the construction of canoes and houses. These lashings were both functional and ornamental].

A notable achievement of Maori art is found in the various ornaments of greenish nephrites and jade-like stones called *pounamu*. The material is found in Teramakau and Arahura rivers on the West coast of the South Island and in the Otago district. *Pounamu* is such a hard texture that it is worked by laborious processes of abrasion. Because of this, and its rarity and beauty, ornaments in this material are highly valued. Fine examples of this beautiful art may be seen in the museums of the world, especially examples of the relatively common human-form *hei-tiki* neck ornament [figure 87]. European collectors have usually sought *hei-tiki* for their size and beauty, but by the Maori they are valued as symbols of ancestors and gain value through their association with previous owners. Some of these ancestral pendants possess great *mana*, a word denoting prestige and magical power, and such specimens frequently possess a personal name.

Maori tattoo on face, thighs, and buttocks is characterized by curvilinear patterns which are directly related to surface decoration in wood-carving and painted rafter design [figure 12]. Ethnologists have an excellent opportunity to observe facial tattoo because of the Maori custom of preserving the heads of both friends and enemies. If a chief died on a distant field of battle, his head was carried home in lieu of his body to comfort his widow and relatives; but the head of an enemy was preserved so that all members of the tribe might have the opportunity to revile and insult it. Thus, feelings of love and hate inspired the skillful technique of preserving heads. The method of mummification was to break in the base of the cranium in order to remove the brain; the loose skin at the neck was stitched to a vine hoop; then the head was subjected to steaming in the earth oven, smoking, and oiling. As the skull was left in position the finished product was both life-sized and life-like. The head of the male chief is adorned with sweeping lines extending across the brow and from nose to chin, with spirals on cheeks and nose. Women of rank are tattooed on chin and lips. Skilled tattooers enjoyed social rank and their services were frequently in demand far from their own territory. Because of tattooers' itinerant habits there appears to be little local difference in tattooing style. Each pattern differs in detail from one individual to another, and in the case of portrait sculpture the identity is more a matter of tattoo than the modelling of features. The distinctive character of Maori tattoo is derived from its relationship with wood-carving, for it appears that the deeply grooved lines cut on the human face imitate carving technique. Buttocks and thighs were also tattooed by the milder method of merely

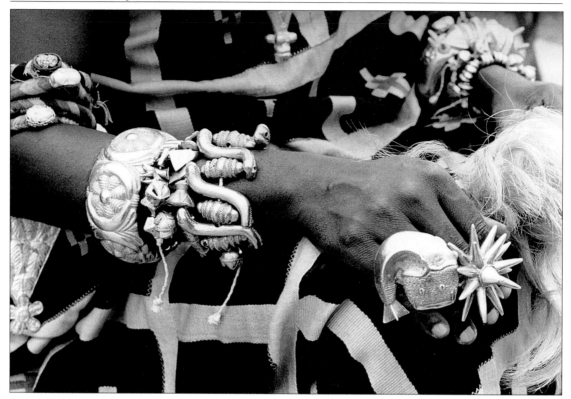

Figure 89. Asante. Ghana. Jewelry detail of paramount chief of Asumegya. Photograph, Doran H. Ross, 1979.

puncturing the skin, then applying bluish or black pigment. . . .

Small human images of the ancestral type occur on numerous artifacts used by fishermen, fowlers, warriors, as well as on utensils of domestic life. Burial boxes in human form are found concealed in caves in the northern districts of the North Island, but we must look to the carved ceremonial house, [storage container], and war canoe for the most abundant and varied range of ancestral images. The ranks of honoured ancestors lining the interior of the ceremonial meeting-house serve as memorials to the great chiefs of the past, keeping before the eyes of living members of a tribe their lineage and history. As it is believed that the power of the ancestor is still a force in tribal affairs it is appropriate that the great ones of the past should be represented in this manner. The out-thrust tongue, tattoo marks, and contorted posture of the war dance, stress the war-like character of the ancestor, thus providing an ever-present example to the young warrior. Eye inlay of shell (*Haliotis iris*) accentuates the fierce aspect of these images, especially in the night, when the people gather to hear the tales

of the past and to discuss the affairs of the day. Exterior carvings of the ceremonial meeting-house are limited to the facade. Massive barge boards are carved or painted, and surmounted with a mask.

Asante*

In contrast to the Maori, the character and contour of the Asante nation owed a great deal to other cultures; to the north, the states of the Niger Bend; to the east, south, and west, other tribes and kingdoms (see map, page 126). Thus, in examining the arts of the Asante, we are principally concerned with cultural confluence—the

*The film *Great Tree has Fallen* (1973) was shown in conjunction with this section. Distributed by University of California Extension Media Center, Berkeley, CA.

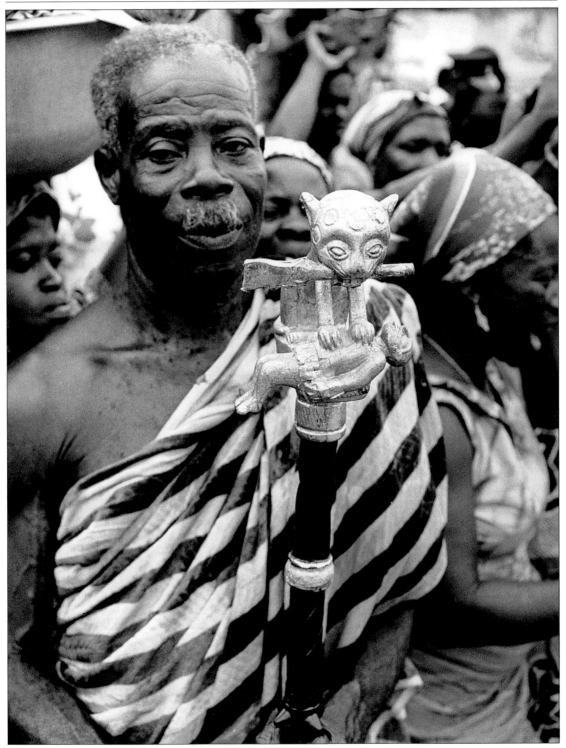

Figure 90. Asante. Ghana. Court counselor holding his staff; finial depicts a leopard with a gun in his mouth standing over a hunter. Photograph, Doran H. Ross, 1976.

blending of previously distinct cultural streams and the effects of that blending on the arts. On the Plains of North America, a similar confluence precipitated a splendid and distinctive flowering of art which also drew upon both traditional (Native American) and introduced (European) forms, but political and economic circumstances precluded its survival. Asante culture and art, on the other hand, has been able to survive substantially intact.

The Asante nation was forged around A.D. 1,700 through conquest, by the kingdom centered at Kumase, of neighboring states of central Ghana (formerly the Gold Coast), occupied by speakers of related (Akan) languages. Their shared history probably goes back much further, probably predating Islamic records of the region's trade in gold. After approximately A.D. 1,500, the trading forts established by Portuguese, Dutch, English, and other European interests along the coast became increasingly influential in the political and economic history of the region. The emergence of the Asante into pre-eminence was largely due to the synthesis they accomplished of these diverse elements, as perhaps usefully seen in the regalia of the king, the Asantehene. His gold necklaces, rings, bracelets, and other ornaments—references to the wealth upon which his political power rests—are to this day used to elevate his person in ways analogous to jade among the Maya and Maori; their forms relate to proverbs, aphorisms, and other elements of the folklore and traditional wisdom—essentially a system of common law—shared by the peoples of the region (figure 89). His cloth, called *kente*, is (as noted earlier) made of rewoven Chinese silk traded in by the Portuguese and their successors (figure 10). One type of throne is local, three

others are based on European straight and folding chairs as prototypes. His royal parasols probably derive from the Islamic states of the Niger Bend, as do his swords, charms and talismans (see figure 91). This process of synthesis and transformation led to the emergence of distinctive forms, first documented by the Bowdich Expedition in 1817, continuing through the establishment of English Colonial dominion late in the nineteenth century until the present day.

The funeral of an Asantehene, including the installation of his successor, is observed over a week during which time rituals oriented toward the continuity of the state in a time of great vulnerability are observed. When a social/political unit is identified with and invested in a single individual, succession necessarily introduces profound stresses, and evocation of ancestral spirits and traditional sanctions are used to reinforce the social fabric. Aside from their obvious value for the living, funeral observances open up lines of "communication" to the world of ancestral spirits; a spectacular "sendoff," with extensive sacrifices, ensures the continuity of good relations between the living and the spirits of the powerful dead. The ceremonies are attended by chiefs and commoners as witnesses to the transition which is taking place; citizens who are otherwise lawyers or teachers, farmers or truck-drivers, re-establish contact with their cultural roots. The presence of chiefs is marked by a sea of parasols, and they (or retainers) carry the symbols of their worldly power—the sword and the gun (figure 91). Greater chiefs ride in palanquins, lesser chiefs walk. People wear red or brown, the traditional colors of mourning. Mourners fast and engage in highly stylized gestures of despair. The Queen Mother officially announces the death of the King and the name of his successor. Delegations take their assigned places for the official ceremonies according to their rank within the official hierarchy. Included in the processions are court counselors (orators, translators, interpreters), their gold-leafed staves carrying carved references to the nature of the state and attributes of leadership (figure 90). Muslim chiefs from Northern Ghana dance to

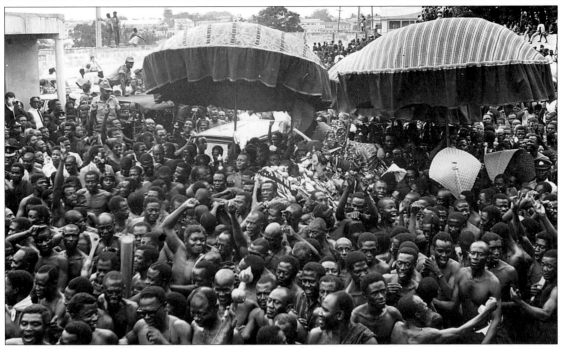

Figure 91. Asante. Ghana. Asantehene riding in palanquin under state umbrellas and surrounded by sword bearers. Courtesy Ghana Information Services.

Figure 92. Asante. Ghana. The late Asantehene Otomfuo Nana Sir Osei Agyeman Prempeh II and the Golden Stool in state at a ritual event in Kumase. From Fraser (1972:141). Courtesy University of Wisconsin Press. Photograph, Embassy of Ghana.

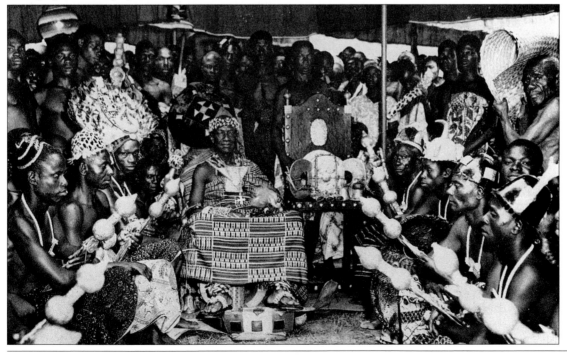

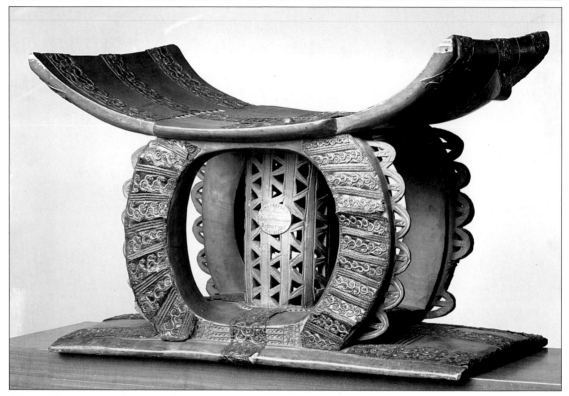

Figure 93. Asante. Ghana. Royal stool of Asantehene Kofi Kakari. Nelson Gallery of the Atkins Museum, Kansas City. Museum photograph.

honor the new Asantehene, their dress, regalia, and gestures clearly deriving from a non-Akan tradition. Finally, the princesses of the royal house put away their mourning garments and don their golden jewelry as a demonstration of the wealth of the kingdom. The procession of the Golden Stool begins the new reign.

As Silverman points out the Golden Stool of Asante is the collective soul of the nation, not merely its symbol (figure 92). Although its form is essentially similar to ordinary stools, the Golden Stool emerged around 1,700 as the central fact of the new nation by descending from heaven to rest on the knees of the first Asantehene. The Golden Stool is not sat upon; rather, it has its own throne, higher than that of the Asantehene (who sits higher than subordinate chiefs, who in turn sit higher than ordinary people). A stool or chair is regarded as intimately bound up with the life-force of its owner; for stools, the central supporting ele-

ment (often a perforated cylinder) collects these vital energies. (For this reason stools—and chairs—are usually tipped on their side or leaned back against a wall when not in use, to prevent harmful forces from invading these intensely personal objects.) All local Akan chiefs have their own stool-thrones, but they are subordinate to the Golden Stool just as their incumbents are subordinate to the Asantehene (figure 93). The Asante (and other Akan states) also maintain stool-shrines, where the thrones of former kings are preserved (figure 94). When a king dies—if the nation had prospered during his reign—his stool will be inducted into this storehouse of ancestral energies. In use, the throne is the natural color of wood; when incorporated into the national shrine, most are blackened through an initial application of a mixture of ground charcoal (soot) and eggs and the subsequent sacrifices of eggs, yams, oil and blood. (Some ceremonial stools, encrusted with

Figure 94. Asante. Ghana. Stool Shrine. Courtesy Ghana Information Services.

sheets and strips of gold, silver, or brass, were not blackened.) The stool-shrine is patterned after the king's palace, including a kitchen where sacrificial foods are prepared for offerings to the ancestral spirits. (Palm-wine was formerly offered as well, now supplanted by imported Dutch schnapps or British gin.)

The Asante share with the other Akan groups a pervasive symbolic system which constantly reiterates and reaffirms codes of behavior and ideology. This system, called by Cole and Ross (1977) "the visual/verbal nexus," consists of visual and verbal forms (proverbs, aphorisms, fragments of folktales) which reciprocally mediate and reinforce each other. As regards visual forms, this complex was seen earlier in the form of the multi- handled "state sword," but is especially clear in the complex of miniature brass sculptures used in weighing gold (figure 97). (Most African systems of measure utilize volume rather than weight, for example, bowls of a certain size for salt or grain.) The system of weights was originally imported from the North, where Muslims used shaped potsherds or bits of brass with pan-scales. When introduced to the Akan area, however, the weights were cast (using the "lost wax" process) in a dazzling array of representational and abstract forms. (Some were literally cast "from life"—the "lost beetle" process.) The lost wax process is as follows: 1. a wax model of the desired weight is made; 2. a funnel-shaped wax stem (sprue) is attached; 3. the composite shape is coated with a layer of fine clay mixed with water—the inner investment—which will capture all the delicate details of the model; 4. an outer investment of coarser clay, to give strength to the mold, is applied; only the end of the sprue remains exposed at the bottom of a cup-shaped depression; 5. a small cup (crucible) filled with bits of brass is attached to the mold, producing a dumb-bell shape; 6. the package is

placed into the furnace, crucible-end down; 7. the wax model is vaporized by the heat and bleeds out through the walls of the mold; when the metal is molten, the mold is inverted, allowing the metal to flow into the space formerly filled by the wax; 8. the mold is broken, sprue removed, and any irregularities filed off. Asante casters also bypassed the wax model stage by attaching the sprue to an actual (organic) object—such as a beetle, seed-pod or chicken's foot—then completing the mold as outlined above; the model would burn to a fine powder which did not impede the flow of metal— hence, the "lost beetle" process.

National treasuries maintained extensive sets of "official" weights, along with scales, boxes, spoons and other paraphernalia, used in taxation, assessing duties and tolls and the like. The system of symbols involved was also used in other contexts, such as parasol finials, "linguists' staves," and sword ornaments, and decoration of treasure-boxes, called *nkuduo* (singular *kuduo*; figure 95). The *nkuduo* derived from brass boxes of Middle Eastern or North African manufacture traded into West Africa as early as the fourteenth century. They were transformed in the Akan area through addition to the lids of more or less elaborate figurative decoration and the transformation of Arabic calligraphy on the body into purely decorative interlace. (While few Asante seem to have been literate in Arabic, Muslim scribes were employed for record-keeping, other administrative duties and communication with the spirit realm. A contemporary parallel: government and business use computers to process information, but bureaucrats and managers need not know how to program or operate their computers; specialists are hired for those purposes.)

Asante mud palaces and other structures are modest compared to the stone cities of the Maya or the richly ornamented communal houses of the Maori. In the realm of sculpture (beyond figurative goldweights and related anecdotal forms) there are carved wooden images of mothers and children. (Compare with similar images among the Senufo.) Commemorative images of terra-cotta consist of a vessel

Figure 95. Asante. Ghana. Kuduo (detail of top). Courtesy National Cultural Center, Kumasi. Photograph, Raymond A. Silverman.

shape with figurative lid. Such vessels are used as a substitute body for funerary purposes, since the actual body is usually interred soon after death and it takes a long time to accumulate the resources necessary for a proper funeral. A bundle containing hair- and fingernail-clippings is placed inside the vessel, which stands in for the deceased at his/her own funeral. After the ceremonies, the vessel is taken to the cemetery (literally, "place of pots") and, thereafter, given periodic sacrifices. (Compare Olmec ceramic babies—a symbolic representation of the human body as container for the soul.)

In this discussion of the arts of centralized societies, we have not mentioned the arts of the common people. For the Maya, most of these arts were probably ephemeral and therefore have not survived; among the Maori, one suspects that elaborated artifacts would have been *tapu*. The Asante (and other Akan groups)

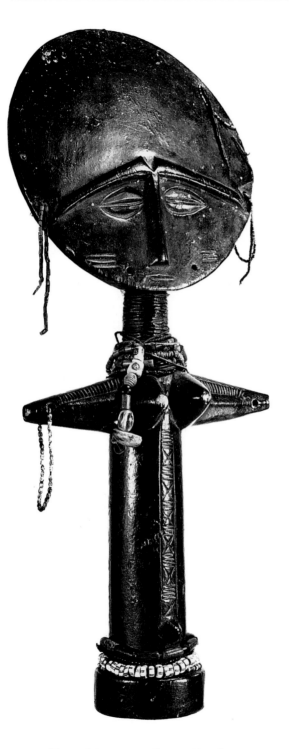

maintain domestic (and community) shrines dedicated to various spirits (including the earth), some of which incorporated sculpture. Healers consulted by childless women may commission small, highly abstract wooden images (*aku-a'mma*, singular *akua'ba*) on their behalf; the woman carries the image on her back in the same way a living baby would be carried (figure 96). These seem to function to reduce anxiety, which may enhance the likelihood of successful conception. The *akua'ba* exhibits the consistent Akan conception of physical beauty: a face with regular, composed features. The rings around the neck allude to the high status to which the prospective mother aspires for her baby: wealthy people eat well and do not labor excessively, accumulating the slight corpulence which such rings copy. After the baby is born, the *akua'ba* often is given to the shrine.

As indicated, the Senufo and Asante are, for all practical purposes, neighbors, and their arts reflect an intriguing pattern of similarities and differences. Immediately apparent is the infrequent use of masks among the Asante—often true of centralized peoples (although there are exceptions). Their sculpture shares soft, blackened surfaces and rounded forms. Small brasses are known from both cultures, along with images of mothers and children, and Asante linguists' staves may relate to Senufo agricultural trophies (see pages 103–04). Given their different linguistic affiliations and the striking differences in social and political organization which exist between them, questions of art-historical relationship between the Asante and Senufo must await further investigation. More broadly considered, Asante art is a good example of how cultural confluence stimulates the reinterpretation of borrowed forms and, through synthesis, the emergence of new ones.

Figure 96. Asante. Ghana. Akua'ba.
Collection Lauren B. Baker, M.D.

Figure 97. Asante. Ghana. Group of Goldweights. Private collection. Photograph, Robert Woolard.

Gold and Power:
Art and Politics
of the Asante

by Raymond A. Silverman

The culturally-related Akan peoples, including the Asante, Fante, Bron, Anyi and Baule, live in south-central Ghana and adjacent areas of Ivory Coast. A distinctive characteristic of Akan culture is its complex political organization and the parallel complexity of the art which supports this organization. We introduce here some of the artistic traditions that are used to establish and maintain political authority in Akan society. Although these traditions are found among all Akan peoples, their fullest expression is found among the Asante who dominated the Akan region during the eighteenth and nineteenth centuries.

With the imposition of colonial rule at the end of the nineteenth century, much of the political power wielded by Akan rulers was transferred to the colonial government and was later assumed by the governments of Ghana and Ivory Coast. As a result of these changes some of the institutions associated with traditional rule atrophied and some ritual fell into disuse. Much of the art associated with these practices, however, continues to be preserved and used by chiefs. (Past and present verb tenses are used to distinguish defunct from ongoing practices.)

The Akan forest is one of the richest gold-bearing regions of the world. Historical and archaeological evidence indicate that during the fourteenth century Mande merchants from the Western Sudan arrived at the northern fringe of the forest and began trading with the Akan for gold. From this time, gold has played a central role in the Akan history. Initially the gold was destined for the *entrepôts* of the Western Sudan and ultimately the great cities of northern Africa and the Middle East, but with the arrival of the Portuguese on the coast in the late fifteenth century, gold began flowing southwards to what was soon to be called the Gold Coast. All of the maritime nations of western Europe participated in this gold trade and established trading forts. It has been estimated that between the years 1400 and 1900, the Akan peoples exported 13,600,000 ounces of gold; roughly seventy percent went to the Europeans on the coast, thirty percent to the north (Garrard 1980:163). These commercial relations served as a vehicle for cultural exchange among the Akan, European and Muslim peoples of the Western Sudan.

The gold trade also played an important role in the evolution of many Akan political and social institutions. Indeed, the founding of the first Akan states was largely a response to the growing necessity of organizing and controlling the production and distribution of gold. Among the Akan, at least until the end of the nineteenth century, gold was equated with power; the higher one's rank and social position, the more gold one had. Akan society is comprised of three basic strata: an elite, commoners and slaves. Each strata, in turn, contains ranked members. Among the elite, for example, there are paramount chiefs, queen mothers, lineage chiefs, military leaders, court officials, village chiefs and priests. Political authority is centralized, focused around the paramount chief who rules with the assistance of various grades of sub-chiefs who have specific military or political responsibilities. A cadre of court officials help with administrative duties.

Gold, which defines wealth, status and authority in Akan society is, not surprisingly, the major material of regalia—that complex of objects that belongs to a particular office and serves as its symbol. Since all regalia at some level is associated with gold, the accumulation and display of regalia effectively asserts one's position; the greater the chief, the more extensive his collection of regalia.

The most magnificent regalia collection is associated with the Asantehene, the paramount chief or king of the Asante. During the eighteenth and nineteenth centuries, the Asante pursued a successful policy of political and territorial aggrandizement that led to the domination of much of southern Ghana and eastern

Ivory Coast. By the end of the eighteenth century the Asante nation (a confederacy of several Akan states) had become one of the greatest political powers ever known in West Africa.

As indicators of the high status of Asante chiefs, certain objects and design motifs were reserved for their use. Thus there are special types of stools and textiles that only the Asantehene may use. An episode from Asante history illustrates the great importance these objects had as symbols of authority. During the second decade of the nineteenth century, the people of Gyaman, an Akan state in eastern Ivory Coast, attempted to shake off the yoke of Asante domination. Their rebellion was initiated in 1811 when the paramount chief, Adinkra, commissioned a gold stool, thereby opposing the existing law which forbade anyone except the Asanthene from owning such an object. Hearing of this defiant act, the Asantehene, Osei Bonsu, ordered Adinkra to destroy the stool. According to tradition, even though Adinkra heeded this demand the rebellion did not end, and in 1817- 1818 Osei Bonsu led an Asante army to Gyaman, and Adinkra was defeated. Today, a gold casting representing Adinkra is suspended from the Golden Stool of Asante (figure 92).

The historical dimension of Asante regalia is as significant as the authoritative, and court historians maintain information pertaining to the provenance of a chief's regalia. Regalia is inherited from a chief's predecessors but each new Asantehene is expected to enrich the collection by commissioning new objects. In this way motifs devised to celebrate the rule of a particular chief or to commemorate a significant event during his reign eventually became a prerogative of his successors. In addition, since the regalia of a chief defeated in battle would be distributed among the chiefs loyal to the victor, a large portion of a state's regalia can be associated with other peoples and rulers. It is held, for example, that the Asantehene's *dwete kuduo*, a silver container that is always set to the king's right when he sits in state, was a trophy taken by the first Asantehene, Osei Tutu, in one of his early military campaigns. Such an object thus serves as a potent symbol of Asante domination as well as a historical marker. Until the end of the nineteenth century, objects of regalia also moved around as political favors, distributed by chiefs who wished to reward or influence rulers of peoples who had come under their political domination.

Stools and other forms of seating, swords, counselor's staffs and umbrellas comprise the major items of regalia. Of these, the most important is the stool (figure 93). The political significance of the object is derived from its meaning in Asante society where stools are much more than seats. A stool used for everyday purposes is commonly referred to as a "white stool" because it is carved from light-colored wood. These stools are used only by their owners since the Asante believe that an individual shares part of his or her spiritual being with the stool. This relationship between stool and owner can continue even after death.

When a chief, priest or other important individual dies, his or her personal stool is transformed into a "black stool"; that is, ritually blackened by using a mixture of soot and eggs. After this treatment it is set in a room with the stools of the ancestors (figure 94). The spirits of the ancestors, venerated in this stool room, are believed able to influence the health and prosperity of the family, community and state. At specific times of the year, chiefs are expected to visit the royal stool shrine and present offerings to their predecessors.

Asante stools owned by the general population are usually between twelve and eighteen inches high and carved from a single piece of soft, white wood. They have a rectangular base, a central support, and a rectangular seat that is generally larger than the base and turned upwards at either end. The base and seat are relatively standard but there is considerable variation in the central support depending on who owns the stool and how it is used. Some designs on the support are for men or women and certain motifs are reserved for chiefs. At one time the image of a leopard or elephant could only be used by the Asantehene, but today the rules governing the use of motifs are

no longer followed; one finds women using men's stools and commoners using stools whose designs were formerly reserved for chiefs.

The leopard or elephant as a symbol for the Asantehene is one instance of how the Asante closely associate visual imagery with verbal communication. Since the leopard and the elephant are perceived as animal-world counterparts of the chief, images of these creatures provide a means of indirectly referring to the individual who sits at the pinnacle of Asante society. To comment on the supremacy of the chief, therefore, one might refer to the image of the elephant and say, "After the elephant, there is no other animal." Not all references, however, are this direct. A stool reputed to have belonged to Asantehene Kofi Kakari, who reigned from 1867 to 1874, is called "circular rainbow" (figure 93). The name comes from the central element, an openwork cylindrical post surrounded by four arched supports. The motif refers to the proverb "The rainbow is around the neck of every nation," which stresses the Asantehene's role in controlling and uniting all of the states that comprise the Asante nation (Cole and Ross 1977:137).

The Asante can call on thousands of such proverbs or aphorisms to illustrate a point or punctuate an argument, but as it requires great skill and intelligence to effectively use proverbs, those who do it well command high respect. Virtually every motif encountered in Asante art carries (or carried) these messages but many, especially those associated with abstract motifs, have been forgotten. Even when the subject of a visual image is easily recognizable it can be difficult to link it with a specific verbal meaning, since different, or even contradictory, interpretations can be summoned depending upon the context. The image of a crocodile with a mudfish in its mouth, for example, may refer to the proverb, "When the mudfish swallows anything, it does so for the crocodile" (that is, a chief benefits from the achievements of his subjects), or alternatively, "Only a bad crocodile harms the mudfish with which it shares the river" (that is, only a

bad chief mistreats his subjects) (see figure 17).

Since stools, for the Asante, function as the symbol of political authority *par excellence*, the images they carry can, in addition to making a general statement about the political and social status of its owner, carry a more specific message. Ceremonial stools of chiefs are easily distinguished from those of commoners by their large size and sumptuous gold or silver repoussé decoration. The royal stool may be likened to a combination of the crown and throne of European monarchies. When an Asante chief assumes office he is "enstooled." "Stool property," like the European "crown property," indicates material belonging to the office—of chief or king—rather than to an individual. When an Asante chief is enstooled, an important part of the ceremony involves his assuming the responsibility for the state's regalia.

The Golden Stool (*Sika Dwa Kofi*, "Gold Stool Born on Friday") is the paramount object associated with Asante authority and power (figure 92). Considered more important than the Asantehene himself, no one may sit on it. When carried or presented in state it is surrounded by its own regalia and attendants. It sits on a special chair which in turn rests on a large piece of elephant skin. Suspended from the stool are brass bells, protective amulets and gold figurative castings representing vanquished enemies.

The Golden Stool is also the supreme symbol of the Asante nation, which was formed late in the seventeenth century when a number of autonomous Akan states, in what is now central Ghana, formed an alliance to fight for independence from the then-powerful and oppressive state of Denkyira. The leader of this alliance was Osei Tutu, the chief of the state of Kumase. During this tumultuous period, the Golden Stool, it is said, was conjured from the heavens (on a Friday) by the priest Anokye. Descending from the sky, as a gift from the supreme deity, Nyame, the Golden Stool reputedly settled on the knees of Osei Tutu thereby sanctioning him to lead the alliance. The Asante believe that the spirit of their nation resides within the Golden Stool and it continues to serve as a symbol of national unity.

Chairs which are found in the palaces of chiefs are related in function to stools but have no religious significance. Unlike stools, however, the chairs are based on European prototypes (see figure 97, center). One type, *asipim*, used by those meeting with the chief, is a wood-frame chair with a piece of animal hide stretched over the seat and back, and decorated with round-headed brass nails, cast brass finials and occasionally repoussé brass bosses. Two other types of chairs are owned and used only by senior chiefs. One of these chair types is derived from a folding chair while the other has the same basic form as the *asipim*, but both are larger than the *asipim* and their decoration more sumptuous, often incorporating cast or repoussé motifs rendered in gold or silver.

State swords, as items of regalia, are second in importance only to the chief's ceremonial stool. Different types of swords are used in various contexts. Asante chiefs own a number of swords that function as symbols of their authority rather than as weapons. The basic sword, whose form may derive from Islamic weapons from the Middle East, has a curved iron blade, usually about three or four inches wide, set in a dumb-bell-shaped wooden hilt (figure 17). The hilt is covered with gold leaf and the blade rests in an animal-skin scabbard. A representational gold casting is often tied to the scabbard and carries proverbial meaning alluding to the power or character of the chief. One of the swords belonging to the chief of the Asante state of Kumawu, for example, has an ornament representing a crocodile with a mudfish in its mouth, a motif whose proverbial associations are discussed above (figure 17). Other gold castings represent trophy heads of vanquished enemies such as Worosa, the chief of the Nafana state of Banda who lost his head in 1765 to Asantehene Osei Kwadwo.

Swords have particular importance in maintaining political relations. Some, used by messengers sent on diplomatic missions, provided evidence that the carriers represented a specific chief. Generals, when selected by a chief to lead a military campaign, were given another type of sword. The Asantehene owns a group of twelve swords which fall into two types; the first is used in rituals directed at purifying the Asantehene's soul and the second for oath-swearings by a sub-chief when pledging allegiance to a senior chief. These ceremonial swords often have multiple openwork blades whose shafts have been twisted into knots or worked into the forms of snakes, and they may also have multiple wooden handles.

Items of regalia known as message sticks or canes were introduced by Europeans on the Gold Coast during the early eighteenth century. These sticks provided credence for envoys carrying messages between Europeans and Asante chiefs. The canes, usually straight shafts surmounted by a decorative silver finial, were given to chiefs as gifts and quickly assimilated into the panoply of the state. European and Asante traditions merged around the end of the nineteenth century to create a new item known as the counselor's staff; a figurative finial was added to the stick and the entire staff covered with gold foil (McLeod 1981:95-101) (figure 90). Owned by the chief, these staffs are carried by court counselors who serve as advisors, historians, and as intermediaries between the chief and his subjects. The counselor's staff is usually between four and six feet in height and constructed in two or three pieces. The detachable finial depicts various subjects that often allude to the chief's role in society. One finial, owned by the chief of the Fante state of Abeadze Dominase, displays a leopard with a musket in its mouth standing over a fallen hunter (figure 90). The proverb associated with this scene, "It is better not to have fired at all than to fire and only wound the leopard," warns that "power must be used judiciously and with precision" (Ross 1982:64). Another popular motif depicts a human hand holding an egg which notes that ruling a nation is like holding an egg: "If one grips the egg too tightly it will crack, but if one's grip is too loose it will fall."

Umbrellas, which provide shelter from the sun and signify the presence of an important object or person, are owned by all Asante of rank (figure 91). Like other Asante regalia, the size of the umbrella, the materials from which

it is made and the verbal symbolism associated with it are indicative of the owner's status. Like the state sword, the umbrella is believed to derive from traditions found among Muslim peoples of the Western Sudan and Middle East. The state umbrella, which is the largest of several types, has a dome-shaped canopy and hanging valance; both usually are made from velvet and other sumptuous imported fabrics. These umbrellas are surmounted by a detachable gilded finial that carries verbal-visual symbolism associated with the state and political authority.

Other categories of Asante regalia are intimately associated with gold but not made of it. All of the paraphernalia used to weigh, store and transport the chief's gold falls into this category. A chief's gold-weighing kit, stored in a section of elephant hide, includes weights (figure 97), balance scales, spoons, blow pans and small boxes for storing gold dust. A chief's kit differs from those of commoners only by the inclusion of the heavier weights needed to transact state business. When the chief's gold-weighing kit is taken from the palace it is placed inside a pair of wallets made of finely tooled and embroidered leather. Found in the treasuries of only the most powerful Akan chiefs are wooden boxes decorated with round-headed brass nails or brass repoussé work similar to that found on royal chairs, used for storing large quantities of gold dust.

Gold dust and other valuables associated with wealth and status would be stored in *nkuduo*, containers made until the end of the nineteenth century using the lost-wax process (figure 95). In the early days of the northern gold trade, Mande merchants imported various types of objects made of brass, an alloy unknown to the Akan before this time. Exotic brassware, like fourteenth- and fifteenth-century bowls and basins manufactured in the Middle East, served as the prototypes for the earliest *nkuduo*. These containers range from simple cylindrical bowls to elaborate hinged and hasped coffers. The ornate examples have lids incorporating three-dimensional figural compositions of leopards, elephants, crocodiles and other creatures—

familiar motifs undoubtedly associated with oral tradition. The scene depicted on the lid of one *kuduo*, which may have been made for Asantehene Kofi Kakari during the second half of the nineteenth century, portrays a chief sitting on a stool, smoking a pipe and surrounded by his retainers (figure 95).

Cloth, like gold, functions as a symbol of Asante wealth and status. *Kente* is the name generally given to a cloth that is produced on horizontal treadle looms (figure 10). Like lost-wax casting, the introduction of this loom was probably associated with the early northern gold trade and this weaving technology was fully integrated into the Akan aesthetic system. The loom generally employs two sets of heddles to yield three-inch-wide strips that are cut and sewn together to produce large cloths. By manipulating the weft threads, Asante weavers are able to create a huge array of intricate multi-colored patterns. Until recently, silk threads (obtained by unraveling imported fabrics) were used to produce luxurious textiles. Cloths incorporating exceptionally complex designs were reserved for chiefs. The relationship between visual and verbal images observed in other contexts also occurs with *kente*, where each pattern is named. The cloth as a whole, combining a number of patterns, is often given a name which is associated with a particular person (usually a chief) or event and thereby carries historical significance.

When a chief appears in public he wears cloth made either of sumptuous imported fabric, such as gold brocade, or a richly-patterned *kente*. Much of his adornment is cast or covered in gold and all of it reflects his position in society. Jewelry includes cast gold finger rings, necklaces, armlets, bracelets and anklets (figure 89). Headgear and sandals are studded with gold ornaments, and Muslim amulets, used for spiritual protection, are often integrated into the ensemble. During processions, chiefs are carried on a litter comprised of a straw basket suspended between two wooden poles and supported by four carriers.

The more important types of Asante political regalia have been discussed above but there are

many more which could have been included: most senior chiefs also maintain guns, shields, knives, fly whisks, drums, side-blown trumpets, so-called "soul-discs," smoking pipes, and imported silver-plate vessels. Dramatic displays of all this material occur at public functions when the political elite gather, such as the annual new-yam festival or the visit of an important dignitary (such as the President of the country). On these occasions, the chiefs parade before their subjects surrounded by their retainers who carry the regalia (figure 91). At such times, the relative status of each chief within the political structure of the state is reflected in the size of his entourage.

Regalia among the Asante is inextricably tied to ideas of wealth, status, power and authority. The vast array of meanings and forms carried by objects represent the richness of both visual-verbal communication and cultural confluence. Regalia can be read on a number of conceptual planes—symbolic, historical, mythological and proverbial. This complexity of meaning elevates the significance of Asante regalia far beyond the relatively simple limits defined by wealth and power.

Confluence

The North American Plains

As noted earlier, the culture which flourished on the North American Plains from about 1750 to 1850 depended on two key elements of European technology: horses and firearms. Before this time hunters had to exploit the vast protein resources of the region, notably bison, either on foot with only spears and arrows or by controlled stampedes whereby large numbers of bison were maneuvered over a cliff and killed simultaneously. While all precontact peoples on the Plains hunted bison, some, primarily those in the eastern section, were settled farmers (see map, page 140). The conditions of the western Plains discourages most crops except those related to grasses, such as wheat. With the introduction of horses and guns, however, some Plains peoples such as the Crow and Cheyenne "retrogressed," giving up a sedentary agricultural way of life to become full-time hunters. While some Plains peoples had used various forms of portable housing before 1750, most permanent habitations now gave way to the eminently portable skin-covered lodges, called tipis, which could be erected and taken down quickly (figure 98).

Plains culture covered a vast area, and offered the appeal of a "jet- set" way of life—constant exposure to the stimulation of new vistas, new forms, and new ideas, with the excitement of hunting and fighting as central to their day-to-day existence. With firearms, it was relatively easy to kill an enemy; more difficult (and requiring more bravery) was counting *coup*—to get close enough to touch him and get away unscathed—or to drive off his horses. For some peoples the number of feathers they could wear in their hair or bonnet was a way of keeping track of such exploits. (Feathers—particularly those of raptorial birds such as eagles—have a long history in Native America as *POWER* materials, also alluding to the transformational capabilities and other accomplishments of the shaman.) Nor did Plains peoples completely abandon agriculture; cultivation of tobacco and other narcotics continued—another shamanic survival. But the distinctive blending and reinterpretation of old and new elements and functions is perhaps most clearly seen in the arts.

Figure 98. Fort Belknap, Montana, Sumner W. Matteson, 1906. Courtesy Milwaukee Public Museum, #43751.

So powerful and evocative were these manifestations of the Plains way of life in the sphere of art and material culture that the mounted Plains warrior with his feathers and buckskins has come to epitomize the North American "Indian."

The production of buckskin garments decorated with quills and other materials was women's work. Some were done with stalks of grass or bird quills, flattened and held in place with animal-sinew thread, others with small porcupine quills which came to predominate. The introduction of aniline (coal-tar) dyes made available a wide range of vivid colors. Panels down the front and/or sleeves of shirts, the side-seams of trousers, or the fronts of moccasins were developed with geometric designs of the sorts previously described as typical of women's art. Wisps of horsehair or scalp-locks were sometimes also attached to shirts, functioning as trophies (figure 101). (The taking of scalps—widely assumed to be an indigenous Native American trait—was in fact borrowed from Euro-Americans. As land was opened up to Euro-American settlement, displacement of Indians was sometimes encouraged by offering bounty for Native American scalps. The idea of scalping was appropriated by the Native Americans as part of their own complex of record-keeping.)

In addition to skin houses and skin garments, most other containers were also made of skin. The parfleche was a folded, rectangular skin envelope used to carry garments, feathers, and other valuables; its painted decoration involved the sorts of geometric forms typical of women's art (figure 99). Similar forms of painted decoration were often applied to cradleboard liners and the insides of elk- or antelope-skin robes made by (and for) women.

From an early date, imported glass beads augmented (and eventually supplanted) quillwork. Among the Cheyenne, beadworking took on a sacramental function. The Trade Guild of the Southern Cheyenne Women possessed and employed in their work various medicine-bags. The members of the Guild would bead walls (tipi liners or partitions), tipis, pillows or bedspreads in fulfillment of vows. The purpose of the vow had to be beneficent—as a cure or a marriage gift for a relative. Proscribed behavior had to be followed throughout the process. Plains people

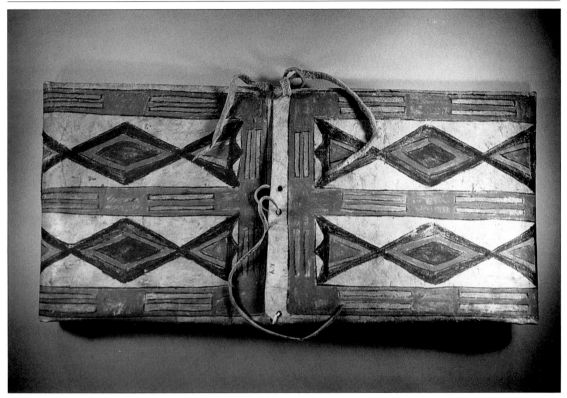

Figure 99. Western Sioux. Plains. Parfleche. Courtesy Southwest Museum, Los Angeles. Museum photograph.

generally had a very refined sense of the nature of sacrifice; with Cheyenne "sacred" beadwork, a woman submitted herself to the regimen of production and offered her creativity.

With the Sun Dance a young man could offer his ability to bear pain. [The name was derived from the sun-gazing ritual performed by the Oglala Sioux. The Dance was neither sun worship *per se* nor particularly sun-oriented.] These men, like the Cheyenne women, participated in response to personal vows. A vow to perform the Sun Dance might be pledged as an earth-renewal ceremony, a prayer for fertility, a reduction of risk in battle or as a relief from illness of oneself or a loved one. All who performed the ceremony—virtually all of the buffalo-hunting peoples of the high Plains—included prolonged dancing before a central pole in a specifically built enclosure. The young men were guided by experienced instructors. The Oglala Sioux and a few other groups would dance against skewers

put through the breast or shoulder muscles, and attached to the central pole or to buffalo skulls, until they ripped out (compare with the Maya; see figure 83). Some who became unconscious would be cut loose but the highest honors went to those who freed themselves.

It could be argued that contact with Euro-Americans both gave rise to Plains culture and eventually killed it off. During the early nineteenth century, North America increasingly became a refuge for the surplus populations of Europe. The government of the United States channeled these refugees into the "open spaces" of the Plains by offering free land to farmers and to railroad interests willing to develop transportation networks. In this context, Plains peoples became an inconvenience, stampeding buffalo-herds across farms, cutting fences, helping themselves to crops, and generally ignoring property rights. The outcome was predictable, including a systematic campaign to eliminate the bison—

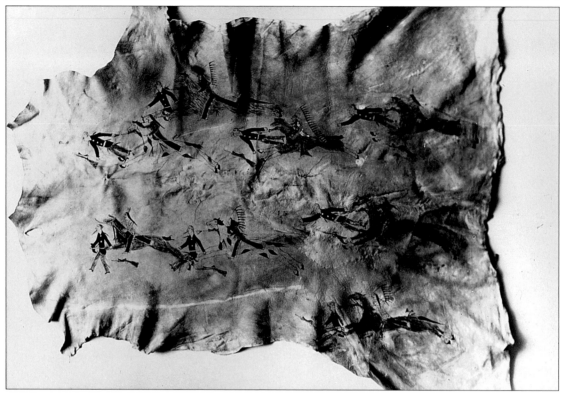

Figure 100. Cheyenne. Plains. Painted Hide. Courtesy Southwest Museum, Los Angeles, #33952.

Figure 101. Plains. Hair-trimmed War Shirt. Courtesy Southwest Museum, Los Angeles, #33951.

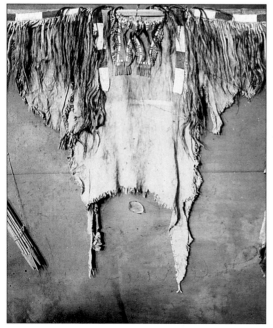

their primary economic resource and central cultural symbol—and a propaganda campaign portraying the Plains peoples as guilty of atrocities against settlers; as a result, they were boxed into ever smaller and less desirable territories. Plains peoples tried to resist this final annihilation, and the struggle was reflected in their arts—specifically, the narrative forms produced by men to record their feats and exploits—on robes, tipi liners, shields, and elsewhere (figure 100).

In the earlier and more traditional contexts for which Native North American men's arts were produced, experiences in the spirit world were usually the subject; for men of the Plains, representations also were oriented toward accomplishment in *this* world. Large animals, whose skins provided surfaces for these narratives, became increasingly scarce as the nineteenth century progressed, and record-keeping was transferred to sheets of industrially-produced muslin or ledger and account books

Figure 102. Plains Culture. Ledger Book Drawing by Howling Wolf (Southern Cheyenne). Book done at Fort Marion Prison, Florida. The drawing combines his traditional signature with the American flag and a written name. Courtesy Southwest Museum, Los Angeles, #CT 91.

(usually) seized by raiding-parties from army posts and farms (see figure 102). The primacy of supernatural assistance was a central aspect of Plains warfare. The notion was that the warrior had to open himself (through medicines, fasting, prolonged chanting, and other means) to the establishment of such relationships with helper spirits. One attribute of such power was the pictographic shield on which the beings and symbols involved were depicted (figure 103). Originally, these shields were discs of thick hide from the hump of a bull bison covered with fine buckskin upon which the motif was painted. The widespread use of firearms made these shields ineffective for physical protection. Consequently, the thick inner disc was omitted, and warriors carried into battle only the painted cover, thought to create a protective aura by virtue of the being or scene represented.

By the second half of the nineteenth century, Plains peoples had been reduced to depending on the federal government for food, clothing, and other necessities of life. They had been deprived of the freedom which was central to the Plains way of life, and were prevented from operating in "the real world." Some holdout groups escaped cultural neutralization by supporting the succession of the Sun Dance, the Ghost Dance. The Ghost Dance was performed to resurrect Indians killed by the Whites, to bring back the bison, and to displace the invading White settlers. Participants danced and prayed for days at a time; on fainting due to fatigue and emotional exhaustion, they experienced visions which were translated into spiritual motifs and symbols. These were drawn upon their garments—now made of government-issue muslin, thought to be protective and restorative.

The original manifestation of Plains culture

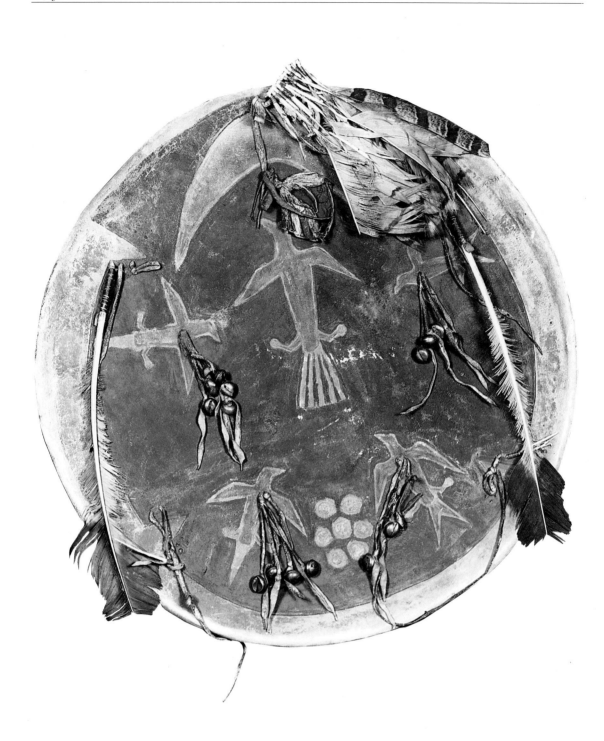

Figure 103. Cheyenne. Plains. Shield with representation of a layered universe (see Kan & Wierzbowski:1979). Gift of General George A. Custer. Courtesy Detroit Institute of Arts #76.144. Museum photograph.

perished in 1890 in the massacre, by United States government troops, at Wounded Knee of a group of Sioux who had come to surrender. But cultures are difficult to kill. The Native American Church of the Plains area may be the only religious body in the United States which has succeeded in convincing the government of the necessity of using peyote and other narcotics in its ceremonies. Inducing altered states of consciousness by such potent sacraments continues a very old Native North American religious technique. In most respects, however, the forms of Plains culture have been perpetuated without reference to their original meaning, such as the "war bonnets" or other gear presented to visiting dignitaries; buckskin garments and feather headdresses have been uncoupled from the integrated system of beliefs and practices which produced and sustained them.

Traditional Societies in the Modern World

Where conditions are favorable and something approaching an ethnic balance is possible, a culture may have adequate time and latitude to adjust and adapt alien forms. Under such circumstances, "confluence" can approach the utopian scene depicted in a sixteenth-century Peruvian vessel, showing three musicians—an African, a European, and a Peruvian—occupying a common ground (figure 104). At that time, European industrial civilization had not yet exterminated traditional forms. The Asante are a good example of a group successfully adapting over time to new cultural elements. On the other hand, a group such as the Plains Indians, whose core culture, given time, might have been sufficiently resilient and permeable to accommodate introduced elements, was devastated.

Responses in art to European imperialism often took poignant forms. In India, for example, a maharajah increasingly frustrated by English colonial expansion accomplished his revenge—after a fashion—by commissioning a six-foot long sculpture of a wooden tiger tearing at the throat of a prostrate Englishman (figure

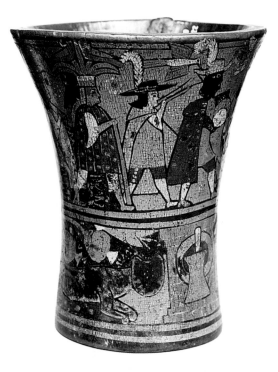

Figure 104. Inca. Peru, Colonial Period. Kero (wooden beaker). Spanish trumpeter marches between African drummer and Native American official. Courtesy Trustees of the British Museum (Museum of Mankind #1950 Am.22.1). Museum photograph.

105). The work contained an organ which produced the sounds of the attacking tiger and the agonies of his victim. Through arts produced at the interface between traditional societies and expanding European presences, we have abundant evidence that the artists were very much aware of what was happening to their lives (see Lips 1937 and Burland 1959).

In Ghana, as noted, adaptation has been generally successful. For example, as a counterpart to the traditional function of *kente* cloth in making social, economic, and political statements, modern (industrially produced) cloth is often printed with political slogans or even photographs of national leaders (figure 106). On the other hand, the impact of increased European patronage on more conventional forms of art—notably sculpture—has been dramatic. As

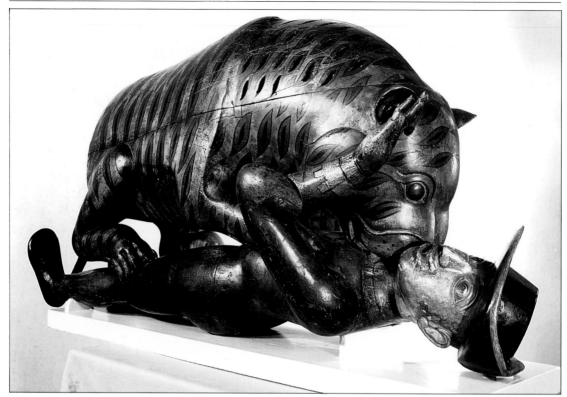

Figure 105. Mysore, India, 1799. Tipu's Tiger. Carved wooden effigy. Presented by the French to Tipu Sultan and Captured at the Fall of Seringapatam. Courtesy the Victoria and Albert Museum, London. Museum photograph.

Figure 106. Etsaka Area, Nigeria. Cloth with Portraits of General Yakubu Gowon. Courtesy UCLA Museum of Cultural History #X76-1776. Photograph, Richard Todd.

we have seen, objects in traditional contexts were characterized by a multiplicity of religious, social, economic and other associations. With the introduction of Christianity, wage-labor, new political forms, etc.—participation, in short, in the wider, interdependent world—these synthetic structures were shattered. Art-production for expatriate tourists and collectors—outsiders—increasingly takes precedence over traditional clientele. Significant changes in form have resulted in most cases, tending for the most part toward standardization, deterioration, or both. In a sense, the state of the arts can be taken as an index of the integrity and viability of a culture.

Some examples: ebony was not traditionally carved in sub-Saharan Africa, being too hard for the soft iron tools which were available. With the introduction of European steel tools, and a chronic need for jobs, an ebony-carving industry was developed in Tanzania and other parts of

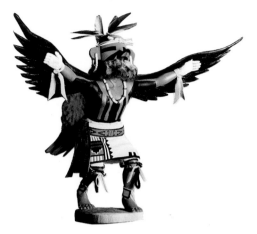

Figure 108. Hopi. Arizona. Eagle Kachina (Kwahu). Artist: Alvin James Makya. From Tanner (n.d.:6). Courtesy Manley-Prim Photography, Tucson. Compare with figure 64.

Figure 109. Akan (Fante). Ghana. Modern Akua'ba. Courtesy UCLA Museum of Cultural History #X65-1526. Photograph, Richard Todd. Compare with figure 96.

Figure 107. Tanzania or Kenya. Ebony Carving. UCLA Museum of Cultural History #X80-1176. Photograph, Richard Todd.

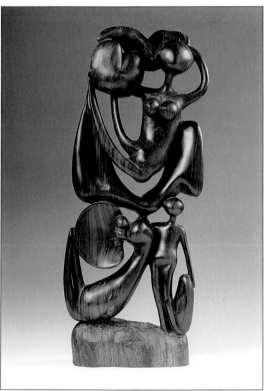

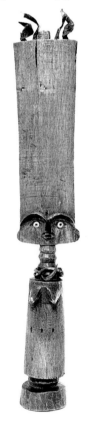

147

eastern Africa—which had no significant tradition of wooden sculpture. Fantasy, sensuousity of form, voluptuous surfaces, and a manufactured, nightmarish, "folkloristic" mythology characterize the designs, catering to European conceptions of artistic quality and—in particular —what African art should look like (figure 107). A similar tendency is evident in Inuit stone-carvings and prints, industries which arose under similar social and economic conditions. Recent kachina images from the Southwest abandon the austere, static forms and muted colors used in traditional contexts, employing garish poster-paints and exaggerated dance postures (figure 108). The heads of Akan *akua'ba* made for sale to Europeans exhibit angular contours and arbitrary details (including janus-faced examples; figure 109). Contemporary sculpture from the Senufo of West Africa produced for non-traditional markets exhibits a similarly attenuated elegance and arbitrariness. In general, collectors (who, for the most part come to "Primitive" art via Modern art) are less interested in normative, "classic" conventions than in those which deviate, which push at the boundaries of aesthetic invention. Such capricious tampering with sanctioned forms would, of course, be unheard of in traditional contexts, and clearly results from demand-pull rather than supply-push.

Convergence

A Reconsideration of Some Aspects of Contemporary Western (Southern California) Art

Zena Pearlstone

In the early 1970s, after four years of field work in Nigeria, Rubin began to expand his research interests to include American popular art and culture. He had learned, from his experiences in Nigeria, that art evolved from the core elements of a culture—daily experiences and accumulated tradition—rather than from the visions of individuals, and he felt the need to bring his African experiences "home." It is essential, he told his students, to look beyond contemporary Euro-American art that separates form from context.

In "Art as Technology" [1972] Rubin first set down the ideas that are central to this book:

> Intense experiential complexes abound in the primary literature on Africa, Oceania and Native America—ecstatic combinations of art and architecture, music and dance, feasting, psychoactive substances of one sort or another, and often more-or-less explicit sexual dimensions as well [see pages 51–54 on the *hevehe* cycle at Orokolo]. Within this frame of reference art is less about objects—or even combinations of objects—than about people, and the social and cultural matrix in which particular communities operate—their values, beliefs, expectations, aspirations, and conventions of behavior. The particular forms and gestures utilized by particular communities, and how and why they are chosen, matter less than that the combination of which they are a part "works," generating the altered states of consciousness through which "the order of the universe"—however conceived—is directly experienced.

Although perhaps unknown to observers whose experience of art has been limited to the Euro-American tradition, substantial progress has already been made in implementing principles of theory similar to those being discussed here. Anthropologists and other behavioral scientists have dealt extensively and in depth with these concerns. More recently, scholars grounded in the humanities have sought to combine the methods and perspectives of art history with those of anthropology in attempting to understand the art of Africa, Oceania and Native America. It is time to examine the principles involved and to determine whether they may be more broadly relevant—to test in depth, in other words, the technological model I have sought to develop.

To test his model, Rubin drew on his field research from Southern California. His work

was based on the premise that there is art in Euro- American culture that functions as it does in traditional African, Oceanic and Native American societies. This art, he felt, has been a part of our culture all along but because we stopped looking for "community" experiences, most scholars have assumed that such art does not exist. Rubin became involved with several Southern California art complexes. In 1971 he initiated a study of the Pasadena Tournament of Roses (Rubin 1979) and in 1972 began to document holiday offerings at Forest Lawn Cemetery (B. Rubin et al. 1979). His interest in body art, particularly contemporary tattoo, was generated by the seminar report of a student in 1976 (Rubin 1988). These primary research concerns were supplemented by reconsiderations of other Southern California phenomena such as the East Los Angeles murals and car customizing. His concluding course lecture drew on all of these artistic endeavors. Because he never committed this lecture to writing, the chapter as it appears here has been assembled from his published material, transcriptions made in consultation and from our conversations.

'DAY OF THE DEAD' PARADE

"Art," Rubin [1972] wrote, "represents a means of investing surplus resources, ultimately resolved into what might be described as available social and cultural energy, toward their capitalization." He saw community hopes and struggles surface in the art of Los Angeles' Hispanic population. The "Day of the Dead" parade recalls traditional phenomena in Mexico. The parade, first proposed and organized by three Mexican artists in residence at Self-Help Graphics, an East Los Angeles artists' workshop, as a means of unifying the Hispanic community and ensuring its survival, celebrates death as a reinforcement of the continuity between the living and their ancestors. Many members of the Hispanic community were called upon to participate: artists provided masks and costumes as did school children, and local performers, musicians and community residents provided additional talent and organizational services. Self-Help

Graphics organized the parade from about 1974 to 1981. They stopped when they felt that the community had reclaimed the event and that a central organizing body was no longer needed.

EAST LOST ANGELES MURALS

In the transformation of the Boyle Heights/ East Los Angeles *barrio* through the Hispanic mural-painting movement of the 1960s Rubin [1972] found support for his "art as technology" model (figure 110):

> The phenomenon apparently originated in the abundant graffiti which served primarily as declarations of territoriality by youth gangs contesting for [control of] the deteriorating neighborhoods. Regarded as eyesores by the municipal authorities and the landlords whose properties were so "defaced", these markers manifested definite characteristics of style and formal invention which were recognized and appreciated by connoisseurs [compare with New York City subway graffiti]. Organizing these qualities—and this energy—within the frame-work of the Mexican mural tradition (freely interpreted, including its Pre-Columbian, Colonial, and Modern phases), extensive suites of murals were developed on the walls of housing projects, schools, stores and offices. Symbols and motifs drawn from many sources were combined—one might say reprocessed or recycled—with little concern for purity of syntax or refinement of expression, but with considerable conviction and creative vigor. These raw materials and the investment of artistic energy were instrumental in bringing about a new sense of shared identity, social solidarity and ethnic pride. The murals have, moreover, become recognized landmarks in the Los Angeles cultural landscape.

This East Los Angeles "investment of artistic energy toward enhancement of social solidarity" offers an intriguing comparison with some of the *kponyugu* masks of the Senufo and related peoples of northeastern Ivory Coast (page 28, figure 7) which:

> combine attributes of power drawn from a wide range of sources in their natural world— the terrible maw of the hyena, tusks of the warthog, horns of antelope or cape buffalo,

Figure 110. Los Angeles. The Plumed Serpent Mural by Willie Herrón, 1972. Photograph Copyright Willie Herrón.

Figure 111. Los Angeles. "UCLA." University of California at Los Angeles Card Stunt. Courtesy UCLA Rally Committee.

leopard's spots, and others—in furtherance of their function as "anti-witchcraft machines": they periodically sweep the villages to drive out malevolent and self-aggrandizing spirits which threaten social order and harmony. That they are not perceived as "religious" seems to be indicated by the fact that their use is countenanced even in areas where Muslims are dominant (Rubin [1972]).

Both the East Los Angeles murals and the West African masks draw on the collective power and knowledge of the community. In both cases traditional, significant concepts and historical events are applied to the needs of the present, creating a collective identity which serves to unify the group.

CARD AND LIGHT STUNTS

In some community-oriented artistic endeavors, as opposed to the masks and the murals discussed above, the contribution of the individual gives way to the collective good. This experience is witnessed in contemporary society by the card (day) and light (night) stunts which are performed at UCLA football halftime events and many other places around the country and the world (figure 111). Here everyone does his or her part with one card or one light although none of the participants can see the glory of the whole.

LOWRIDERS

Rubin noted how the Southern California ideology of transportation and mobility affected communal artistic endeavors. Customized cars and hot rodding reached their peak in the mid-1950s. The connotations of "vehicles/travel/transportation" and "the magic in moving out" (compare with the introduction of horses onto the American Plains) had and has a special

Figure 112. Los Angeles. Customized car at Los Angeles Autorama. Photograph, Arnold Rubin, 1974.

resonance. Mobility is a way to escape; mobility implies options. These concepts are important enough that people look for ways to individualize their vehicles (consider personalized license plates). By the early 1970s the gangs of Southern California's Hispanic community countered the "hotrodder" with the "lowrider." The owners of these cars were motivated jointly by gang loyalty and the possibility of finding the perfect car. Resituated on tiny wheels, these cars went "low and slow," only a few inches from the ground. As opposed to Anglo cruising, which was destination-oriented, these cars, like the Hispanic *paseo*, were slow-motion oriented to show off the car and its occupants. These low-riding cars, however, are not only lowered but painted, often elaborately and often by hand, as well as refurbished and redecorated. And in mobile Southern California car customizing spread. Groups were organized to decorate and refurbish cars; some have velour interiors, chandeliers and bars. Cars came to be seen as works of sculpture and were elevated to uselessness—never driven, only shown with the trophies won in competitions (figure 112). In the same way Asante stools, as discussed above, are elevated beyond seats. Customized cars, like stools, were art forms people could create themselves—they were not related to the world of "fine art" or to museums. These were forms of expression and creativity that could be appreciated by one's peers.

BODY ART

Over the last ten years of his life Rubin delved increasingly into the artistic complexity of body art which, in Euro-American culture, until recently, was never considered as part of the realm of fine art. Rubin [1986] noted that throughout this book, in the arts of Africa, Oceania and Native America:

Figure 113. California. Back Tattoo (Japanese flower and water designs) by Ed Hardy, 1978. Courtesy UCLA Museum of Cultural History. Photograph, Richard Todd, 1987.

We have seen the variety of forms and traditions, and the range of functions which focus on the adornment of the human body—clothing, coiffure, jewelry, body painting, tattoo, cicatrization, and scarification. Whatever else they do, these impulses to alter the human body for purposes which are fundamentally aesthetic may be seen as global, and provide a basis for more extensive alterations of the environment. The sources of these impulses seem to be in observed relations between the individual and the natural and cultural environment in which he/she is situated, and the ways in which the forms available in these environments can be appropriated and manipulated. In terms of the scale of the work, the nature of the commitment, and the available sources, tattoo, in late twentieth century Euro-America, is among the most demanding of these forms, both for the artist and his client.

Body art in Southern California changed around 1960 when a Renaissance in the art of tattoo began to reflect the personal statements of individuals. More clients began to be tattooed by a greater number of artists, now using new pigments and drawing upon diverse images and designs. Previously, tattoo was characterized by what is called the "International Folk Style" where small, standardized, highly conventional stock designs were transferred, most commonly to arms and legs, by means of reusable stencils. The "International Folk Style" is also characterized by agglomerate designs, often executed by many different artists resulting in collections of conflicting styles, sizes and images with little attention given to the relation between the designs and the individual's anatomy. The emphasis was on high volume, "assembly line" operations.

The Tattoo Renaissance, centered originally on the West Coast, emphasizes customized designs for the individual. Japanese design triggered the first wave of this expansion, followed by a variety of traditional styles drawn primarily from the Pacific Basin (figure 113). Ethnic traditions became folk art and artists who tattooed, rather than tattooists who transferred, came to the fore. The clientele changed radically, from prisoners and sailors to members of the middle class. Women, increasingly since the 1960s, have become avid tattoo clients. Over time ethnic designs have been joined by custom designs derived from a large number of nontraditional sources, including the personal visions of the client. The designs and their placement on the body are determined by the recipient in collaboration with the tattooist (see Rubin 1988:233-5).

THE PASADENA TOURNAMENT OF ROSES

While tattoo is a personal/individual expression in some ways similar to the Plains Sun Dance (page 141), the Rose Parade is a *bona fide* community event. Even though an annual festival since 1890 (1989 marked the hundredth anniversary) and a ritual of reintegration, the Rose Parade, before Rubin's attention, was not previously considered worthy of art-historical study. The parade is comparable in meaning and intent to aspects of many ceremonies in Africa, Oceania and Native America which involve "similarly brief, intense experiences of a dramatically transformed landscape, marking nodes in the passage of time in the life of the community and leaving little or no material residue" (Rubin [1972]). The tournament appeals to vast numbers of people. In 1989 there were about one million people along the parade route and an estimated 350 million watching on television or via satellite. Rubin (1979:672-3, 675-6) summarized the parade as follows:

> The modern Tournament of Roses features up to sixty self-propelled floats, many of which reach the maximum dimensions allowed—fifty feet long by eighteen feet wide by sixteen feet high. The floats are decorated exclusively with fresh flowers and other vegetable materials in their natural state. Open automobiles, also decorated with flowers, convey the president of the Pasadena Tournament of Roses Association (which organizes the parade every year), the mayor of Pasadena, and the grand marshal of the parade, an invited notable who serves as symbolic master of ceremonies. The rose queen and six rose princesses ride a special float, also completely decorated with flowers. Twenty-two marching bands, numbering approximately 2,000 musicians and other personnel, appear in each parade, along with a maximum of forty-two elaborately costumed

Figure 114. Pasadena, California. Tournament of Roses Float, "The Wizard of Oz." Photograph, Arnold Rubin, 1973.

equestrian groups, consisting of about 250 riders, whose saddles and other tack must be heavily mounted with silver.

The parade starts precisely at [8:15] A.M. on the first of January, and travels a distance of slightly more than five miles through the center of Pasadena. More than 1,500,000 spectators watch the parade in person; many take up positions on Colorado Boulevard the afternoon before and spend the night sleeping on the sidewalk. The parade is televised by . . . national networks and . . . local stations; Canadian and Mexican coverage, along with . . . satellite transmission to Europe and the Pacific Basin brings the total estimated television audience to well over [300,000,000] persons. . . .

Unquestionably, the large number of enormous complex floats made each year are the most spectacular aspect of the parade [figures 114, 115]. The modern float can best be conceived as a huge three-dimensional collage, in which fresh flowers are used to realize complex color and textural effects. Sophisticated engineering techniques and a wide range of specialized materials provide a foundation for the flowered surface, and concepts often include intricate animation sequences. The application of flowers, many of which are extremely delicate and fragile, must proceed according to a very precise schedule, so that all blossoms reach their peak display simultaneously at 8:30 on the morning of January 1. The finished construction must be able to traverse, under its own power, a distance of slightly more than five miles. Finally, the float is designed for a life of three days, after which it is torn down and the process begins again.

The whole event represents a cross-section of popular culture in the United States, remaining conservative while indicating what is significant in peoples' lives. Involving an entire year's worth of organization, the parade is coordinated by the Pasadena Tournament of Roses Association, which has about 1,300 members. From the regular membership, twenty-five directors are selected who, with the mayor and vice-mayor

Figure 115. Pasadena, California. Tournament of Roses Float, "Great Day." Photograph, Arnold Rubin, 1972.

of Pasadena, act through an executive committee of ten to conduct the business of the Association. Typically the President will have served between twenty and thirty-five years and the other directors will have been in the organization for some time. Rubin felt that the main source of the association's strength was "the sheer number of active members, the initial momentum accumulated by the organization over its long history, and the extraordinary articulation and refinement of its structure" (see Rubin 1979:679, 707). Of the Association Rubin (1979:708) noted that "organizations resembling the Pasadena Tournament of Roses Association, similarly gerontocratic in structure, cohesive in function, and conservative in outlook are well known in the anthropological literature."

Rubin and a number of students researched the parade for five years during which time he drove three floats. He was later fond of describing the driving experience, likening it to the kinds of endurance and skill observable in African, Oceanic and Native American festivals. Since float drivers are hidden under the masses of flowers and constructions, they cannot see out and must have guides; they manage primarily by keeping their eyes locked to the center line of the road which has been painted pink. The drivers, who get no sleep the night of December 31, are confined to the inside of the float from about 5 A.M. to noon. Beginning at 8:15 A.M. the float moves at two and one half miles per hour for four hours. There are no bathroom facilities, making it necessary for the drivers to essentially fast and refrain from drink before the event. Participants are in a state that can be compared to some aspects of initiation rituals or sacred vows. When the floats turn the corner from Orange Grove Boulevard onto Colorado Boulevard, the drivers, who can see ahead at ground level, are confronted with a mass of television cameras and an unbroken tunnel of

157

people (many of whom have been there all night). The sense, Rubin noted, is one of other-worldly euphoria. All normal life is suspended. With the perfume of the flowers, the noise of the crowds and the motors, and the general exhaustion, one enters an altered state.

Rubin describes the Rose Parade as a cultural phenomenon such as we get in the rest of the world: it draws on mythology and creates mythology. Float themes include historical, patriotic, and religious subjects, topical humor, engineering *tours de force* (such as mobile ice rinks), and a wide range of exotic motifs, such as Gothic cathedrals and Japanese gardens (Rubin [1972]). The imagery can be esoteric—as in the "Hat Float" of 1972 which represented various kinds of headgear from the short-lived television series "Lidsville"—or universal, such as America the Beautiful or the Last Supper, the latter entered in 1939 by the city of Laguna Beach, reproducing Leonardo da Vinci's painting and using, probably for the first time, the petal-mosaic technique on a large scale (Rubin 1979:699). Each year sees technological advancements. In 1973 the "Wizard of Oz" float initiated now standard visuals; the character's heads moved and steam emerged from the tin man's helmet (figure 114). In 1988 some float designers flirted with novel ways of getting around the height restrictions—creatures would "unfold" vertically at specific times.

In 1972 Rubin drove and documented the evolution of the "Great Day" float sponsored by Libby, McNeill and Libby and built by Festival Artists (Rick Chapman, builder; Don Davidson, designer) (figure 115). The title of the float was derived from the theme—in 1971, "The Joy of Music"—which generally is announced in March; the selling of designs to sponsors begins soon after. Construction of "Great Day" began in June. The frame was comprised of a steel chassis truck engine and six-inch pipe sections. While the float design emphasized delicacy and a rich texture it involved heavy duty energy; thirty-nine conical rays revolved simultaneously (the barber pole principle) to create the appearance of radiating sunlight—one of the most complex animation systems installed in a Rose Parade float to that time. Once the complex engineering was completed, the chassis was painted to correspond to the color of the flowers. From mid-October to November polyurethane foam was applied (figure 116). Into this material flowers are inserted and seeds and leaves attached. Activity at the "Great Day" (and all float) location(s) rose to a pitch between Christmas and New Year's Day when the designers put in twenty-four hour days and hundreds of volunteers applied flowers and other materials. On the "Great Day" float each white spot was an orchid which in 1972 sold for about $20.00 retail. (The "Great Day" float organizers, however, had miscalculated the flowers' life span and they turned brown before the float got to the judges' stand.)

Rubin (1979:708-10, 674) saw the process and enactment of the Rose Parade as a parallel to many African, Oceanic and Native American ceremonies:

the concept of the pageant seems remarkably similar to that of the potlatch of the Northwest Coast of North America; vast quantities of vegetable gold in the form of the rarest, most exotic, and most expensive flowers which can be had, are sacrificed in a huge explosion of completely ephemeral manufactured objects as an expression of the community's sense of wealth, stability and well-being. . . .

The tournament's role in celebrating the ripening of the citrus crops is a feature that is shared with many other annual festivals. Also frequently encountered is the presentation of the nubile women of the group accompanied by a demonstration of physical prowess by the young men in the form of athletic contests. [The rose queen and princesses are chosen from among Pasadena students. They must be unmarried and emphasis is on "wholesomeness" and "typical American girls." The parade takes place on the morning of the Rose Bowl football game.]. The tournament's very reliance on living flowers as the primary vehicle of artistic expression, especially in midwinter, carries strong overtones of sexuality and fecundity; in biological terms, flowers function as ostentatious signals of sexual receptivity analogous to the estrus in mammals. Flowers, other vegetable materials, and feather ornaments of various sorts carry such implications elsewhere [see Williams 1940]. Each float and the parade itself, seems validly construed as a complex organism evolving in space and time, in terms

Figure 116. Chassis of "Great Day" Float Covered with Polyurethane Foam. Photograph, Arnold Rubin, 1972.

of a germination-growth-florescence-decline-decay sequence, for which the minimal design element, the individual flower, becomes a persuasive metaphor. . . .

Like other annual festivals—chronological markers which serve to punctuate and accent the passage of time and generations—the parade constitutes a powerful and unifying force for the community through a periodic reintegration of its members and reaffirmation of its shared values, ideals, and aspirations. Its occurrence on the watershed represented by the first day of the year provides a dramatic revitalization and renewal that have been sufficient to raise the spirits of residents, and guests, even during the darkest days of the 1933 economic depression. . . .

The Pasadena Tournament of Roses and its components, especially the floats, stand as the antithesis of elitist "art for the cultivated few." The tournament employs broad strokes and sweeping gestures . . . and does not require contemplation or critical elucidation. More conservative than avant-garde, and resting firmly on an unquestioned system of shared values, the tournament is nevertheless also responsive—on its own terms—to the currents of contemporary life, exalting its heros and affirming its fundamental verities in terms that are comprehensible, at some level, to all.

At the end of the parade all floats are taken to the post-parade area where thousands flock to view the constructions close up. After three days, they are taken apart. Analogous to the *hevehe* cycle of the Papuan Gulf (pages 51–54), these are constructions which must be destroyed; this is art made to die. But when there is death, there is usually rebirth. Specifically, themes and floats disappear only to reappear; five years after "Great Day" the "Hour of Power" float was designed with the same engineering concept of counter-rotating cones. Most important, however, is the fact that the continuity of the Tournament of Roses lies in renewal rather than retention.

Figure 117. Pasadena, California. Doo Dah Parade, "Ladies Against Women". Photograph, Arnold Rubin 1982.

THE DOO DAH PARADE

Rebirth of the Rose Parade surfaced in another form on Sunday, January 1, 1978, when the first Doo Dah Parade made its way along Colorado Boulevard (when January 1 falls on a Sunday the Rose Parade takes place on January 2) taking advantage of the audience expecting the Tournament of Roses. Critical, topical, highlighting the foibles of American society, Doo Dah opposes the Rose Parade. Run by a self-appointed "czar" the Doo Dah "intentionally [inverts] a number of key features of the dominant event. Where the Rose Parade [features] innocuous floral beauty and [emphasizes] competition and regulation, the Doo Dah Parade [is] associated with outlandish and unconventional behavior and [has] no rules and no prizes" (Lawrence 1987:124). Almost anyone (or thing) can enter. The Doo Dah Queen was one year a sixty-year-old former bar and hotel owner, another year a middle-aged housewife who volunteered, and a third, a female impersonator in an entry called "The Torment of Roses." As the parade expanded it moved to the Sunday after Thanksgiving, banned motorized vehicles except wheelchairs, and because of city time limits restricted itself to 125 entries—"First come, first served" decreed the czar. Over the years some entries have come to be well known. Those which have caught the public fancy include the Marching Leech Kazoo Band whose members dress as giant blood-suckers, a Richard Nixon impersonator carrying a sign reading "I'm No Crook!", Ladies Against Women carrying signs such as "Ladies—Rock the Cradle, Not The Boat" (figure 117) and the Synchronized Briefcase Drill Team—bank officers dressed in executive suits and managing precision drill performances with their briefcases so successfully that they have appeared on television shows and in a rock video. With an increasing array of presentations and a

Figure 118. Los Angeles. Forest Lawn Cemetery, Christmas 1986. Photograph, Zena Pearlstone.

mushrooming audience the Doo Dah Parade has become a major counter to the Rose Parade.

FOREST LAWN CEMETERY

Like renewal, maintaining contact with spirits and ancestors is embodied in the community festivals of Africa, Oceania and Native America. This kind of contact can be observed every year in Southern California alongside the towering trees, memorial architecture and substantial statuary at the Forest Lawn Cemetery in Glendale. Here, on major holidays—Christmas, Easter, Mother's Day and Memorial Day—relatives and friends come to refurbish and decorate gravesites with ephemeral and homemade constructions. They cut back grass and weeds growing over the markers of the dead, polish the bronze until it shines and then leave their remembrances. As appropriate to the season one can find egg-carton crosses (figure 118), gilded macaroni

Christmas trees, a letter and five pennies for Baby Bobbie, an Egg McMuffin, a sock-doll Baby Jesus, a wind-up helicopter, scattered bread-crumbs and the birds and squirrels they attract, Easter bunnies, cardboard rabbit ears or a great yellow chrysanthemum with stick-on eyes (see B. Rubin et al. 1979:65-6). In Babyland, a section of the cemetery originally set aside for young children and where space is no longer available, today's youngest occupant would be fifty years old and the oldest more than seventy, yet offerings still appear regularly at many of these grave-sites. Such gestures of love and respect for the dead seem to be as old as humanity itself. Rubin [1972] saw this art as meeting profound human needs:

> Graves are often groomed on these occasions, and appear to be the objectives of family pil-grimages. Although crosses and other religious symbols are included among the offerings . . .

the majority of such offerings do not seem to be fundamentally religious. Other conventions predominate from flowers, highly generalized and fundamentally affirmative references to rebirth and renewal, to flags, declarations and reinforcements of shared heritage and identity, to styrofoam Easter bunnies and plastic Santa Clauses. . . .

Approached objectively, Forest Lawn clearly offers an abundance of cultural and behavioral data which far outweighs in its implications any proposed ''breaches of taste'' or ''aesthetic deficiencies''. . . . It must . . . be acknowledged that plastic Santa Clauses and styrofoam Easter bunnies comprise the forms and concepts which mass culture and mass production have furnished to meet what is obviously a deeply felt need, a need which ''fine'' artists—painters and sculptors—are not meeting.

Rubin felt that the phenomena discussed above, with their universal intents and motivations, unite all people geographically and temporally. In May 1986 he transcribed the following for me to read to his class:

Consciously, willingly, unconsciously or unwillingly, every person can and does participate in a web of decision-making about art and material culture analogous to that which has been at the core of this book. This is, moreover, not a remote, esoteric abstract phenomenon of the sort usually termed ''aesthetic.'' Rather, it is bound up with every community's most fundamental social, political, economic and spiritual values. Our objective, then, drawing upon a series of ''case-studies,'' has been to try to raise the process to a conscious level, so that these decisions, small and large, can be informed rather than reflexive. In this sense, the forms and functions involved provide more than channels of access to the ways of life of peoples of other times and places. Given the manipulative approach toward social and cultural forms which characterizes late twentieth-century man, the experiences of other peoples provide essential information on available options and some of what seem to be the consequences thereof. So, whatever else we can say, this is clearly not. . . .

Courtesy UCLA Rally Committee.

Appendix

The Return of Ritual*

Ted Kaptchuk

Both faith and ritual are terms borrowed from religion, but they do not signify the same thing. Faith is one of the ways in which people are healed; ritual, among other things, is what makes faith work.

Why are some people affected by faith healers and others not? Why were some saved by Mesmer's magnetic fluid, others by Hahnemann's potentised potions, and yet others by the balance of water and fire? For that matter, why does it seem that penicillin is so dependable? 'Magic bullets' heal, not people, but a particular disease state of people. They are powerful substances that cause change based on physical, chemical and biological laws independent of human will, imagination or belief. Drugs are dependable, repeatable and work most of the time. They have a magical ability to transform an undesirable state to a desirable one. But science is not the only magic that mankind has developed —only the latest, most successful and mechanical form of it. There are other types of magic

that require participation, intention and engagement and a non-scientific sense of the sacred and the special. They can coerce and persuade, perhaps not as reliably as penicillin but nevertheless with their own force. And they have much to do with healing.

Ritual is nothing less than magic, and that magic includes the most powerful medicine known, the placebo; it includes myth; and it includes 'the word', my term for the shared experience of the healer resonating with the healed. Ritual is performance using symbols of what is thought to be powerful in the cosmos. This dramatic enactment changes the actual. It is part of all the healing arts, including scientific medicine. These are strong claims, for they seemingly run counter to scientific medicine's rejection of and separation from the subjective. Part of what I will say is that there is more to scientific medicine than science.

It is difficult to make the major mental shift that this statement entails without a shock. Perhaps in comparing the two true stories below you will experience with me the shock of recognition.

*From: *The Healing Arts: A Journey Through the Faces of Medicine* (1986).

In the early 1950s a new treatment for anginal heart pain was being introduced to surgical wards around the United States. It consisted of a dramatic form of surgery, not performed to remove something or to repair something but to shut off a perfectly good artery so that the body would stop being lazy and start using the smaller arteries to free the heart. Called 'mammary artery ligation', it showed early promise and the procedure quickly gained in popularity. Patients were performing better on exercise tolerance tests, showed a much more stable heartbeat on the electrocardiograph, and needed less medication. The success rate was reported to be 80 per cent, but then some questions arose and a double-blind clinical test was proposed.

In a double-blind test, neither patient nor examining doctor knows if a real medication has been taken or if surgery has really been performed. It is designed to eliminate the subjective element from a test, to prevent the doctor who wants it to succeed from unwittingly looking at the records more favourably, or to prevent the patient from being misled into thinking he is better, or actually being better because he thinks he should be. This is the placebo effect. In a double-blind crossover test the patients with and without the drug switch places a second time around. Obviously, this is not possible in surgery. It is rare, in fact, for any surgical procedure to be able to be tested double-blind. By today's ethical standards this arterial surgery study would not be allowed. Yet in the 1950s it proceeded, primarily at the University of Kansas Medical Center.

A notice was sent out inviting angina patients to apply for admission to a promising new surgical programme. Availability of places was said to be limited, and only those with seriously weakened functioning were accepted. The 'lucky' ones were told that medical scientists would observe the results of these operations closely.

At the hospital each patient was introduced to a team of total strangers, to whom he or she was literally entrusting his or her life. The patient was most dependent on the famous surgeon-scientist, an acknowledged pioneer in his field, resplen-dent in his white coat and stethoscope. The others accede to him, but they also have their special uniforms and nametags and hierarchy. The patient obeyed them all, undressing when told, eating and sleeping as commanded. The patient had never done this for anyone else in his life. He did not question anything, for he had been told that this was how he was going to be healed.

The night before the operation, the procedure was explained again. The patient was told why the surgery was necessary, what dangers it posed. The chances were good but there was no guarantee, and the patient had to sign a paper acknowledging that he knew the risks and was willing to give his 'informed consent', even though that was not yet the law.

In the early morning nurses assembled in his room to shave all the hair of his upper body, to bathe him vigorously with antiseptic soap, to inject him with antibiotics as protection against fever-producing microbes, to ply him with pills to make him groggy and to dry up his fluids, in fact to stun him into passivity. Bottles were strung around him with needles ready to be inserted in him at the proper time. He was then hoisted on to a trolley and wheeled to the operating theatre.

In a special room adjoining the theatre, the team made its last-minute preparations. The surgical team washed and dressed, tied up any long hair, put boots over their shoes and masks over their entire faces, leaving only their eyes exposed. Each one now raised his hands above his head and walked backward into the theatre, spinning around immediately in a dance-like movement to be put into a special gown from attendants. Sterile gloves were pulled over the hands. Each, like a vestal virgin, was now poised for his particular duty.

The patient was now made inert, lifeless, a non-person, with special gases that put him or her into an altered state in which only the involuntary bodily system functioned. The transition to health via a rite that recognises only flesh and blood can only come about if the person is reduced to flesh and blood.

When the body on the operating table was

no longer conscious, this was the signal for an index card to be passed to the surgeon. Selected at random, this card told whether the patient should be opened up for artery ligation or merely marked with the scalpel to create a similar scar indistinguishable from that of an operation. The patient had not been told about the cards and the possibility of a sham operation, nor would he be told.

The patient recuperated in the hospital, fully believing that he or she had undergone the life-saving operation. None of the hospital staff except the initiates in the operating theatre knew that some patients had not been operated on. The initiates had been cautioned never to talk about any patient and they were not permitted to see any of them outside the theatre.

One after another many operations were performed and an equal number were faked. The reactions of patients began coming in, from interviews and electrocardiograms. A picture emerged of the difference between the two groups. It didn't make sense: those receiving just the scars were significantly better! The advantage of this group over the group which had undergone surgery was exactly the same by both objective and subjective standards: the fake group had a 40 per cent improvement in its ability to exercise, electrocardiogram and reduction in medication, and a 100 per cent improvement in subjective evaluation of health; the 'real' group had corresponding figures of 30 and 76 per cent.

It sounds like good news: the 'sacred rites' helped both groups substantially. The *American Journal of Cardiology* (April 1960) reported the results with typical enthusiastic comments from members of both groups. But then came the bad news: the mammary artery ligation was considered a failure because it was no better than just giving a patient a scar! No one bothered to look into the reasons for success in *both* cases. The procedure was abandoned. Even if the ritual could improve a patient's ability to walk up the stairs or to reduce his medications and make him feel better, it was not to be done again. It sounds cruel and unscientific, if science means pragmatism. But we are obviously not ready yet for 'shaman surgery'

In the American southwest lives the most populous native [North American] tribe in the USA, the Navahos. Their ceremonies are famous for their colour, intricacy and fervour. Until recently between a quarter and a third of their productivity was devoted to religious chants, and most of that in times of sickness. A Navaho family was willing to pay for the services of the chanters with a substantial amount of its annual income, sometimes several years' income.

How would this tradition deal with a person having the same symptoms as an angina-sufferer? Consider the case of an older Navaho man who feels chest pains whenever he exerts himself and often has shortness of breath. Like the average American, he might rely on self-help measures for aches and pains, stomach upsets and colds, or he would call on his neighbour who had experienced something similar. The Navahos' equivalent of our over-the-counter drugs would be common herbs, which he might search for himself or trade for. There is a Navaho tradition of waiting for things to take their course, saying a simple prayer or trying a sweat bath. But for major illnesses and problems that seem to go on and on, like us the Navaho would go to an expert.

Their diagnostician, our medical equivalent, is called a 'hand-trembler'. The hand-trembler goes to the man's home and asks both him and his family about the illness. The trembler reaches into his bag and produces a 'medicine bundle' made of buckskin and containing coloured gems and stones, painted rods, corn pollen and eagle feathers. These tools will enable the trembler to unite himself with invisible spirit realms, where the significant things in life are decided. The trembler now takes a crystal in his palm, holds it above the patient, and with his eyes closed begins to chant and pray. The drone of the diagnostician fills the small room, as he searches his mind for the cause of the illness. It may have been witchcraft from an enemy, vengeance from one of the gods for not receiving due respect, or retribution for impure ritual or sexual activities. The trembler runs down the list of possibilities, aloud. The animal kingdom is significant: perhaps a coyote had urinated on a rock where

the man later sat, or ants trampled by a bear had touched him. Only when he thinks of bats does the diagnostician's hand begin to shake. He senses that the old man has chopped down a tree with bats living in it; and bats have a special significance to the Navahos as the messengers of the spirit world and as teachers. The trembler becomes quiet again, opens his eyes, and prescribes one of the thirty chants known to the Navahos, the 'Hail Chant.' He knows of no other for this malady, and he recommends a specialist, a chanter, the 'Navaho surgeon'.

And so, despite the expense, the family arranges for the chant ceremony in two weeks' time. The tent is cleared and in the four corners oak sprigs and corn pollen are placed. Ritual water is sprayed on the walls, and a herbal fumigation completes the cleansing. Relatives and friends will be invited to partake of little cakes made of the finest corn and resembling hailstones.

The ceremony begins as the sun disappears over the horizon, the symbol of time entering the realm of dreams. From now on there is to be no quarrelling, eating of corn dumplings or, for specifics, urinating facing north. The first two days are consumed in the purification ritual of the sweat baths. Four pokers point out of the fire to the four corners of the earth. Dancing over these, the assembled purify themselves of worldly faults accumulated over a lifetime.

Now it is the patient's turn. He is made to vomit and to clean his bowels by taking herbs. The suds from the soapy yucca cactus clean him, and fragrant herbs anoint him. A cacophony of drums, rattles, whistles made of the largest bone of the eagle wing (to make his spirit soar), and 'bull-roarers' made of wooden slates (to cleanse and strengthen him with their screeching) fill the room. The patient is moved to a public confession of his sins and his violations of taboos. The climax of the ceremony is now about to be reached, and the arena is purified and readied.

The third day begins with a new forcefulness in the drums and rattles. Now the songs begin, acted out with gestures and stances. Reeds are lit—filled with fragrant plants, bluebird feathers and native tobacco—as a sign to the gods. And

the patient is identified to the gods by the eagle and owl feathers, as well as snake-like painted sticks, placed on him. The gods are also offered refreshments in the form of cornmeal figurines in the shape of porcupines and snakes. If everything is done precisely the gods will perform their healing act.

The chanter is the key. His songs tell the story of Rainboy, a Navaho hero. Sometimes it sounds like a morality play, at other times like *Star Wars*. It starts with the simpler Rainboy, an innocent gambler, getting into all sorts of small scrapes. Rescued by the humblest of the Navaho Holy People, the Bat, Rainboy eventually wanders to a strange land ruled by the White Thunder God, master of the rare winter thunder. Out of nowhere, the wife of White Thunder lassoes Rainboy with a preternatural rainbow, and seduces him. Contorted by jealousy, White Thunder takes revenge. He smashes Rainboy into small pieces, scattering them in all directions. But the other gods take pity on the innocent Rainboy and a war ensues between them, the kind Holy People, and the angry White Thunder and his allies. This cosmic clash creates the Navaho map and their customs once and for all. The battlefield is the sacred space of the Navaho; the only real time is this 'main event'. A truce is finally established so that healing rites can be performed.

The bits and pieces of Rainboy are gathered by the Thunder People and placed between sacred buckskin. White Wind is put under the top cover and Rainboy starts to move but he can't get up. Now Little Wind enters the buckskin bed, giving Rainboy the power to hear and move his fingers. Talking God sends moisture under the covers so that the boy now has tears, saliva, perspiration and the use of most of his joints, but he still cannot arise. Another god blesses him with corn pollen to give him fingernails, toenails and hair. Insect and Spider People gather his blood and nerves. Still something is lacking.

The Holy People decide to undertake the four-day Fire Dance. Each Holy Person performs his own song and dance. Gradually Rainboy's parts become whole, and he emerges from the

covers. Now he is presented with gifts: he is to be in charge of rain, mist and holiness, of beautiful birds and the harvest. Once an ordinary mortal, now he is invited to join the Holy People.

Rainboy has made the full journey. He has gone to the Land Beyond the Sky, he has been dismembered, and he has been renewed by fire. Because he has known brokenness, his new intactness is different; because he has died he is now resurrected. But before he becomes a Holy Person himself he must teach the story of his journey and his healing ceremony to his brother and sister, who pass it down to the Navaho ancestors. This ritual of the timeless past is now being re-enacted for the old man, and to make it real the boy-hero himself will be brought to the tent.

So it is that on the fifth day the patient is told to wait outside the tent. Inside, long before dawn, the chanter begins to draw on the floor elaborate pictures made of multicoloured sands, representing the story of Rainboy: his encounters with White Thunder, with the other Thunder People, with the forces who have healed him, with Female Corn, Cornbeetle, God, Frog and Bat, all of whom embody the ultimate power and reality of the traditional Navaho. The chanter spends hours constructing this elaborate picture with pulverised stones of red, yellow, blue, pink, black and white. Unless each detail is correct the ceremony may be worthless or harmful.

As the sun rises the patient is called inside and told to sprinkle cornmeal on one picture and to recite prayers. Then he returns to the centre of the tent; the moment of transformation is at hand. The drumbeats and rattling become intense as the entire community squeezes into the tent. At last the chanter places his moistened hand on the sand picture and solemnly touches the old man. The patient is now one of the Holy People. He repeats after the chanter:

This I walk with, this I walk with.
Now Rainboy I walk with.
These are his feet I walk with,
This is his body I walk with,

That is his mind I walk with,
This is his twelve plumes I walk with.

The drumming, the chanting and the incense-burning continue. The progression of feelings goes from restored health via happiness to beauty. The chants continue all through the sixth day, and on the seventh they reach a glorious climax: 'In beauty I walk. . . . In old age wandering a trail of beauty, living again, may I walk. . . . It is finished in beauty. It is finished in beauty.' He is transformed into a god, and those around him with their own ailments are likely to be healed with him. For several days thereafter the old man stays by himself, leaving his hair unwashed and eating unusual foods. It takes time to return to his former human self, whole again.

I have described these two examples of the ritual of healing in considerable detail so as to make the point that what we see through modern eyes as superstitious twaddle may not be so different from our own rites. Granted, the surgeon does not intend the ministrations of his staff and the aura of his operating theatre to be ritualistic. But to the patient the effect of the smells of strange gases and antiseptics are like incense; the sounds of whirring motors are like drums; the monotonous voices over the intercom are like chants; the gowns and masks are like tribal costumes. The Navaho firmly believes that the chanter knows what he's doing, just as the angina patient has complete confidence in the art and science of surgical procedures. The distinction is that the surgeon has a different viewpoint of how he heals. I don't mean to suggest that fake surgery is an effective or ethical way to deal with disease; my point is that there is a strong ritual element in much of modern medicine. Ritualistic healing is not being squarely faced and examined.

John Powles, writing in *Social Science and Medicine*, asks if the coronary care unit so prominent in 'engineered' medicine is not as ritualistic as 'the magicians of old', in terms of its lack of scientific efficacy. He cites other examples, such as the doctor who knows that an upper respiratory infection is viral but prescribes an antibiotic anyway because his patient 'deserves

it.' He knows in his heart of hearts that his patients don't understand the difference between a virus and a bacterium, and may feel better just by being 'treated'.

Is there a way of getting a closer understanding of the potential power these rituals all share? Fortunately, a mass of information on this healing force has begun to accumulate in the most unexpected place, the scientific laboratory. It relates to that controversial subject, the placebo effect.

There is a long literature on the power of suggestion. In the 1920s many attempts were made to improve the conditions of people working in factories, and it was found that virtually any change would improve productivity simply because the workers were being attended to. In medicine, the drug explosion of the fifties began to put extreme pressure on researchers to prove efficacy as well as safety. Double-blind drug studies were introduced. In the United States, the Food and Drug Administration became notorious for its rigid standards, resulting in what the pharmaceutical companies called the 'drug lag' of five years and often more from the introduction of a new product to its approval and marketing. The way to show efficacy seemed to be to disentangle the 'real' properties, the chemically demonstrable effects, of a drug from the subjective state of the one taking it. As mentioned earlier in connection with sham surgery, this means testing two groups of people, both of whom believe they are taking the drug, though they are aware that they are part of a study. This subterfuge is carried out by creating a fake pill, identical in size, colour and taste to the real pill as far as is technically possible. Like the little sugared tablet given to children to please them, this pill is called a placebo, from the Latin 'I will please'.

In effect science was being asked, in the double-blind test, to confront, evaluate and discard that tiny ritual effect of taking a pill. As described earlier, the word 'double' refers here to the fact that the eagerness of the researcher/doctor to see a cure is also taken into account. The placebo effect implies both 'Wishing will make it so' and 'Knowing the expected answer induces one to see it.'

Herbert Benson and Mark Epstein noted in the Journal of the American Medical Association in 1975 that it was abundantly clear that the effect of the placebo was not only surprisingly strong but also consistent. About one-third of those people taking a placebo would be treated by it as well as if they had taken an effective medication. Strangely, the placebo seems to mimic other aspects of a drug: the better the drug the better the placebo is. It must also be emphasised that when the placebo works it works like the drug—that is, it actually makes physical changes in the body. It isn't that the patient simply believes his ulcer is better—it actually heals; or that the arthritic believes he can walk—his inflammation is actually reduced. Virtually any organ or physiological system in the body can be reached by the placebo effect. Inert though placebos may be, they can affect adrenal gland secretion, angina, blood cell counts, blood pressure, rheumatoid arthritis, vasomotor function, gastric secretion, insomnia, pupil dilation and contraction, respiration, fever, pain of various kinds, the cough reflex and even the common cold. There is nothing in the 'green pharmacy' or in the modern armoury of drugs with such power and versatility.

To see the placebo as simply an example of faith or the power of suggestion would be a mistake. It has a dependability and breadth of application that root it deeply in every healing process from surgery to the shaman, from chiropractic to Chinese herbalism. In attempting to discount its effect in healing, science has documented the technology of magic and displayed it like a wonder drug—which it is. The possible can change the actual.

The placebo works on many levels. It can be enhanced by the patient's perception of the healing performer. In an experiment with bleeding gastric ulcer patients, an inert pill was given to two well-matched samples, in the first case by a senior physician who characterised it as a potent drug; in the second case by a nurse who said that the drug might or might not be effective. The first group had an actual, not

imagined, recovery rate of 70 per cent, while that of the second group was only 25 per cent.

Packaging can have totally unexpected effects, too. The small white pill, perhaps because it is so common, performs the placebo effect the worst. The best are multicoloured capsules; if large, they should be brown and green; if small, red/orange or pink. The response also depends on the illness: anxious or phobic patients respond better to green placebos, depressives to yellow ones. If the pill is supposed to be a stimulant, you might guess that red and pink would perform better than blue. It has been shown that brand names like Disprin work faster than those which have merely a generic name like aspirin.

The placebo is a chameleon; it can turn itself into anything the healer wishes it to be, even if the effects are diametrically opposite. Asthmatic patients were told that an inhalant would induce asthma—it did; then they were told that there was another substance that would reverse the attack—it did. Both substances were the same, an inert saline solution. In a famous experiment reported by Stuart Wolf in the *Journal of Clinical Investigation* (again, one that would not be countenanced today), pregnant women suffering from nausea were given syrup of ipecac, which normally causes nausea by stopping stomach motility. They responded as expected, and a small balloon swallowed to enable their stomach contractions to be studied showed that motility had been reduced. The next day the women were given the same drug, but told it would stop nausea. It did, and the balloon showed that the contractions had increased.

As this example suggests, the placebo is far from harmless. In one of the early, double-blind studies of birth control pills, fully 30 per cent of those who took the placebo reported decreased sex drive. In this very large study there were also complaints of headache, increased menstrual pain, and nervousness and irritability. Other drug trials, reported in *The Annals of Internal Medicine* by D. M. Green in 1964, whose purpose was to test for drug effectiveness and not for side effects, have turned up such hard-to-imagine problems as constipation, skin eruptions, palpitations and hearing loss. And several studies

have even disclosed the unhappy news that there can be severe withdrawal symptoms after discontinuing an inert pill!

If the placebo is more than the power of suggestion, more than faith in science, or more than distrust of medications (as the negative effects might indicate), just what is it? Science has no answer yet. I think science cannot find an answer, because it is not the sort of thing that science deals with. For science, time is endless, space limitless, values relative and truth progressive. People are interchangeable and there is no room for enchantment. For ritual and myth, some part of space and time are qualitatively different from others. Connecting to 'sacred' time and 'charged' space is the driving force of magic. Science recognises itself by its separation from such subjective and special experiences, and our medicine men try to keep their distance from the placebo like a duck hunter who has just shot a skunk. The placebo and magic are more like a unicorn; they don't exist on the same level as ducks or skunks. The scientist wears a very special kind of sunglasses that filter out unicorns the way they filter out ultra-violet light. And if a unicorn somehow appeared, science would describe it as a horse with a large bump on its head. But the medical scientist will have to take off the glasses to see what Norman Cousins calls 'the medicine man within'.

In discussing the limitations of modern medicine, Powles suggested a direction we must explore if we are to understand the ritual of medicine that includes the placebo effect. He hints at the tendency of medical science to hold tenaciously to 'engineered' medicine, simply adding on *ad hoc* patches when confronted by something like suffering. He writes:

The problem of disease cannot be reduced to the purely technical one of the prevention and correction of biological malfunctioning. Nor is it sufficient just to add on the dimension of emotion . . . For in addition . . . there is the threat that disease poses to be the individual's sense of his own integrity and well-being. This existential challenge, in the ultimate, is the threat of oblivion.

Most recently, Eric J. Cassel has focused on the same issue, the larger dimension of suffering, in the *New England Journal of Medicine*. The actual disease or injury may be only a small part of the pain of suffering, he points out; suffering may also include the fear and the reality of devastating medical treatment, of social isolation, of disruption of life. In general, Cassel defines suffering as 'the state of severe distress associated with events that threaten the intactness of the person'. The philosopher Heidegger calls it 'being at issue'.

What the Navaho diagnostician and the sham-surgeon and the placebo in all its forms have to do with one another is the idea of intactness. It is this reality that the [Inuit] shaman, in Claude Levi-Strauss' famous commentary, 'The Sorcerer and His Magic', eventually stumbles upon. The shaman tells, in a published biography, how he decided one day to infiltrate the ranks of his fellow [Inuits] and expose their superstitious shaman practices. The more he learned, the more he realised that the shamans were indeed aware of the qualities of performance in their art. Yet they continued practising their magic because they genuinely believed that they were healing, and that their people would benefit from their rituals. Eventually he became a shaman himself, retaining his scepticism in his cortex but leaving it behind in his healing ministry to his people.

The Navaho 'Hail Chant' described above is a full-blown Wagnerian opera compared to the average scene in a hospital. It has the added trimmings of total community involvement, the cathartic component of confession, some herbal elements, and the sensually transforming force of music, dance, rhetoric and poetry. Is the chanter slightly sceptical of his own performance? Perhaps. But the difference between the surgeon and the chanter comes down to what part of the total healing experience each emphasises. The surgeon sees his healing world as 95 per cent physical and 5 per cent ritual. The shaman sees his world as just the opposite.

It is all too easy for anyone raised in Western culture to miss the fundamental dimension of life as seen by pre-literate people. The seven-day ritual of the 'Hail Chant' contains the essential Navaho truth, just as the tableau of Adam and Eve conversing with God and the snake in the Garden of Eden defines the identity of some of us. The tribe maintains its sense of intactness by surrounding itself with this vision of what existence is all about, immersed in both a close-to-nature and supernatural experience which we find hard to visualise. The essential content of the story of Rainboy is that dying is at the core of life, that brokenness is the core of wholeness.

Thus the 'Hail Chant' is far more than something designed to create the placebo effect, more than a mindless performance. Just as modern surgery is more than empty ritual and is concerned with removing tumours, attaching retinas and replacing joints, the Navaho ritual has its own real content. It connects the Navaho with his cosmos and allows for an experience of transcendence that can heal.

The myth, if we can call it that, on which bio-medicine operates is alien to us. It has no cosmology or meaning. Its forces are just as mysterious to the layperson as academic theology is to the average believer. It presents a face of remoteness and impersonal power, with marvelous terms such as X-rays and ECGs and CAT scans and the nuclear power resonator and positron emission tomography scanner—terms and names which would excite the imagination of Mesmer himself. We must believe that those demons are further barriers to annihilation, but they are not concerned with what is important in our lives. But they never let us get beyond being a bundle of statistics wrapped in human form. Our personhood appears as an irrelevant spectator. They are incapable of evoking in us what the 'Hail Chant' invokes in the Navaho, the experience of what it means to journey through life, and how that life can have intactness, vitality, cohesion and personal purposefulness. And so we have lost our feeling for the sacredness of the world, and our place in it.

Yet we continue to hold, as human beings must, to fragments of what was once our oneness with the world. Deep within each of us are personal myths that sustain and enrich the drama

of our lives. We have sacred places, too: our hometown, the place where we fell in love. And special moments: the last moment with a parent, the birth of a child. A sacred meaning need not to be pious or cosmic: it can be devotion to organic gardening or skill in embroidery. They are what activates our deepest part, enlists our commitment and connects us to the process of being alive. These personal vestiges of the sacred may not be as strong as the unified myth of a tribal people, but they are what makes it possible to live in a real sense. When we face the threat to our existence, they are what we most fear losing. Medicine that ignores this can never be fully healing.

There is one last lesson we can learn from the Navaho myth: healing ceremonies do not exist solely for redressing suffering. Sickness reaches down into the deep-seated paradoxes of the human dilemma and the healing ceremony is a way to the inner realm of the spirit, what the Navaho calls *biigistiin*, or the one who lives within. We might use the word 'soul'. Illness for the Navaho is the rare opportunity to intensify this journey to a deeper experience. It brings him to the source of his being, so that his brokenness can be transformed into intactness, so that our healing can encompass a reconciliation with our humanity beyond any question of just physical repair.

Bibliography

Adams, Richard E.W.
 1970 "Suggested Classic Period Occupational Specialization in the Southern Maya Lowlands." *Peabody Museum, Harvard University, Archaeological and Ethnological Papers* 61:487-98.

Anonymous
 1953 *Lands and Peoples*, Vol. 5. New York: The Grolier Society.

Anonymous
 1970 *National Museum of Anthropology, Mexico City*. Milan: Newsweek and Arnoldo Mondadori Editore.

Appiah, Peggy
 1979 "Akan Symbolism." *African Arts* 13(1):64-7.

Beckwith, Carol.
 1983 *Nomads of Niger*. New York: Harry N. Abrams, Inc.

Berndt, Ronald M. (ed.)
 1964 *Australian Aboriginal Art*. New York: Macmillan.

Bochet, Gilbert
 1981 "Mother and Child." In Susan Vogel, ed., *For Spirits and Kings: African Art from the Paul and Ruth Tishman Collection*. New York: The Metropolitan Museum of Art.

Boxer, C.R.
 1967 *The Christian Century in Japan 1549–1650*. Berkeley and Los Angeles: University of California Press.

Buehler, Alfred, Terry Barrow & Charles P. Mountford
 1962 *The Art of the South Sea Islands*. New York: Crown Publishers, Inc.

Burland, Cottie
 1959 *The Exotic White Man*. London: Thames and Hudson.

Carpenter, Edmund
 1968 "We Wed Ourselves to the Mystery: A Study of Tribal Art." *Explorations* No. 22: 66-74.

Charlesworth, Max, H. Morphy, D. Bell & K. Maddock
 1984 *Religion in Aboriginal Australia*. St. Lucia: University of Queensland Press.

Coe, Michael D.
 1987 *The Maya* (4th ed.). New York: Thames and Hudson.

Coe, Michael D. and Richard A. Diehl
 1980 *In the Land of the Olmec* (2 vols.). Austin: University of Texas Press.

Coe, William R.
1962 "A Summary of Excavation Research at Tikal, Guatemala, 1956–1961." *American Antiquity* 27:479-507.

1965 "Tikal: Ten Years of Study of a Maya Ruin in the Lowlands of Guatemala." *Expedition*, Bulletin of the University of Pennsylvania: 8(1):5-56.

1967 *Tikal: A Handbook of the Ancient Maya Ruins*. Philadelphia: University of Pennsylvania.

Cole, Herbert M.
1975 "The Art of Festival in Ghana." *African Arts* 8(3):12-23, 60-2, 90.

Cole, Herbert M. & Doran H. Ross
1977 *The Arts of Ghana*. Los Angeles: Museum of Cultural History, University of California, Los Angeles.

Colton, Harold S.
1959 *Hopi Kachina Dolls*. Albuquerque: University of New Mexico Press.

Cordell, Linda
1984 *Prehistory of the Southwest*. Orlando: Academic Press.

Crawford, I.M.
1969 *The Art of the Wandjina: Aboriginal Cave Paintings in Kimberley, Western Australia*. Melbourne: Oxford University Press.

Culbert, T. Patrick
1970 "Sociocultural Integration and the Classic Maya." Paper presented at the 35th Annual Meeting, Society for American Archaeology, Mexico, D.F.

Delange, Jacqueline
1974 *The Art and Peoples of Black Africa*. New York: E.P. Dutton & Co., Inc.

Diabaté, Tiegbe Victor
1981 "Helmet Mask (Kponyugu)." In Susan Vogel, ed., *For Spirits and Kings: African Art from the Paul and Ruth Tishman Collection*. New York: The Metropolitan Museum of Art.

Fanon, Frantz
1967 *Toward the African Revolution*. New York: Grove Press, Inc.

Farb, Peter
1968 *Man's Rise to Civilization as Shown by the Indians of North America from Primeval Times to the Coming of the Industrial State*. New York: Avon.

Fraser, Douglas
1972 "The Symbols of Ashanti Kingship." In Douglas Fraser and Herbert M. Cole, eds., *African Art and Leadership*. Madison: The University of Wisconsin Press 137–52.

Garrard, Timothy F.
1980 *Akan Weights and the Gold Trade*. London: Longman.

Gerbrands, Adrian A.
1957 *Art as an Element of Culture, Especially in Negro Africa*. Leiden, Holland: E.J. Brill.

Gerbrands, Adrian A. (ed.)
1967 *The Asmat of New Guinea: The Journal of Michael Clark Rockefeller*. New York: The Museum of Primitive Art.

Glaze, Anita J.
1975 "Woman Power and Art in a Senufo Village." *African Arts* 8:3:25-9, 64-8.

1981a *Art and Death in a Senufo Village*. Bloomington: Indiana University Press.

1981b Selected Essays in Susan Vogel, ed., *For Spirits and Kings: African Art from the Paul and Ruth Tishman Collection*. New York: The Metropolitan Museum of Art.

1986 "Dialectics of Gender in Senufo Masquerades." *African Arts* 19(3):30-9, 82.

Goldwater, Robert
1964 *Senufo Sculpture from West Africa*. New York: The Museum of Primitive Art.

Griaule, Marcel
1950 *Folk Art of Black Africa*. Paris: Les Editions Chêne.

Haselberger, Herta
1961 "Methods of Studying Ethnological Art." *Current Anthropology* 2(4):341-84.

Haviland, W.A.
1970 "Tikal Guatemala and Mesoamerican Urbanism." *World Archaeology* 2(2):186-198.

Holas, B.
1960 *Cultures Matérielles de la Côte d'Ivoire*. Paris.

1962 "Annotated Glossary of Senufo Sculptured Objects." For *Senufo Sculpture from West Africa*. New York: The Museum of Primitive Art.

Inverarity, Robert B.
1950 *Art of the Northwest Coast Indians*. Berkeley and Los Angeles: University of California Press.

Johnson, Edward
1654 *A History of New England & etc..* London. Quoted in *The Indian Historian*, Spring 1974, 7(2):55.

Kan, Michael & William Wierzbowski
1979 "Notes on an Important Cheyenne Shield." *Bulletin of the Detroit Institute of Arts*, 57(3):124-133.

Kaptchuk, Ted & Michael Croucher
1986 *The Healing Arts: A Journey Through the Faces of Medicine*. London: British Broadcasting Corporation.

Kopper, Philip
1986 *The Smithsonian Book of North American Indians Before the Coming of the Europeans*. Washington, D.C.: The Smithsonian Institution.

Kyerematen, A.A.Y.
1964 *Panoply of Ghana*. London: Longmans, Green and Co. Ltd.
1969 *Kingship and Ceremony in Ashanti*.
–70 Kumasi: University Press.

Lawrence, Denise L.
1987 "Rules of Misrule: Notes on the Doo Dah Parade in Pasadena." In Alessandro Falasi, ed., *Time Out of Time*. Albuquerque: University of New Mexico Press.

Lekson, Stephen
1988 "The Idea of the Kiva in Anasazi Architecture." *The Kiva* 53:213-34.

Linton, Ralph & Paul S. Wingert
1946 *Arts of the South Seas*. New York: The Museum of Modern Art.

Lips, Julius E.
1937 *The Savage Hits Back*. New Hyde Park, New York: University Books, 1966.

Mamiya, Christin J. & Eugenia C. Sumnik
1982 *Hevehe: Art, Economics and Status in the Papuan Gulf*. Los Angeles: Museum of Cultural History, University of California, Los Angeles, Monograph Series Number 18.

Marriott, Alice
1956 "The Trade Guild of the Southern Cheyenne Women." *Bulletin of the Oklahoma Anthropological Society* 4:19-27.

McLeod, Malcolm D.
1981 *The Asante*. London: British Museum Publications, Ltd.

Miller, Mary E.
1986 *The Murals of Bonampak*. Princeton: Princeton University Press.

Morley, Sylvanus G. & George W. Brainerd
1983 *The Ancient Maya*. Fourth edition. Revised by Robert J. Sharer. Palo Alto, California: Stanford University Press.

Morris, Ann Axtell
1933 *Digging in the Southwest*. Santa Barbara and Salt Lake City: Peregrine Smith, Inc., 1978.

Moulard, Barbara L.
1985 "Form, Function and Interpretation of Mimbres Ceramic Hemispheric Vessels." In Anthony Lace Gully, ed., *Phoebus 4*. Scottsdale: Arizona State University.

Mountford, Charles P.
1964 *Aboriginal Painting from Australia*. New York: Mentor- Unesco.

Munn, Nancy D.
1973 "The Spatial Presentation of Cosmic Order in Walbiri Iconography." In Anthony Forge, ed., *Primitive Art and Society*. London: Oxford University Press.

Newton, Douglas
1961 *Art Styles of the Papuan Gulf*. New York: The Museum of Primitive Art.

Ortiz, Alfonso
1969 *The Tewa World: Space, Time, Being, and Becoming in a Pueblo Society*. Chicago: University of Chicago Press.

Pastier, John
1975 "Living Space for Psychic Energy." *Los Angeles Times*, July 21, IV:9-10.

Patton, Sharon
1984 "The Asante Umbrella." *African Arts* 17(4):64-73, 93-4.

Rasmussen, Knud
1929 *Intellectual Culture of the Iglulik Eskimos, Report of the Fifth Thule Expedition 1921-4* 7(1). Copenhagen.

Rathje, W.L.
1971 "The Origin and Development of Lowland Classic Maya Civilization." *American Antiquity* 36:275-85.

Rattray, Robert S.
 1923 *Ashanti*. London: Oxford University Press.

 1927 *Religion and Art in Ashanti*. London: Oxford University Press.

Richter, Dolores
 1979 "Senufo Mask Classification." *African Arts* 12(3):66-73, 93-4.

 1981 Selected essays in Susan Vogel, ed., *For Spirits and Kings: African Art from the Paul and Ruth Tishman Collection*. New York: The Metropolitan Museum of Art.

Ross, Doran H.
 1977 "The Iconography of Asante Sword Ornaments." *African Arts* 11(1):16-25, 90.

 1982 "The Verbal Art of Akan Linguists' Staffs." *African Arts* 16(1):56-57, 95.

Ross, Doran H. and Timothy F. Garrard (eds.)
 1983 *Akan Transformations: Problems in Ghanaian Art History*. Los Angeles: Museum of Cultural History, University of California, Los Angeles.

Rothenberg, Jerome
 1969 *Technicians of the Sacred*. Garden City, New York: Anchor Books, Doubleday and Company, Inc.

Rubin, Arnold
 [1972] "Art as Technology in Sub-Saharan Africa and Southern California," typescript.

 1975 "Accumulation: Power and Display in African Sculpture." *Artforum* 13:9:35-47.

 1979 "Anthropology and the Study of Art in Contemporary Western Society: The Pasadena Tournament of Roses." In Justine M. Cordwell, ed., *The Visual Arts: Plastic and Graphic*. (World Anthropology: An Interdisciplinary Series; proceedings, IXth International Congress, ICAES, 1973.) The Hague: Mouton 669–716.

 [1986] Class Notes in Possession of the Editor.

 1988 "The Tattoo Renaissance." In Arnold Rubin, ed., *Marks of Civilization*. Los Angeles: Museum of Cultural History, University of California, Los Angeles, 233–62.

Rubin, Barbara, Robert Carlton & Arnold Rubin
 1979 *L.A. In Installments: Forest Lawn*. Santa Monica: Westside Publications.

Schele, Linda & Mary Ellen Miller
 1986 *The Blood of Kings: Dynasty and Ritual in Maya Art*. Fort Worth: Kimbell Art Museum.

Smith, Watson
 1952 "Kiva Mural Decorations at Awatovi and Kawaika-a." *Papers of the Peabody Museum of American Archaeology and Ethnology, Harvard University*, XXXVII, Cambridge, Massachusetts.

 1972 *Prehistoric Kivas of Antelope Mesa. Papers of the Peabody Museum of American Archaeology and Ethnology. Harvard University*. XXXVIIII, Cambridge, Massachusetts.

Tanner, Clara Lee
 1976 *Prehistoric Southwestern Craft Arts*. Tucson: University of Arizona Press.

 n.d. *Ray Manley's Hopi Kachinas*. Tucson: Ray Manley Photography.

Thévoz, Michel
 1984 *The Painted Body*. New York: Skira.

Thompson, J.E.S.
 1970 *Maya History and Religion*. Norman: University of Oklahoma Press.

Tylor, Edward B.
 1871 *Primitive Culture*. New York: Henry Holt and Company. (Reprinted 1958 as *The Origins of Culture and Religion in Primitive Culture*. New York: Harper and Row.)

Venegas, Sybil
 1977 "El Dia de los Muertos: Towards a Chicano Cultural Renaissance." *La Gente*, Noviembre 12.

Vogel, Susan (ed.)
 1981 *For Spirits and Kings: African Art from the Paul and Ruth Tishman Collection*. New York: The Metropolitan Museum of Art.

Waite, Deborah
 1966 "Kwakiutl Transformation Masks." In Douglas Fraser, ed., *The Many Faces of Primitive Art*. Englewood Cliffs, New Jersey: Prentice Hall.

Weaver, Muriel Porter
 1972 *The Aztecs, Maya and Their Predecessors: Archaeology of Mesoamerica.* New York: Seminar Press, Inc.

Willey, Gordon R.
 1966 *An Introduction to American Archaeology, Vol. I North and Middle America.* Englewood Cliffs, New Jersey: Prentice Hall.

Williams, F.E.
 1940 *Drama of Orokolo: The Social and Ceremonial Life of the Elema.* Oxford: Clarendon Press.

Wood, W. Raymond & Margot Liberty
 1980 *Anthropology on the Great Plains.* Lincoln and London: University of Nebraska Press.

Index